WILLIAM MORRIS

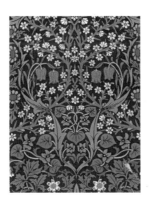

Publisher and Creative Director: Nick Wells
Senior Project Editor: Catherine Taylor
Art Director: Mike Spender
Layout Design: Jane Ashley
Production: Chris Herbert
Copyeditor: Ramona Lamport
Proofreader: Amanda Leigh
Indexer: Eileen Cox

FLAME TREE PUBLISHING
6 Melbray Mews
Fulham, London, SW6 3NS
United Kingdom

www.flametreepublishing.com

First published 2019

19 21 23 22 20

1 3 5 7 9 10 8 6 4 2

A CIP record for this book is available from the British Library.

ISBN: 978-1-78755-307-1

Every effort has been made to contact copyright holders. We apologize in advance for any omissions
and would be pleased to insert the appropriate acknowledgement in subsequent editions of this publication.

While every endeavour has been made to ensure the accuracy of the reproductions of the images in this book,
we would be grateful to receive any comments or suggestions for inclusion in future reprints.

Printed in China

WILLIAM MORRIS

Author: Julian Beecroft Foreword: Helen Elletson

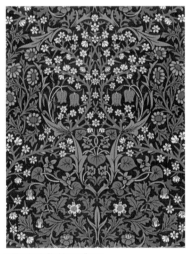

William Morris, *Blackthorn* wallpaper

FLAME TREE
PUBLISHING

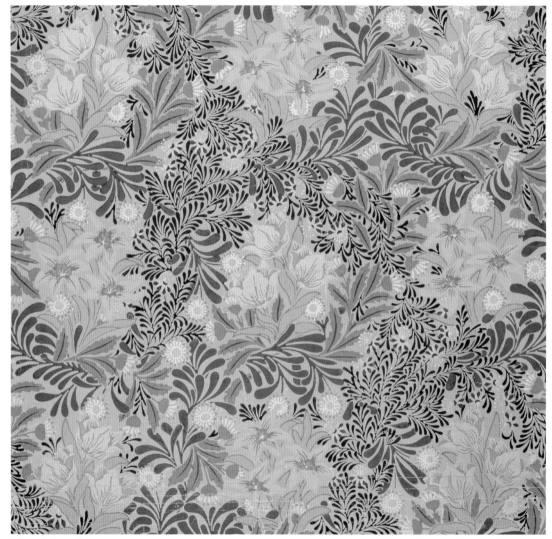

William Morris, *Bower* wallpaper

Contents

William Morris, Design for *Trellis* wallpaper; *Vine* wallpaper; *Wey* furnishing textile

Arras school, *Boar and Bear Hunt* tapestry; William and Jane Morris, *St Catherine* embroidery; John Henry Dearle, *The Arming and Departure of the Knights*

William Morris, *Acanthus* wallpaper; printing blocks for *Tulip* textile; *Evenlode* furnishing textile

William Morris, 'How I Became a Socialist' pamphlet cover; *The Strawberry Thief* furnishing textile; Morris and Edward Burne-Jones, *Writhing Tree* window

Edward Burne-Jones and John Henry Dearle, *Angeli Ministrantes* tapestry; John Henry Dearle, *Iris* wallpaper; William Arthur Smith Benson, Coffee pot

How To Use This Book

The reader is encouraged to use this book in a variety of ways, each of which caters for a range of interests, knowledge and uses.

- The book is organized into five sections: **Life**, **Inspiration & Influences**, **Media & Techniques**, **Politics & Society** and **Arts & Crafts**.
- **Life** provides a snapshot of how William Morris's life and work developed, and discusses how different people and events affected his life and career.
- **Inspiration & Influences** explores how Morris's work and outlook were impacted and inspired by a wide range of artworks, artists, writers and thinkers – from medieval tapestries to his colleagues in the Pre-Raphaelite Brotherhood.
- **Media & Techniques** examines the different media with which Morris worked or the materials in which his designs were executed, from painting to the production of tiles, textiles, wallpapers and printed books.
- **Politics & Society** reveals how Morris was deeply affected by events and injustices of his time, how his views developed and how he got involved in politics and activism.
- **Arts & Crafts** looks at the movement that Morris played a fundamental part in inspiring – some key players and examples.

1. Title of work (Note all works are by William Morris, unless another artist's name is given at the foot of the page)

2. Date of work (if known)

3. Picture credit

4. Information continuing the narrative of the chapter, discussing the item pictured where appropriate

5. Place in which the work was created (if known)

6. Medium in which the work was created (if known)

7. Related works, either from the same or other artists, with similar styles, techniques or subject matter

8. Name and dates of artist or creator if not William Morris

326

Oak Tree wallpaper, 1896

Courtesy of XXX Images/Alamy Stock Photo

The logic of Morris's thinking about the market system in which, as a businessman, he had to operate ran along the lines of the following: the choice we are offered by the 'free' market is not what we might actually choose based on our personalities and our deepest spiritual and material needs, but only what those who trade in the marketplace interpret these personalities and needs to be. Ergo, we should make these things for ourselves rather than buying things from a shop – even a shop such as Morris & Co. that sells quality carpets, fabrics and wallpapers such as this one. Only then will we understand how things are made and will thereby better appreciate the work of other makers; while at the same time, the experience of making will imbue us with a sense of fulfillment far richer than the pleasure of simply buying things from a shop. Alas, for Morris, the division of labour at the heart of the modern economy had served to deny the majority this experience of how to make things. 'What are the difficulties that beset its manufacture, what it ought to look like, feel like, smell like; or what it ought to cost apart from the profit of the middleman' – a set of factors amounting to far more than a mere technical challenge.

CREATED
Merton Abbey, London

MEDIUM
Wallpaper

RELATED WORKS
Jasmine wallpaper by William Morris, c. 1872

John Henry Dearle (1859–1932)

Foreword

When William Morris died aged sixty-two, one of the doctors attending him on his deathbed commented that Morris had done the work of 'some ten men', while another said that he had died of 'simply being William Morris'. There are few who cannot fail to be impressed by Morris's prodigious output; he was a designer, craftsman, writer, poet, lecturer, printer, typographer, socialist and conservationist.

To write a biography on such a multi-talented man is no easy task, but Julian Beecroft offers us not only a clear and comprehensive survey of Morris's life and work, but also brings a refreshing new perspective. Beginning with a background to Morris's early life in the context of the Great Exhibition and everything that Morris objected to in an industrial society, Julian tracks Morris's artistic development, the scope and variety of which is incredible. After a couple of false starts as a trainee priest and then an architect, Morris finally realized where his true talents lay and became aware that he was inherently talented at pattern designing.

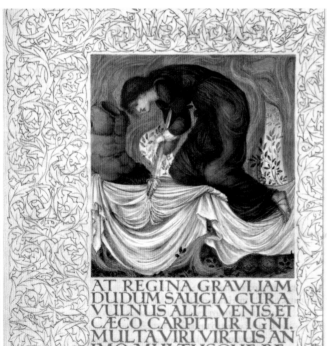

William Morris, *Dido Stabbing Herself*, opening of Book IV of Virgil's *Aeneid*

In founding his interior design company, Morris's goal was ambitious: to provide a tasteful but affordable alternative to the mass-produced items shaped by the Industrial Revolution. The firm was to become the most successful interior design company of all time; Morris's patterns are still being reproduced today, withstanding

over a century of changing taste. He mastered the techniques of weaving, dyeing and hand block-printing, and produced beautiful tiles, stained glass, furniture and wallpaper. However, Morris was more than a craftsman and designer. He was actually better known in his lifetime as a poet and writer, producing epic poems based on classical and northern mythologies, published to great acclaim. He went on to found the Society for the Protection of Ancient Buildings, in the process saving countless buildings from unnecessary 'restoration'; an organization that is still going strong today. Morris put Ruskin's views into action, reacting against the age of machinery and the corresponding degradation of the worker by dedicating many years of his life to the socialist cause and giving hundreds of lectures throughout the country. His last great undertaking was the foundation of the Kelmscott Press, his own private printing company, which had an enormous impact on worldwide typography and fine printing. Created with the finest-quality handmade paper, the blackest ink especially imported from Germany, illuminated initials, newly-designed type and beautiful woodcut illustrations, these glorious books remain unrivalled to this day.

Morris did not operate in a vacuum, though, and so it is particularly fascinating to view the works of contemporary designers and artists including Walter Crane, Charles Francis Annesley Voysey and the Pre-Raphaelites pictured alongside Morris's, as well as art from the past that Morris was so inspired by. We also see the creations of those who were to follow in Morris's footsteps, demonstrating that the founder of the Arts and Crafts Movement had a lasting legacy. This securely places Morris in context, enabling a full appreciation of the man who was a designer of international significance.

As Curator of Kelmscott House, Morris's home for the last eighteen years of his life, I have had the privilege of caring for, interpreting and researching the varied art work Morris produced. It has made me truly appreciate the talent and skill he brought to every craft he mastered. After spending the last twenty years immersed in the world of William Morris, I am delighted to see this new publication, which provides an innovative and comprehensive account of a true Victorian polymath. I strongly believe that over a century after his death, Morris remains just as relevant today as he was in his lifetime. Enjoy this wonderful journey to discover the life and work of one of the greatest men of the Victorian age.

Helen Elletson, 2019

Introduction

Among the many great Victorians, William Morris (1834–96) was one of the most remarkable. A reformer and an innovator not simply in many disciplines but in so many spheres of life, he began by refusing the aesthetic norms of his era, believing that the ordinary man and woman deserved better than the poor standards of design that existed in Britain during the early Victorian period in which he was raised. However, like John Ruskin (1819–1900), the great intellectual whose thinking came to influence him so deeply, Morris realized that the shoddiness of so much Victorian design reflected a rottenness at the core of Victorian society, and in middle age was both bold enough in his thinking and brave enough in his actions to seek to change it.

Like Ruskin, Morris was born to great privilege. His father was a successful discount broker in the City of London but had also made a personal fortune from investments in a Devon copper mine. Shielded from awareness of the dehumanizing effects of the Industrial Revolution, which would surely have included working conditions in the mine from which his own family profited, Morris spent a carefree childhood in the environs of Walthamstow, today a bustling suburb of north-east London but then a rural Arcadia on the edge of ancient Epping Forest. It was here, during one of the long walks he often took with only his imagination for company, that he came across Queen Elizabeth I's Hunting Lodge at Chingford Hatch, an almost forgotten building from a distant past that seemed of little interest to industrial Victorian England. For Morris, however, whose precocious mind was already crammed with the romances of Sir Walter Scott (1771–1832) – he later claimed to have read them all by the age of seven – this discovery was a revelation of a past whose values seemed both more refined and, implicitly, more humane than those of the present. The lodge sparked his lifelong interest in architecture as a civilizing force, but also a deep reverence for the pre-industrial past and a simpler way of life in harmony with the natural world. This, in time, became the basis for a design aesthetic that made him so successful in his own lifetime and so influential, even today, for designers both in Britain and abroad.

As a teenager, Morris briefly boarded at the recently opened Marlborough College in rural Wiltshire, an unruly institution where he thrived in everything except his studies. Steeped in books on archaeology and church architecture which he found in the school's library, as well as the novels and romances he had read as a child, he earned the respect of the other boys for the imaginative stories he invented to entertain them in the dormitories at night. Then in 1851

he was taken out of the school by his mother and privately educated by the Rev. Frederick Guy, a High Anglican priest who steered Morris towards the Anglo-Catholic Movement that became increasingly popular during what was a time of greater religious tolerance. Guy also instilled a love of Gothic architecture, a style that was beginning to shape the tastes of Victorian architects of the Gothic Revival and the clients they served.

In the same year, at the age of 17, he was taken to see the Great Exhibition at the Crystal Palace in Hyde Park. This first-ever world exposition was intended to show off the brilliance of British industrial manufacture and design to the citizens of Britain and visitors from abroad. However, Morris was less than impressed, finding the building itself to be so ugly that he refused to step inside it. With his own aesthetic tastes already firmly established – above all a rejection of the products and ideas of the Industrial Revolution – it was an antipathy, at first instinctive, that he would later find confirmed by some of the most radical thinkers of the day.

The following year, at the entrance exam for Exeter College, Oxford, Morris sat next to Edward Burne-Jones (1833–98), with whom he struck up an instant and close friendship that would last the rest of his life. Oxford was home to what was known as the Oxford Movement, which sought to reinvigorate ceremony and ritual in the Anglican liturgy. Morris and Burne-Jones both flirted with the idea of becoming Roman Catholics, and at this point Morris's future seemed to lie with the Church. However, bored with theology – the subject he was supposed to be studying – he immersed himself instead in medieval history, and from this his attention moved quite naturally to British intellectuals whose ideas about art and society were grounded in that historical period. The critique by Thomas Carlyle (1795–1881) of Victorian *laissez-faire* capitalism and his endorsement of feudal socialism, as set out in the book *Past and Present* (1843), was based on idealized notions of how life was lived in a twelfth-century monastery. Ruskin's devotion to the Middle Ages was inspired by Carlyle, just as he, too, inspired Morris in that regard.

For the moment, any thoughts of politics were many years in the future, although his eventual contribution to fundamental social change would be considerable. On graduating in 1855, having rejected the Church as a career, Morris decided to become an architect and, in January the following year, entered the Oxford practice of George Edmund Street (1824–81), one of the leading Gothic Revivalists of the day. It took him just nine months to realize he was as ill-suited to the office life of an architect as he was to the offices of the Church, and once again he could be thankful that the private income of £900 per annum he received from his father's mining investments made it possible to abandon a second career. Encouraged by Burne-Jones, but above all by Dante Gabriel Rossetti (1828–82),

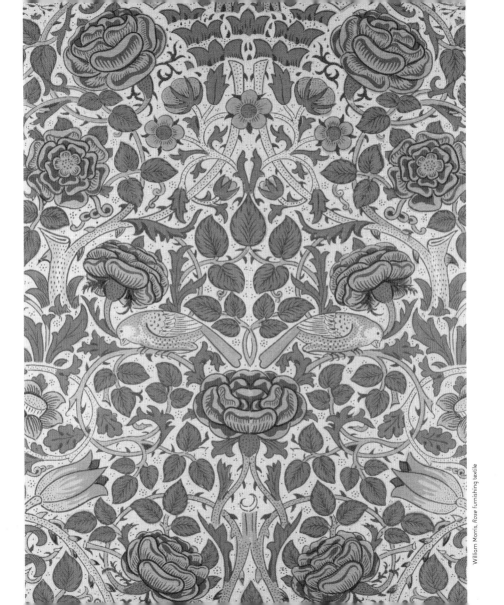

William Morris, *Rose* furnishing textile

one of the founder members of the Pre-Raphaelite Brotherhood, he took up painting but struggled with depicting the human figure. Rossetti was also an accomplished poet, and Morris, who had written poems since his student days, would publish a first collection, entitled *The Defence of Guenevere and Other Poems*, in 1858. Over the course of his life, he would go on to write and publish in all kinds of genres, including further collections of poetry, stories, novels and romances, as well as political and cultural essays that remain influential today.

Morris's poetry alone, especially the hugely popular collection *The Earthly Paradise* (1868–70), would make him a leading public figure, the achievement for which he was so well-regarded in his own lifetime that he was offered the position of Poet Laureate upon the death of Alfred, Lord Tennyson (1809–92). His literary activity would certainly

William Morris, Design for a tapestry depicting *Acanthus and Peacocks*

have been enough on its own to have secured his place in history, but Morris was a man of restless energy and copious talents he had both the money and the resolve to develop. In 1860, having commissioned a newly built house, known as Red House (*see* page 32), from architect Philip Webb (1831–1915) – another lifelong friend, whom he had first met in the Oxford practice of Street – he invited his friends to help him decorate it, in doing so pursuing his own dream of establishing an artistic fellowship along the lines of the monastic communities of the Middle Ages. However, this was mid-Victorian England rather than its medieval counterpart, so while the dream of an artistic commune remained elusive, Morris was quick to recognize the commercial potential of the creative products his friends were capable of making. In 1861, with the income from his mining shares now in decline and still without a definite career, he set up the company Morris, Marshall, Faulkner & Co., referred to as 'the Firm', whose seven founding partners included Webb, Rossetti, Burne-Jones and another leading painter of the

period, Ford Madox Brown (1821–93). From their initial showrooms in Bloomsbury to an eventual shop on Oxford Street, London's prime shopping street, the Firm sold original designs of handmade objects, offering a high-quality alternative (and a philosophical rebuke) to the derivative, mass-produced wares of industrial manufacture that so depressed Morris, and which epitomized for him the aesthetic bankruptcy of mid-Victorian Britain.

As the years passed, all the original partners except Webb and Burne-Jones drifted away from working for the Firm, and in 1875

William Morris, *Granville* wallpaper

Morris bought out the other partners and renamed the company Morris & Co. (*see* page 66). However, over the course of more than three decades, Morris himself expanded the range of his company's activities, mastering one decorative art after another, from embroidery to printed wallpapers, to printed textiles and then woven textiles, to tapestry and carpets, and finally calligraphy and illustrated books. In each discipline he created classic designs that are still admired, and in some cases still purchased, today. His legacy is profound, with practitioners in many disciplines counting Morris among their most significant figures. A designer and a conservationist, a a political activist and a maker of all manner of textiles, he still looms large in the annals of each field. Taken together, these achievements amount to a legacy that few other figures of his time can match. His aesthetic credo of beauty and utility continues to matter to us, as it did to the generation that followed him and was so inspired by his message. His socialist credo is perhaps overshadowed by some of the dreadful events of the twentieth century that occurred in the name of socialism, although his essays and lectures are among the most lucid of their time. Seeing how his own society denied so many of its citizens the chance of a decent life, in which they had both the liberty and the leisure to create and appreciate beauty, for the last 20 years of his life he worked tirelessly to change it, through lectures, essays and other writings that even today blaze with an urgency that is hard to ignore (*see* Politics & Society, pages 218–85).

William Morris

Life

Water House (now The William Morris Gallery), *c.* 1750

From 1840, Morris lived with his parents and siblings in a grand Georgian mansion called Woodford Hall, with a 50-acre park that backed onto Epping Forest. His father worked in the City firm of Sandersons, which ensured him a comfortable living. In 1845 his involvement in a mining consortium, the Devonshire Great Consolidated Copper Mining Company (also known as Devon Great Consols), led William Snr to take a 30 per cent stake in the venture, which secured the family fortune for the following two decades. It was during his formative years at Woodford Hall that William Jnr discovered a love of nature and a fascination with history that informed the great work of his later life. However, in 1847, following his father's sudden death, William's mother Emma moved William and his eight brothers and sisters to the rather more modest surroundings of Water House in Walthamstow, where the family remained until 1856. Today, this is home to the William Morris Gallery, originally opened by Labour prime minister Clement Attlee (1883–1967) in 1950. It is still the only public museum dedicated to the work and activity of William Morris.

CREATED

Walthamstow, London

MEDIUM

Architecture

RELATED WORKS

Woodford Hall, Woodford, Essex, UK

Unknown architect, eighteenth century

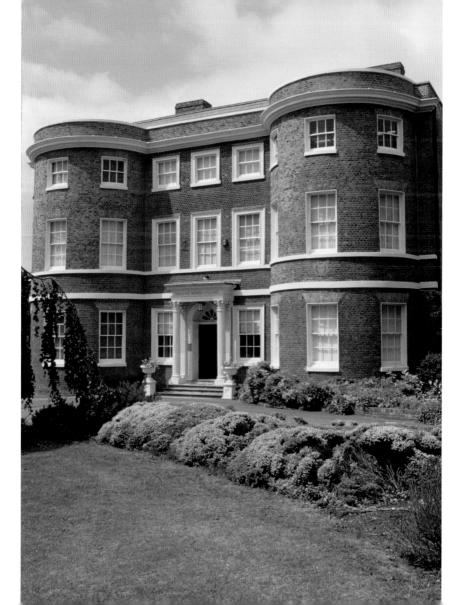

Chair with *Glorious Gwendolen's Golden Hair*, 1856–57

A house in Red Lion Square was the second London address where Morris lived for a time after the years he spent in Oxford as a student at Exeter College and then for nine months as a trainee architect in the firm of George Edmund Street. While he was still there, Morris's great friend Edward Burne-Jones had already moved to London and fallen in with the Pre-Raphaelite Brotherhood, in particular Dante Gabriel Rossetti. In June 1856, when Street's practice moved to London, Morris moved with them, though he gave up the profession altogether the following month. He and Burne-Jones shared digs, first at 1 Upper Gordon Square in Bloomsbury and then, from late November, in three unfurnished rooms at 17 Red Lion Square, also in Bloomsbury. Finding that they had no furniture, Morris designed a pair of crudely constructed, high-backed solid oak chairs. Their resemblance to furniture of the medieval period, which Morris, Burne-Jones and Rossetti all held in high esteem, was further strengthened by the painted decorations Rossetti and Burne-Jones respectively applied to each of the chairs. These depict scenes from Morris's own poem, 'Sir Galahad, A Christmas Mystery', which drew on the Arthurian legends they all loved.

CREATED

London

MEDIUM

Painted oak chair

RELATED WORKS

The Prioress's Tale decorated wardrobe by Philip Webb, 1859

William Morris (1834–96) **and Dante Gabriel Rossetti** (1828–82)

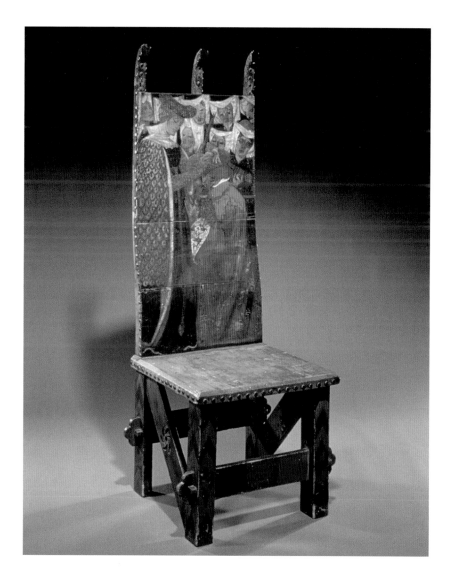

If I Can, 1857

Courtesy of Kelmscott Manor, Oxfordshire, UK/Bridgeman Images

Being a practical man concerned with how things were made, Morris was endlessly curious about new disciplines and techniques. Having abandoned architecture, and far from content in his new vocation as a painter, in 1857 – during his time at 17 Red Lion Square – he commissioned an embroidery frame to be made for him, which was based on an antique model. A natural autodidact, he was soon so proficient in the craft that he had developed his own preferred method of 'laying and couching'. This he taught to his housekeeper, known as 'Red Lion' Mary, who executed the designs he gave her for the remainder of his time at Red Lion Square. The *If I Can* hanging is the first that Morris produced himself. His personal motto, indicating his openness to try new things and his willingness to work hard to achieve them, the phrase 'If I Can' appears elsewhere in his oeuvre (though in the French form of 'Si je puis') – for example, as one component in the pattern of a stained-glass window at Red House, to which he would move just a few years later.

CREATED

London

MEDIUM

Embroidery

RELATED WORKS

Daisy embroidery, 1860

Sir Lancelot's Vision, study for the fresco painting in the Oxford Union, 1857

Courtesy of Ashmolean Museum, University of Oxford, UK/Bridgeman Images

During their time at Oxford, Morris and Burne-Jones had immersed themselves in the stories and poetry of the Middle Ages or its modern re-creations, including texts based on the legends of King Arthur: Alfred, Lord Tennyson's 'The Lady of Shallot' and *Le Morte d'Arthur* by the fifteenth-century writer Sir Thomas Malory (*c.* 1415–71). This seminal work of late medieval English had been rediscovered by another of Morris's heroes, Sir Walter Scott, at the end of the eighteenth century and by Morris's time was hugely popular. It was Malory's book that Morris and his artist friends turned to for inspiration in 1857, when Rossetti, still a young painter at the time, received an important commission to decorate the walls of the debating hall (today the library) of the Oxford Union. By all accounts, Rossetti, Morris, Burne-Jones and Arthur Hughes (1832–1915), another painter associated with the Pre-Raphaelites, had a ball completing the work, but despite the frescoes dazzling those who saw them at first, the group's inexperience soon showed through. Lacking knowledge of fresco technique, they had painted onto damp clay which had not been properly prepared, and within a year the brilliant colours of their medieval design had almost completely faded.

CREATED

Oxford

MEDIUM

Watercolour and gouache over black chalk on paper

RELATED WORKS

La Donna della Finestra, c. 1881

Dante Gabriel Rossetti (1828–82)

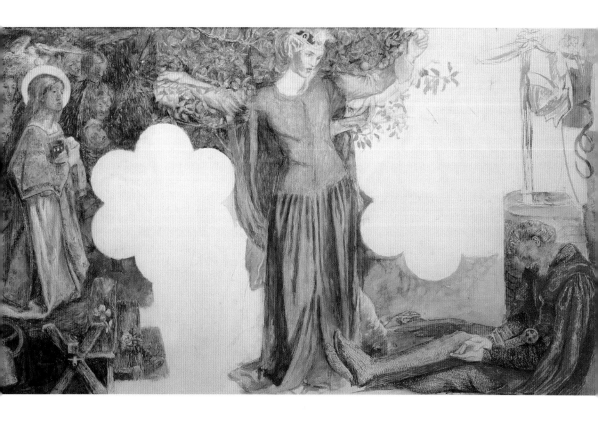

Queen Guinevere (La Belle Iseult), 1858

Courtesy of TopFoto.co.uk

Morris's brief career as a painter was a source of frustration, but without it he might never have met his wife. Jane Burden (1839–1914) was the dark-haired daughter of an ostler and a laundrywoman. Also a gifted embroiderer who would later work with Morris on a number of pieces, it was Jane's undoubted beauty that caught the eye of Rossetti at a theatre in Oxford, and he asked her immediately if she would work as an artist's model for the murals at the Oxford Union he had been commissioned to paint. Rossetti and his friends were always on the lookout for what they called 'stunners' – women of arresting but unconventional beauty who could model for the legendary female figures in their mural scheme. As soon as he saw her, Morris was smitten and asked her to model for this painting of the tragic figure of Iseult (or Isolde). The gap between the siren intensity of Jane Burden, as she appears in photos taken just a few years later, and the rather winsome figure depicted in this tentative painting confirmed to Morris that he was not meant to be a painter. He told her plainly, 'I cannot paint you but I love you.'

CREATED

Oxford

MEDIUM

Oil on canvas

RELATED WORKS

St George cabinet, 1862

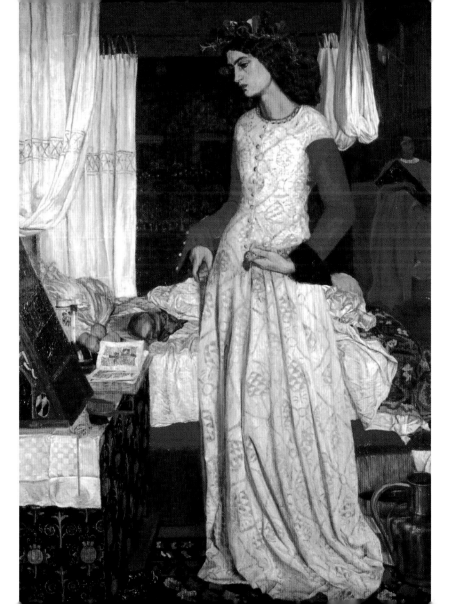

Red House, Bexleyheath, 1860

© Steve Cadman

Morris and Jane were married in April 1859 but had nowhere to live. So, with a vision of communal living inspired by the Middle Ages, and enabled by a significant investment income, Morris commissioned his friend Philip Webb to design the couple a house, to be built in Bexleyheath in Kent; today a south-east London suburb, at that time it was a rural backwater three miles by horse and cart from the nearest railway station. Webb's first commission, the house was known as Red House because of the colour of the unadorned brick with which it was built, a radical material for a domestic building of the period. It was also revolutionary in its use of an L-shaped corridor to link the rooms, and in the details of the exterior façade being determined by the functional requirements of the interior. A landmark structure, Red House has elements of the Gothic Revival then at the height of its popularity. But with its use of vernacular elements, it clearly points the way to the Arts and Crafts style, of which Webb would be a leading exponent, inspiring the next generation of architects, among them C.F.A. Voysey (1857–1941) and Charles Rennie Mackintosh (1868–1928). Red House was the only dwelling that Morris would ever own.

CREATED

Bexleyheath

MEDIUM

Architecture

RELATED WORKS

Standen, 1892–94

Philip Webb (1831–1915)

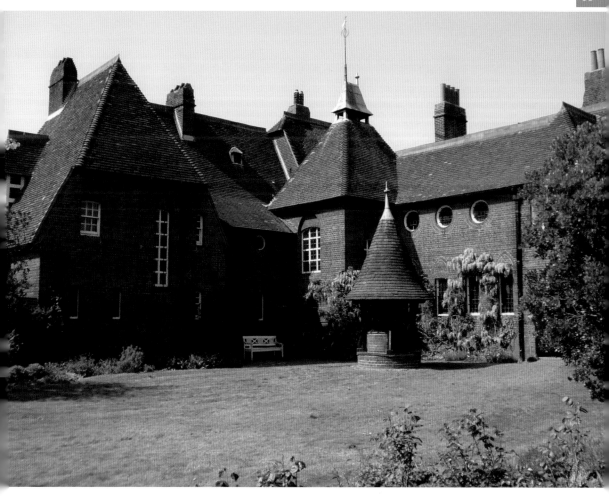

Lady Clare, c. 1857–60

Courtesy of The Fitzwilliam Museum, University of Cambridge, UK/Bridgeman Images

Red House was built to reflect Morris's ideals of domestic living. He railed against the bric-a-brac adornment that was the common, cluttered aesthetic of most Victorian homes, his own values being pithily expressed in his famous dictum: 'Have nothing in your house that you do not know to be useful or believe to be beautiful.' Treating the newly finished Red House like a blank canvas, Morris invited his friends to come and decorate it, and over the next few years the interior walls were filled with extraordinary murals, many of which were covered over by subsequent owners of the house and are only now being rediscovered by art conservators working for the National Trust. One of these, which covered a wall in what was William and Jane's bedroom, was a piece entrusted to Elizabeth (Lizzie) Siddal (1829–62), a regular at the house until her tragic early death. By then Rossetti's wife, Lizzie had been the model for *Ophelia* (1851–52) by John Everett Millais (1829–96), another of the original Pre-Raphaelites, and in countless images by her faithless husband, too. Even in her own time she was seen as a significant artist in her own right.

CREATED

Hastings, Sussex

MEDIUM

Pen and ink, brown and black wash over graphite on paper

RELATED WORKS

Elizabeth Siddal Standing at a Window by Dante Gabriel Rossetti, 1854

Elizabeth (Lizzie) Eleanor Siddal (1829–62)

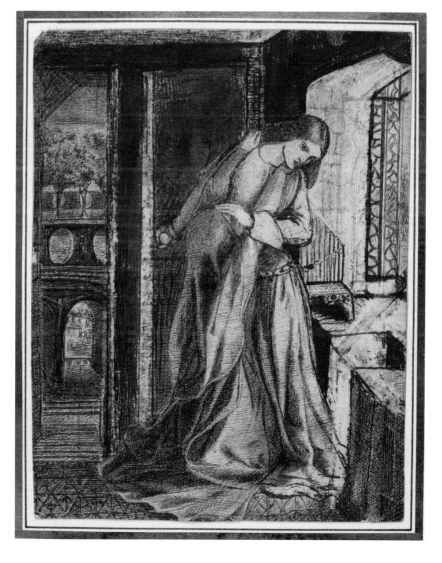

The Resurrection, 1861

In 1861, still without a proper career, Morris decided to go into business doing what he loved best. With six other partners (*see* page 38), including some of those – such as Webb and Burne-Jones – who had helped to decorate Red House, he started Morris, Marshall, Faulkner & Co. Its initial range of products and services, such as painted furniture and stained glass, drew heavily on the medieval aesthetic of the Pre-Raphaelite Brotherhood which was such a feature at Red House. Luckily, the 1850s and '60s saw a boom in church building in England in the Gothic Revival style, so the new company secured plenty of work designing stained-glass windows, such as this commission for All Saints Church in Selsley in Gloucestershire, an early building by the Gothic Revival architect George Frederick Bodley (1827–1907). Morris, Rossetti, Brown, Burne-Jones and a stained-glass artist called George Campfield (1861–98), who Morris had appointed as foreman at the Firm, all worked on this project to a scheme devised by Webb. Before long, the company's convincing medieval re-creations had earned them two gold medals in the Medieval Court at the International Exhibition held at the Crystal Palace in 1862.

CREATED

Selsley

MEDIUM

Stained glass

RELATED WORKS

The Ascension by William Morris, 1861

Edward Burne-Jones (1833–98)

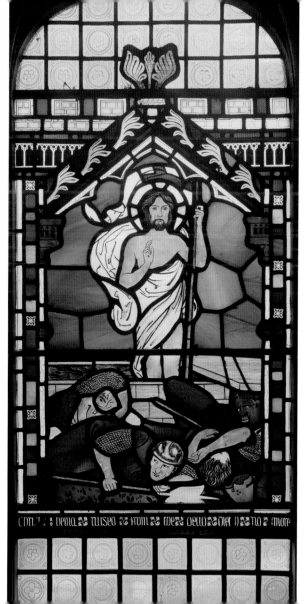

Design for *Trellis* wallpaper, 1862

Courtesy of Private Collection/The Stapleton Collection/Bridgeman Images

By the time he was painting the Oxford murals, Morris had recognized that his capacity for figure drawing was no match for his friends'. In that enterprise his main contribution had been decorative ornament in the form of the tendrils of climbing plants surrounding the figures. Five years later, in 1862, he was a married man with a house and a young family to support. With income from his mining interests now in certain decline, his new company was both a bold artistic venture and something of an economic necessity. Aside from Rossetti, Burne-Jones, Brown and Webb, the other partners were Charles Faulkner (1833–92), a friend from his Oxford days, and Peter Paul Marshall (1830–1900), an amateur painter. The Firm, as it became known, was committed to making 'work of a genuine and beautiful character', which, in line with Morris's most deeply held beliefs, would be made by hand. Among services they offered to potential clients were the reviving mediums of mural decoration and stained glass. However, by 1862 Morris had also turned his gift for decorative art to the design of wallpaper. Here, the birds were drawn by Webb, whose talent for depicting animals Morris came to depend on time and again.

CREATED

London

MEDIUM

Watercolour on paper

RELATED WORKS

Leaves from Nature illustration from *The Grammar of Ornament* by Owen Jones, 1856

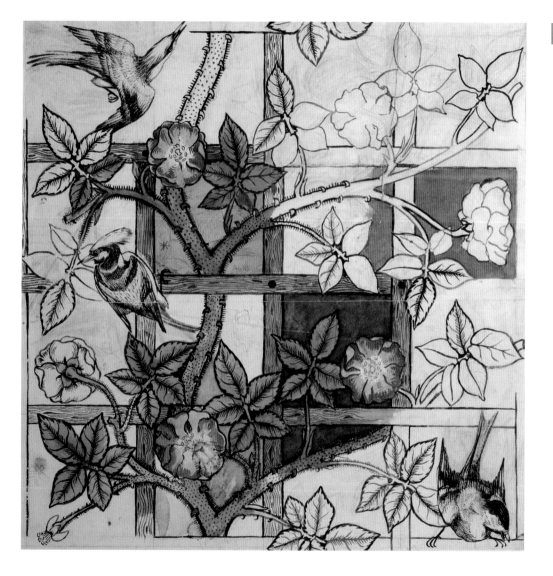

Daisy wallpaper, 1864

Courtesy of Private Collection/Bridgeman Images

While family life continued at Bexleyheath, the Firm was based in premises just a few doors down from Morris's former lodgings in Red Lion Square in Bloomsbury. By 1864, when he came to design his second wallpaper, *Daisy*, a daily commute of at least three hours in total had become such a struggle that, late in the year, he contracted rheumatic fever. Morris had had visions of Red House becoming home to an extended artistic community based along medieval monastic lines, and at one point he drew up plans to build an extension to the house, to accommodate Burne-Jones, his wife Georgiana (1840–1920) and their children. It is also likely that the Morrises' marriage had begun to deteriorate during this period, despite the birth of their two children: Jenny (1861–1935) and May (1862–1938). Furthermore, in this remote setting Jane was restive for personal reasons of which Morris was not yet aware. Those troubles aside, seeing how impractical it was to live so far away from his business in London, with great reluctance Morris decided to sell his home – his 'palace of art', as he called it – and by the autumn of 1865 they had left, never to return.

CREATED

London

MEDIUM

Wallpaper

RELATED WORKS

Nowton Court wallpaper by Augustus Welby Pugin, 1840

26 Queen Square, moved here in 1865

Morris moved his family to a rented property at 26 Queen Square, which again was in Bloomsbury, little more than a stone's throw away from his former digs. For several years, the Firm's showrooms and offices had been based at another address in Red Lion Square, where a furnace had been built in the basement to fire the stained glass and tiles that were among the company's early product ranges. In a clear sign of Morris's developing sense of social responsibility, he also trained and employed homeless boys from London's East End. However, by 1865 the company had outgrown its initial premises, so Morris rented a large house on Queen Square where both the family and the Firm (showrooms and workshops) could be comfortably accommodated. From now on, he effectively ran the business on his own, with the other partners returning to their varied occupations while doing occasional work for the Firm. But while Morris was a gifted designer and entrepreneur, and by all accounts an enthusiastic salesman, he could not keep control of expenditure and by 1865, despite a steady stream of orders, the Firm was in some financial trouble.

CREATED

London

MEDIUM

Architecture

RELATED WORKS

17 Red Lion Square, London

Sir Amédée Forestier (1854–1930) (drawing)

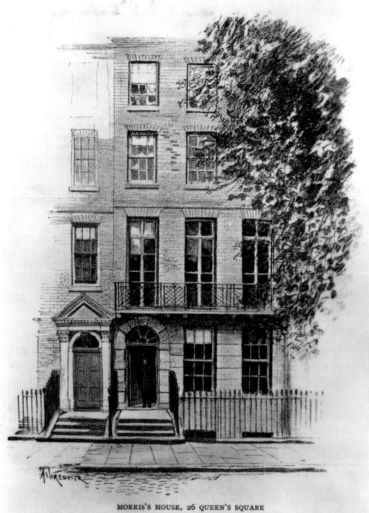

MORRIS'S HOUSE, 26 QUEEN'S SQUARE

The Green Dining Room at the V&A, 1866

Courtesy of Pierre Tribhou

To put the company finances back on an even keel, Morris appointed George Warington Taylor as business manager (*see* page 50), which freed him up to oversee the creative activity at which he excelled. Then in 1866, the Firm received two significant public commissions, both in London, which refilled the company coffers but also spread its reputation to a wider, well-connected clientele. The first was the redecoration of the Armoury and Tapestry Room at St James's Palace, while the second was the interior design of a new dining room at the South Kensington Museum, today the Victoria and Albert Museum. The Firm's commission, which became known as the Green Dining Room, was one of the three dining rooms in very different styles that today are still just as they were when first installed at the heart of the museum. A collaborative effort with Webb and Burne-Jones, who designed the exquisite stained-glass windows, the Green Dining Room is still an impressive space. Its combination of dark-green wallpaper, heavily embossed with a complex olive branch pattern, and blue-painted wood panelling inlaid with small panels of figures or foliage against a gilded background must have dazzled when it was opened in 1868.

CREATED

London

MEDIUM

Interior decoration

RELATED WORKS

Gamble Room, Victoria and Albert Museum, London by James Gamble (1835–1919)

Fruit (or *Pomegranate*) wallpaper, 1866

Fruit (or *Pomegranate*) was the third wallpaper Morris designed and the first after moving to Queen Square in London in 1865. Over the previous three decades, the British wallpaper industry had grown exponentially, but the patterns available when Morris began were either weak imitations of French Empire style or those based on conventionalized natural forms like the papers created by Augustus Pugin (1812–52) for the new Palace of Westminster a generation earlier. The much larger house that Morris now occupied with his family left ample room in which the Firm's activities could expand. As well as the showroom and office on the ground floor, there was also a ballroom in the courtyard at the back, which was turned into a big workshop surrounded by several smaller ones. The ballroom was linked to the main house by a wide wooden gallery in which the glass-painters went about their work. Morris's own studio was on the first floor. Freed from the exhausting commute, he revelled in being back in London, as over the next decade and a half he threw himself into the work for which he is now best remembered, designing one classic pattern after another.

CREATED

London

MEDIUM

Wallpaper

RELATED WORKS

Cockatoo and Pomegranate wallpaper by Walter Crane, 1899

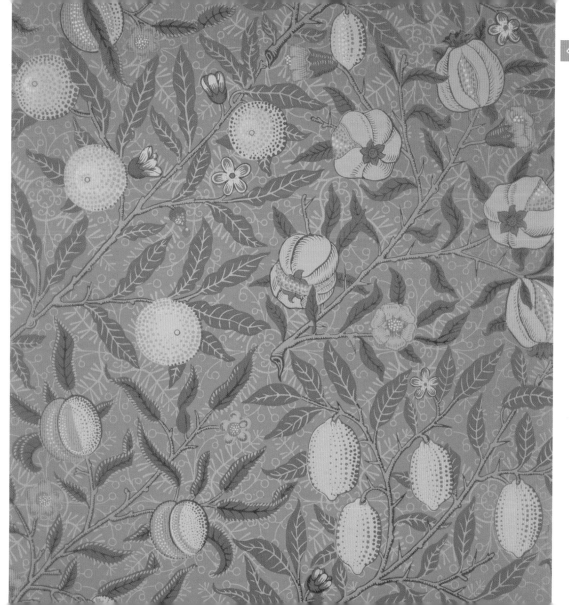

Diaper wallpaper, 1868–70

Courtesy of Private Collection/The Stapleton Collection/Bridgeman Images

As if designing was not enough, Morris also had energy spare for writing poetry. Having written nothing since before his marriage to Jane, he now embarked on a huge cycle of poems called *The Earthly Paradise*. In the midst of this he also composed another, book-length poem entitled *The Life and Death of Jason*. This was well received when published in 1867, but *The Earthly Paradise*, which came out the following year, was a publishing phenomenon. Enduringly popular in Morris's own lifetime, it raised him to the highest rank among the English poets of his day, alongside Tennyson and Robert Browning (1812–89), although today the poem is almost forgotten. At the same time, Morris was expanding the range of designs he could offer to his clients. The name of this one, meaning a repeating geometrical or floral pattern, is as generic as the pattern itself. In those cases when a client wished to use more than one paper in a single room, Morris would recommend this one as a secondary or ceiling paper. Initially produced in yellow and olive colourways, by the end of the 1870s it was available in a further seven colours.

CREATED

London

MEDIUM

Wallpaper

RELATED WORKS

Grace Diaper wallpaper by Augustus Welby Pugin, *c.* 1840

Indian wallpaper, 1868–70

Courtesy of Private Collection/The Stapleton Collection/Bridgeman Images

This paper is one of a group of four that Morris adapted from historical sources, in this case possibly from a design by Sir George Gilbert Scott (1811–78). Morris is still admired for his originality and his firm principles, but he was also a commercial pragmatist, keen to offer a range of solutions to suit all tastes. To begin with, his enthusiasm for business had not been matched by his acumen. He was too generous to his fellow partners and too partial to the good things in life, with a regular habit of a couple of bottles of wine every day which in the long run may have compromised his health. This lax control on spending was what Warington Taylor was brought in to address after a slump in the market for stained glass, then the main source of revenue, meant the Firm's profits were insufficient to keep up payments on loans taken out by Morris and his mother to set up the company with an adequate capital sum. However, Morris was easily distracted by his many interests, and projects were often left unfinished and thus unable to generate any income. Warington Taylor seems to have encouraged him to tackle one thing at a time.

CREATED

London

MEDIUM

Wallpaper

RELATED WORKS

Mosaic ecclesiastical wallpaper by Augustus Welby Pugin, mid-nineteenth century

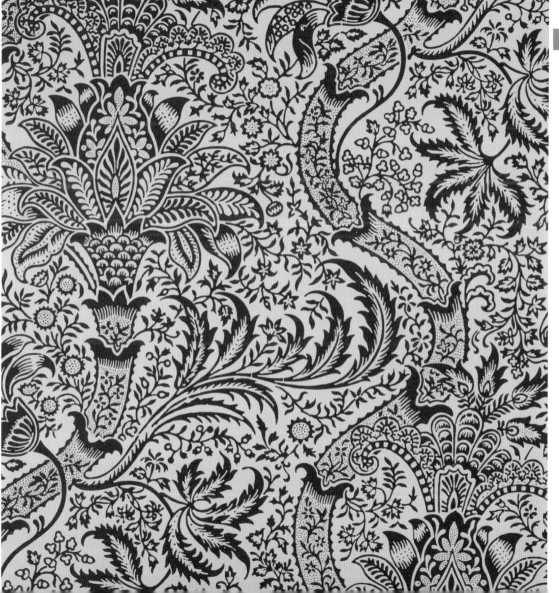

Jasmine Trail (or *Jasmine Trellis*) furnishing textile, 1868–70

Courtesy of Private Collection/The Stapleton Collection/Bridgeman Images

In the late summer of 1869, Jane and William travelled to the spa town of Bad Ems in Germany, so that Jane, who was seriously ill with what is thought to have been a gynecological complaint, could take a cure. There were also other reasons to leave England for a while, as by now Jane was widely suspected to be having an affair with Rossetti, whom for some time she had been visiting alone at his house in Cheyne Walk in Chelsea, ostensibly to pose as a model. Fuelling Morris's suspicions, during the six weeks' sojourn at the spa, Jane and Rossetti kept up a vigorous correspondence, with Rossetti's letters littered with satirical cartoons of Morris and caustic ridicule of the Morrises' marriage. The young Henry James (1843–1916) was acquainted with the Morrises during this period, and described Jane as a 'figure cut out of a missal ... an apparition of fearful and wonderful intensity', with whom Rossetti was clearly becoming obsessed. Morris was depressed by what was happening, but his creative energy was nonetheless undimmed. As well as poetry, he turned his attention to a new visual medium, furnishing textiles, for which this was his first design.

CREATED

London

MEDIUM

Furnishing textile

RELATED WORKS

Trellis wallpaper, 1862

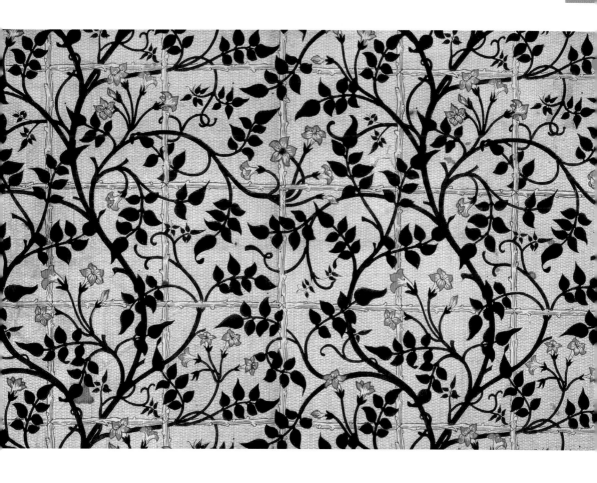

Utrecht velvet furnishing textile, *c.* 1871

This upholstery fabric, whose name derives from stamped velvets originating in Holland and Belgium during the seventeenth and eighteenth centuries, was sold at the shop in Queen Square from 1871. In the same year, Morris and Rossetti took out a joint lease on Kelmscott Manor, an Elizabethan house in the tiny hamlet of Kelmscott in the Oxfordshire Cotswolds, close to the source of the River Thames. Morris described the house and the setting as 'heaven on earth', and they appear as such in the closing scenes of his later Utopian novel *News from Nowhere* (1890, *see* page 88), the frontispiece of whose first edition was a woodcut illustration of the manor house. However, Morris's domestic situation was anything but heavenly, and one of his reasons for renting this rural retreat was almost certainly so that Rossetti and Jane could carry on their affair without being a continuing source of scandal for London society. Morris seems to have treated his wife's infidelity with remarkable tolerance, so it is likely that the strikingly progressive attitudes he professed towards sex and marriage in later life were already a fundamental part of his thinking at this time.

CREATED

London

MEDIUM

Upholstery material

RELATED WORKS

Gothic *Speaker's Bed*, curtains and pelmet by Augustus Welby Pugin, *c.* 1850

Decorated translation of *The Rubáiyát of Omar Khayyám*, 1872

After completing *The Earthly Paradise* (*see* page 48), Morris became interested in calligraphy, turning an earlier passion into yet another skill. As with everything he did, he showed immediate technical facility and by August 1870 had completed *A Book of Verse*, whose dedicatee was Burne-Jones's wife, Georgiana. Mirroring Jane's betrayal of Morris, Burne-Jones had begun a passionate affair with the Anglo-Greek sculptor and model Maria Zambaco (1843–1914). Morris and Georgiana found great solace in each other's company, and Morris may even have fallen in love, although if this was the case, it was unrequited. In the years between 1870 and 1875, Morris completed several further book-length calligraphies, including Edward FitzGerald's (1809–83) 1859 translation of verses by the Farsi poet Omar Khayyam (1048–1131), *The Rubáiyát of Omar Khayyám*, which became one of the most popular books of the late nineteenth century. One of his finest manuscripts, it was inscribed on vellum obtained from Rome, which Morris insisted must be as hard and as smooth as that found in the medieval books from which he had learned the art. However, calligraphy was a skill he learned purely for the pleasure of using it, with no commercial motive.

CREATED

London

MEDIUM

Illuminated manuscript

RELATED WORKS

The Aeneids of Virgil, 1874–75

2

OMAR KHAYYÁM

And once departed may return no more.

Now the new year reviving old desires

The thoughtful soul to solitude retires

Where the White Hand of Moses on the bough

Puts forth, and Jesus from the ground suspires.

Iram indeed is gone with all its rose,

And Jamshyd's seven-ringed cup where no one knows,

But still the Vine her ancient ruby yields,

And still a garden by the water blows.

And David's lips are locked, but in divine

High-piping Pehlevi with Wine, Wine, Wine,

Red Wine, the Nightingale cries to the Rose

That yellow cheek of hers to incarnadine.

Design for *Vine* wallpaper, *c.* 1872

Courtesy of Private Collection/The Stapleton Collection/Bridgeman Images

The densely patterned *Vine* wallpaper shares the same characteristic with a series of papers created in the 1870s, quite different from the more open design of early classics, such as *Trellis* (*see* page 166) and *Daisy* (*see* page 40), from the previous decade. By the time Morris began designing it in 1872 he had absorbed a wholly new culture from a land where grapes would never grow but which deepened his awareness of the interconnectedness of the aesthetic and political spheres of life. Morris was already a keen student of the ancient Icelandic sagas when, in 1869, he met the Icelandic linguist and theologian Eiríkr Magnússon (1833–1913). The two became friends, with Morris taking lessons in the language from the scholar. These progressed so well that within a few months the pair had embarked on a series of translations of the sagas, such as *The Story of the Volsungs and Niblungs*, which was published the following year. Six years later, Morris rendered the same story in 10,000 lines of English verse. His daughter May later insisted that this was the literary work her father 'held most highly and wished to be remembered by'.

CREATED

London

MEDIUM

Watercolour on paper

RELATED WORKS

The Garden of Eden by Charles Francis Annesley Voysey, *c.* 1923

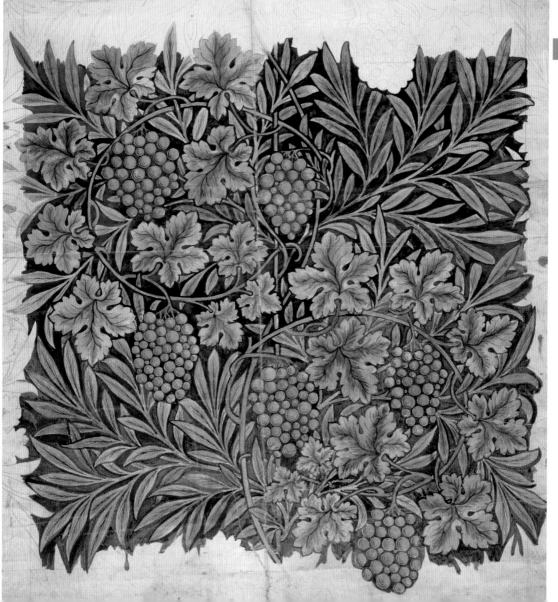

Vine wallpaper, 1873

Courtesy of Private Collection/Bridgeman Images

By late 1872, the Firm was riding the mid-century wave of an expanding Victorian middle class. With the order book swelling, more space was needed at Queen Square to accommodate offices as well as further workshops, showrooms, and, most happily for Morris, a small dye shop in the basement for the textiles that would mark the next big expansion of the Firm's product range. So Morris moved his family to Horrington House in Turnham Green, West London, where they would live for the next six years. Then in spring 1873, shortly after moving into the new house, and following a period of illness, Morris was persuaded by Burne-Jones to take a two-week holiday in Italy; Burne-Jones revered the Italian Renaissance, but it held little interest for Morris, who was temperamentally a man of the North. Nonetheless, he relented and off they went by train through the Alps to Florence and Siena. But the visit confirmed to Morris that Renaissance Italy was when the rot began that led to the present age of industrialization and debased society. While he did admire what he saw, he also found evidence of 'recklessness and folly'.

CREATED

London

MEDIUM

Wallpaper

RELATED WORKS

Peacock Garden wallpaper by Walter Crane, 1889

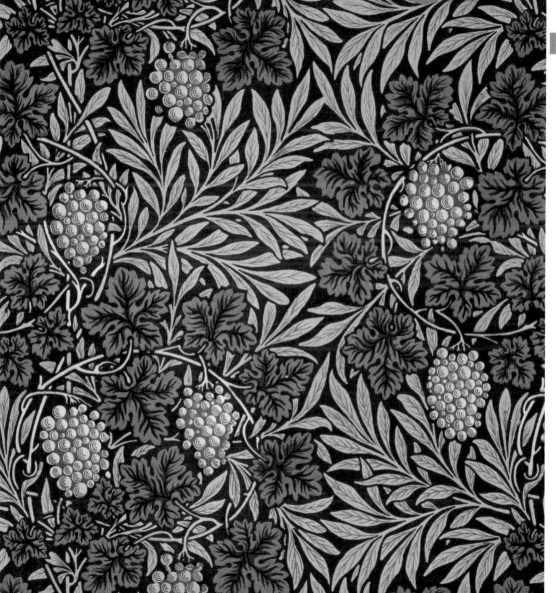

Page from *The Story of Hen Thorir,* c. 1873–74

In mid-summer 1871, Morris, Magnússon, Faulkner and an army officer called William Herbert Evans set out from Edinburgh by Danish mail boat to Iceland. This two-month pilgrimage to the land of the sagas, a journey he repeated in 1873, would be the great adventure of Morris's life, the more so for leaving behind his greatest misery, the affair between Jane and Rossetti which at that time had reached a torrid stage. It would also confirm his already strong instincts about what was necessary for the good life that everyone had a right to expect, and how far his own society was from meeting that need or even caring what it was. Seeing that Icelandic society, though poor, was nonetheless harmonious, he reasoned 'that the most grinding poverty is a trifling evil compared with the inequality of classes'. Above all, in this simple community he found few social divisions and almost no division of labour, with every man or woman expecting to do their fair share of the most menial tasks. By way of negative example, *The Story of Hen Thorir*, which Morris produced as an illuminated manuscript, tells a morality tale about a poor but selfish man who, on becoming a wealthy merchant, ignites a feud with his neighbours that culminates in his death.

CREATED

London

MEDIUM

Illuminated manuscript

RELATED WORKS

King Hafbur and King Siward, c. 1873

Odd of the Tongue, and others named

THE STORY OF HEN THORIR

Chap 1: of men of Burgfirth

HERE was a man hight Odd, the son of Onund Broadbeard, the son of Wolf of Fitia, the son of Thorir Otter; he dwelt at Broadbolstead in Reikdale of Burgfirth; his wife was Jorun, a wise woman and well skilled; four children had they, two sons of good conditions, and two daughters: one of their sons hight Thorod and the other Thorwald: Thurid was one daughter of Odd, and Jofrid the other. Odd was bynamed Odd of the Tongue; he was not held for a just man.

A man named Torfi the son of Valbrand the son of Valthiof the son of Orlyg of Esjuberg had wedded Thurid, daughter of Odd of Tongue, and they dwelt at the other Broadbolstead.

At Northtongue dwelt a man named Arngrim the son of Helgi, the son of Hogni, who came out with Hromund

Kelmscott Manor tapestry room (modern recreation of décor), 1870s

Courtesy of Bridgeman Images

Kelmscott Manor backs on to a gentle stretch of the Upper Thames where Morris, an enthusiastic angler from childhood, would commune with the river, fishing rod in hand. The house was only ever used as a holiday home, and mostly in summer, to which in later years Morris and his family would travel upriver by boat all the way from London, a restful journey of some 200 miles. Hung with four seventeenth-century tapestries, the Tapestry Room on the first floor was used by Rossetti as a studio for the few years he lived there. But the idyll that Morris found in Kelmscott was marred by the presence of Rossetti. The painter had begun taking chloral in the late 1860s to cure his insomnia and he gradually developed an addiction, which almost certainly contributed to his increasingly erratic behaviour. In 1872 he suffered a complete nervous breakdown and thereafter showed growing signs of paranoia, hearing voices and the ringing of bells. Eventually, even Jane could no longer tolerate his mental instability, and in 1874 Morris demanded that Rossetti give up his part of the lease and leave.

CREATED

Kelmscott

MEDIUM

Architecture

RELATED WORKS

Great Hall, Hampton Court

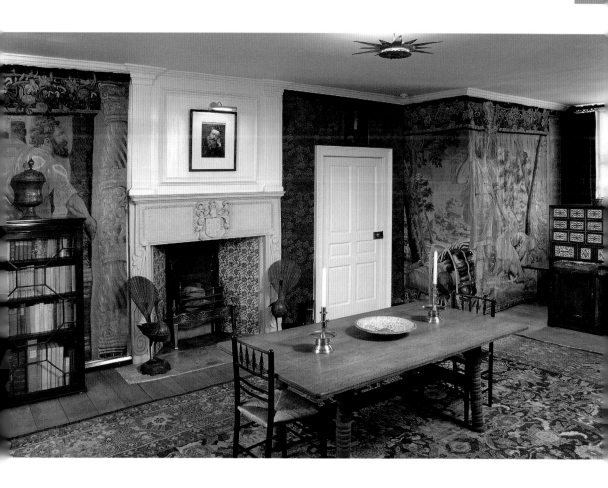

Tulip and Lily woven carpeting, c. 1875

Courtesy of Private Collection/Bridgeman Images

In May 1875, after more than a year of difficult negotiations, Morris bought out the other partners in the Firm, paying each one the sum of £1,000 and taking full control of the company, which he now renamed Morris & Co. Ford Madox Brown remained bitter about the move for years afterwards, while Rossetti spitefully insisted that his own compensation payment be placed in trust for Jane. However, with the drug-addicted painter having been forced to leave Kelmscott Manor the previous year (*see* page 64), Morris could now enjoy a new level of peace and stability in his life. This carpeting was probably among the first designs the new company put on the market following the takeover; in a further demonstration of Morris's ultimate pragmatism, it was woven by machine. Despite his supposed hatred of the industrial process, lacking the facilities to make it himself he turned to a company in Heckmondwike in Yorkshire to make it for him. However, he was less than happy with the colours evident in samples he was sent, confirming his feeling about items made by machines and thus the need to find alternative solutions based on the old ideals of craftsmanship he had always espoused.

CREATED

London and Heckmondwike

MEDIUM

Machine-woven carpet

RELATED WORKS

Lily machine-woven carpet, 1875

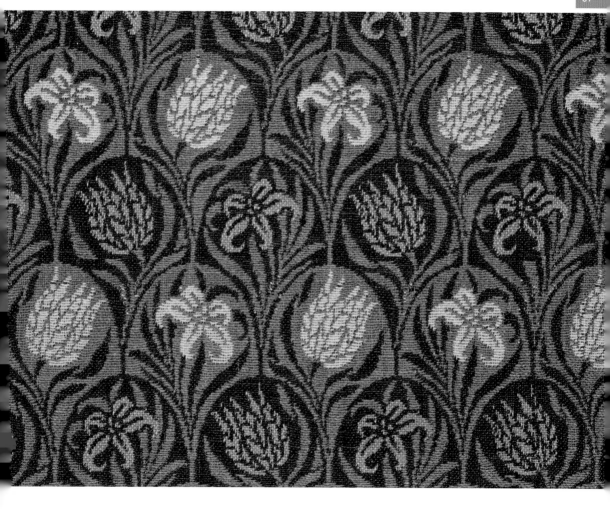

Tulip furnishing textile, 1875

Courtesy of Art Gallery of South Australia, Adelaide, Australia/South Australian Government Grant/Bridgeman Images

This is one of five textile designs that Morris drew in 1875. His dissatisfaction with the garish colours of synthetic dyes for printed textiles had led him to experiment with natural dyes at Queen Square from 1872. However, he realized he lacked both the facilities and the expertise to achieve the results he wanted, so in 1875 he travelled to Leek in Staffordshire, to the dyeworks of Thomas Wardle (1831–1909), brother of George Wardle, Morris's business manager after the departure of Warington Taylor. *Tulip* was one of the first Morris textiles produced by Wardle's Hencroft Dyeworks (*see* page 180), using natural dyestuffs, following hands-on experiments that Morris himself conducted with Wardle and three of his dyers. Morris, whose hands were dyed permanently blue during this period, confessed to loving the 'delightful work; hard for the body and easy to the mind'. Wardle's father had used natural dyes in his own silk-dyeing business in the 1830s, but by the 1870s the use of synthetic aniline dyes was standard practice in the industry. However, Wardle was keen to revisit techniques that he remembered from childhood. Catching Morris's enthusiasm, he later wrote of 'being led on by the charm of his personality and the wide range of his artistic ability'.

CREATED

London and Leek

MEDIUM

Printed cotton

RELATED WORKS

Flowers and Leaves with Birds fabric by Charles Francis Annesley Voysey, *c.* 1893

Venus and Aeneas, opening of Book I of Virgil's *Aeneid*, 1876

With 12 projected illustrations by Burne-Jones for the opening pages of each book, *The Aeneid* was the most ambitious of the 18 illuminated manuscripts – or 'painted books', as he called them – that Morris produced between 1869 and 1875, although *The Aeneid* was a project he worked on for two years but never finished, with only six of the 12 books transcribed onto vellum. Morris later sold the text to Charles Fairfax Murray (1849–1919), a second-wave Pre-Raphaelite painter who was also an assistant to Burne-Jones. Some years after Morris's death, Murray commissioned another artist, Louise Powell (1882–1956), to complete the illuminations and the calligrapher Graily Hewitt (1864–1952) to finish the blue and gold lettering of the books. Murray was also involved in another project by Morris, *The Odes of Horace*, working with Burne-Jones on the opening pages of three of the four books that were done. This project also remained unfinished and the books are now kept in the Bodleian Library, where as a student at the University of Oxford Morris had spent long hours poring over medieval examples of an art form he was later inspired to revive.

CREATED

London

MEDIUM

Watercolour on vellum

RELATED WORKS

The Odes of Horace, 1876

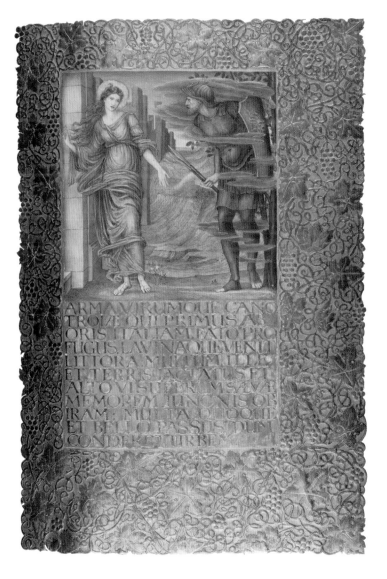

ARMA VIRVMQVE CANO
TROIÆ QVI PRIMVS AB
ORIS ITALIAM FATO PRO
FVGVS LAVINAQVE VENIT
LITTORA MVLTVM ILLE
ET TERRIS IACTATVS ET
ALTO VI SVPERVM SÆVÆ
MEMOREM IVNONIS OB
IRAM MVLTA QVOQVE
ET BELLO PASSVS DVM
CONDERET VRBEM

Design for *Bluebell* or *Columbine* furnishing textile, 1876

Courtesy of PKM/Planet Art

By 1876, when Morris created this pattern, he had been working with Thomas Wardle for the best part of a year but was still dissatisfied with the results. Intriguingly, given Morris's imminent commitment to socialism and his hatred of an industrial system that condemned whole families to the workhouse, when Wardle wrote to him that more staff would be needed to execute the new technique of pencilling indigo blue, Morris suggested using children at a lesser wage, as he was already doing himself. He was keen that the process he demanded should be made as efficient and as economic as possible. Inevitably, his emphasis on quality and craftsmanship meant his products could not be priced at a level that made them affordable to people on modest incomes. When Morris & Co. opened a store on London's Oxford Street the following year, in which Morris regularly served his customers in person, the clientele was invariably the middle class with enough disposable income to be able to shop at the high end of the market. Inevitably, the most lucrative decorating contracts, which saw him 'ministering to the swinish luxury of the rich' (*see* page 242), as he put it directly to one such client, were from those with the deepest pockets.

CREATED

London

MEDIUM

Printed cotton

RELATED WORKS

Bourne by John Henry Dearle, *c.* 1905

Proserpine, 1877

Despite his eviction from Kelmscott Manor, Rossetti was still as obsessed with Jane as he had ever been. Over the next few years, she continued to model for him, giving rise to a series of iconic pictures including *Astarte Syriaca* (1877) and *Proserpine*. For the first half of 1876, Rossetti rented a house in Bognor Regis, on the Sussex coast, where Jane came and stayed with him; but on discovering how severe his addiction had become she resolved to end the relationship. At the same time, with his children now teenagers, Morris himself was becoming more of a hands-on father, which may have been why his social conscience, allied to an aesthetic sensibility as finely tuned as any in Victorian England, was now more deeply stirred. In 1877, appalled by the crude restoration of a church in Burford, near his home at Kelmscott, and also by Sir George Gilbert Scott's proposed restoration of Tewkesbury Abbey, Morris founded the Society for the Protection of Ancient Buildings. The SPAB, which became known as 'Anti-Scrape', marked the beginning of the modern conservation movement and organizations such as the National Trust. From then on, at some cost in loss of business to the Firm, Morris refused to supply stained glass to any building that was being restored.

CREATED

Bognor Regis

MEDIUM

Oil on canvas

RELATED WORKS

Astarte Syriaca, 1877

Dante Gabriel Rossetti (1828–82)

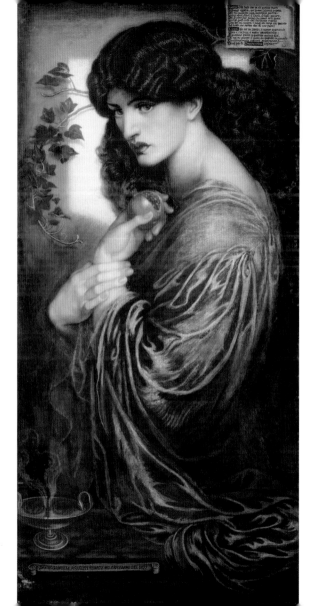

The *Artichoke* hanging, 1877

Morris had been making embroideries from the late 1850s, even before Red House, and in the early years it was the only kind of decorated textile the Firm could offer. By the mid-1870s, to keep pace with demand, the company was employing a group of needlewomen supervised by Jane, an accomplished embroiderer herself. Having developed his style of richly complex patterning in mediums such as wallpaper and printed textiles, and with a new market for embroideries from clients familiar with these other designs, Morris also offered patterns which clients could themselves embroider for their own homes. *Artichoke* was among the most popular of these crewelwork (*see* page 194) embroideries. Commissioned by Ada Godman (1850–1900) in 1877, she traced the design on to linen and then worked it in wool, making several panels over a period of more than 20 years. Ada's house, Smeaton Manor in Northallerton, North Yorkshire, was designed by Webb, also in 1877. In the 1890s, the same wall hanging was used at Standen in Sussex, another house designed by Webb, in this case embroidered by the owner, Margaret Beale (d. 1936), and her daughters. The Beale house was decorated throughout with furnishings, fabrics and wallpapers by Morris & Co.

CREATED

London

MEDIUM

Crewelwork on linen

RELATED WORKS

Lotus hanging, 1875–80

William Morris working on a tapestry, after 1878

Courtesy of The Fitzwilliam Museum, University of Cambridge, UK/Bridgeman Images

This cartoon by Burne-Jones, one of the many affectionate portraits he made of his friend in his natural element over the years, brilliantly captures the complete immersion in work for which Morris was renowned. Morris considered tapestry the 'noblest of the weaving arts', being the only one offering a richness of expression that was comparable with painting (*see* page 188). He had encountered some of the greatest examples of the medium during his travels in northern France in the mid-1850s, but it was not until 1878 that a tapestry loom was set up in his bedroom and he began to tackle it himself. By then he had mastered several other mediums, and before long had achieved a similar, remarkable facility in what was the most complex discipline of them all. However, Morris also understood his strengths and weaknesses, and with tapestry requiring skills of draughtsmanship similar to painting, those pieces designed by Morris & Co. over the next two decades were collaborative ventures: Burne-Jones drew the figures, Webb the birds (*see* page 38) and animals at which he was especially skilled, and Morris the foliage at which he excelled, with further contributions from John Henry Dearle (1859–1932), a young apprentice who rose through the ranks, eventually becoming Morris & Co.'s chief designer.

CREATED

London

MEDIUM

Pencil on paper

RELATED WORKS

Resolution, or the Infant Hercules by Dante Gabriel Rossetti, 1869

Edward Burne-Jones (1833–98)

Peacock and Dragon furnishing textile, 1878

In the spring of 1879, Morris moved his family from the small property at Turnham Green to a large Georgian house a short distance away on the Thames at Hammersmith, where he would live for the rest of his life. This he renamed Kelmscott House after the idyllic country manor house he retreated to at the other end of the river in the summer months. Before long, he had converted the stables and coach house of the Hammersmith home into a workshop for making hand-knotted Hammersmith carpets and rugs (*see* page 212); it was yet another craft skill he rapidly mastered. By this point, Morris & Co.'s activities had also further expanded to include not only tapestries but woven textiles as well, such as that shown here. At first production of these had been outsourced, but in June 1877, with a view to bringing these activities also under his own control, he recruited Louis Bazin, a French silk weaver from Lyon, renting space in Great Ormond Yard to accommodate the mechanical Jacquard loom the Frenchman brought with him. After a slow start that was not helped by a language barrier that Morris was not inclined to bridge, Bazin finally got to grips with what his new boss was after, and yet another product line was established.

CREATED

London

MEDIUM

Woven woollen fabric

RELATED WORKS

Design for a floral woven textile by Lindsay P. Butterfield, *c.* 1905

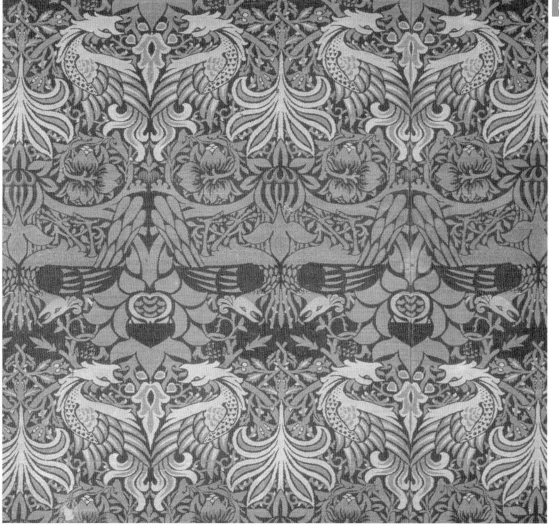

Wey furnishing textile, *c.* 1883

Morris was always looking to be self-sufficient, for economic reasons and for quality control, too. In 1881, with the help of William De Morgan (1839–1917), who had designed for the Firm in the past but now had his own ceramics business, Morris secured much larger additional premises at Merton Abbey, then 7 miles south of London, a series of large wooden sheds which had once housed a Huguenot silk-weaving business (*see* page 142). The works were ideally situated on the River Wandle, giving Morris's dyers all the clean water they needed for their work, plus an area of meadows next to the site on which to lay out dyed cloths for drying. Although furniture, tiles, wallpaper and embroidery remained at Queen Square, Morris moved production of his printed and woven textiles, his carpets and stained glass to Merton Abbey, expanding the existing facilities with eight new sunken vats and installing several hand-operated looms. He also introduced pay and conditions for his workers, including adolescent apprentices, that were better than those enjoyed by most Victorian skilled manual workers. In 1883, inspired by Merton Abbey's riverside location, Morris began designing a new series of printed textiles, including *Wey* and *Wandle* (*see* page 144), based on tributaries of the Thames.

CREATED

Merton Abbey, London

MEDIUM

Printed cotton

RELATED WORKS

Poppies by Lindsay P. Butterfield, 1899

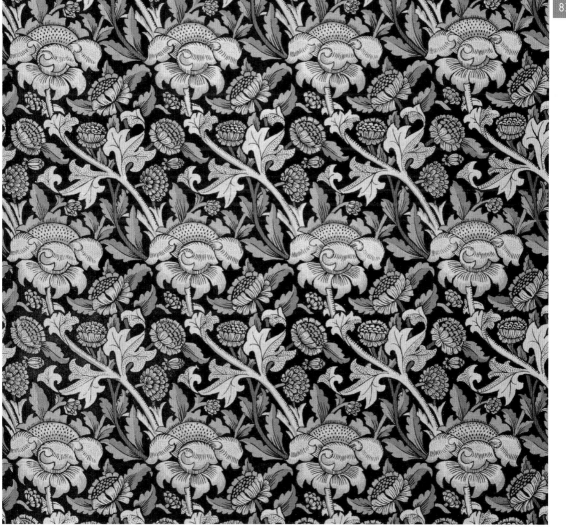

Rose furnishing textile, 1883

Courtesy of Private Collection/Bridgeman Images

In the mid-1880s, with the company now thriving after the move to Merton Abbey, where this textile was produced (*see* page 204), Morris was able to hand over the day-to-day running to George Wardle and the bulk of design work to Dearle. His attention was now drawn not by a new creative discipline but by politics (*see* Chapter 4). An instinctive Liberal in his youth, he had become disillusioned with the party in the late 1870s. Following the logic of his own sympathies and those of men such as Ruskin (*see* page 13) and Carlyle (*see* page 14), whose writings he had long admired, in January 1883 he joined the Democratic Federation (later renamed the Social Democratic Federation – SDF – at Morris's insistence) before quitting the following year to found the more radical Socialist League with Eleanor Marx (1855–98), the youngest daughter of Karl (1818–83). In 1882, he had read Marx's *Das Kapital*, which reinforced his disavowal of parliamentary methods in favour of revolutionary overthrow of the current system. In his later novel, *News from Nowhere*, he makes clear how the future Utopia depicted is realized only after violent struggle. With 25 per cent of people in late Victorian England still living in abject poverty, and with many men and the majority of women still denied a vote, Morris and his fellow Socialists in the SDF could see no other way.

CREATED

Merton Abbey, London

MEDIUM

Printed cotton

RELATED WORKS

Daffodils by Lindsay P. Butterfield, *c.* 1895

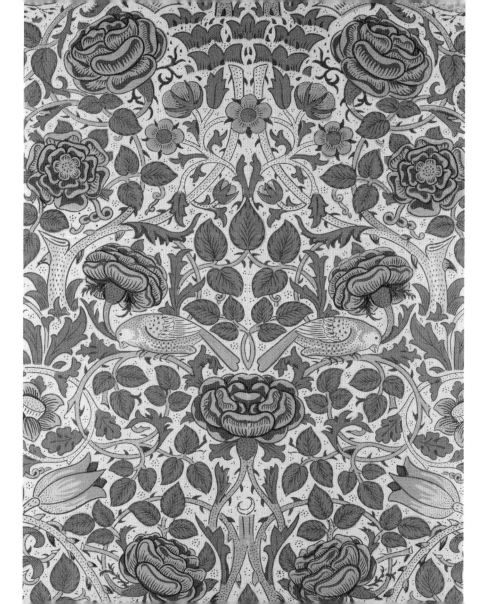

Blackthorn wallpaper, 1892

Although not apparent from his limited artistic output in this period, there is no doubting the profound effect that socialism had on Morris as a person. While Dearle continued the design work for furnishing patterns (as shown here), Morris now poured his time and money into furthering the activities of, first, the SDF and then his own Socialist League; for the latter he founded a paper, *Commonweal*, which he both wrote for and edited (*see* page 260). He had also begun to tour the country, giving lectures and writing essays with titles such as 'How We Live and How We Might Live' (*see* page 258) and 'Useful Work Versus Useless Toil' (*see* page 248). The best of these lay out a still astoundingly clear vision of what was wrong with his own society and how it should be fixed. However, if it is hard to believe that the author is the same man as the one who wrote the escapist poetry of *The Earthly Paradise*, in many ways he wasn't, as he put art to one side in these years to favour a political activism he pursued with equal vigour. As well as the lectures and political writing, Morris also organized meetings of branches of the League at Merton Abbey and Kelmscott House, and in 1885 was arrested along with seven others taking part in a mass protest against police disruption of socialist meetings in Stepney in East London (*see* page 262).

CREATED

Merton Abbey, London

MEDIUM

Wallpaper

RELATED WORKS

Birds and Poppies wallpaper or textile design by Charles Francis Annesley Voysey, *c.* 1900

John Henry Dearle (1859–1932)

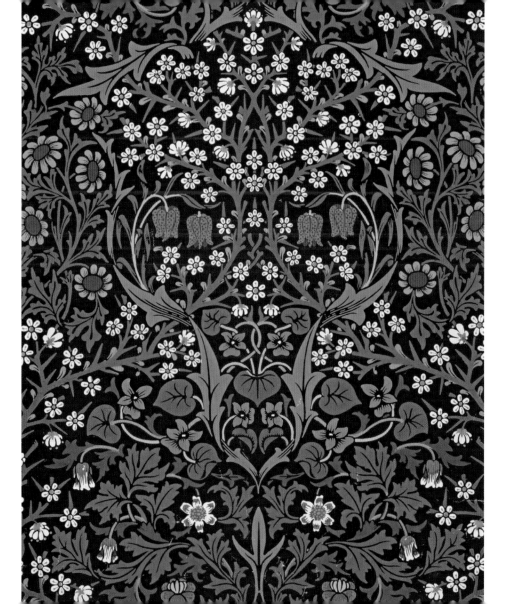

Morris's bedroom, 1891–95

Courtesy of Kelmscott Manor, Oxfordshire, UK/Bridgeman Images

Morris's years of political activity culminated in the publication of *News from Nowhere* in 1890, a future fiction that skilfully turns its 'historical' awareness on the terrible conditions of life that pertained in the late nineteenth century, before a bloody civil war of the mid-twentieth century that ushers in a new era of shared prosperity and peace. The novel's most dramatic chapter recounts a confrontation during that war between riot police and a group of peaceful protesters in Trafalgar Square. This was based on Morris's own first-hand memory of the events of 13 November 1887, which became known as 'Bloody Sunday' (*see* also page 88), when a series of peaceful protest marches from different parts of London, comprising some 10,000 socialists, anarchists and unemployed workers, was brutally set upon by soldiers, cavalry and 2,000 police as they converged on Trafalgar Square. Hundreds of marchers were injured that day. Then, in a second protest the following weekend, a protester called Alfred Linnell (1846–1887) was kicked by a horse and killed. Morris himself composed a 'Death Song' for Linnell's funeral that was much praised. However, the Socialist League was beginning to fragment, and the years of political activity had taken a heavy toll on a man now entering the last phase of his life. Despite, or perhaps because of, the turmoil he'd witnessed, Morris was moved to write the ode to rest that adorns the pelmet of this bed ('For the bed at Kelmscott', 1891).

CREATED

London

MEDIUM

Oak, embroidered textiles

RELATED WORKS

Tapestry Room, Kelmscott Manor

Pelmet and bed curtains embroidered by May Morris (1862–1938); **bed cover by Jane Morris** (1839–1914) **and Mary De Morgan** (1850–1907)

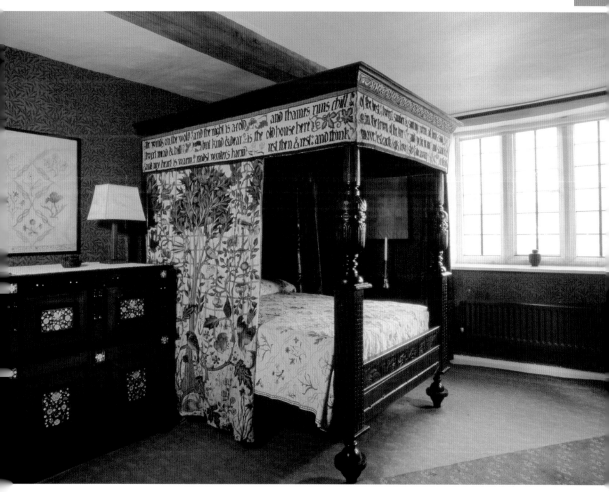

The Drawing room, Kelmscott House, Hammersmith, 1899

Morris today is regarded as one of the founders of the British Labour movement, although by 1890 his immediate political influence had all but disappeared. However, in the field in which his concrete achievements stretched back over decades and across so many disciplines, he remained the towering figure of his time, revered by a host of skilled artist-craftsmen of the next generation, such as Voysey, Charles Robert Ashbee (1863–1942) and Arthur Heygate Mackmurdo (1851–1942), who as leaders of the Arts and Crafts Movement had coalesced around the philosophies Morris had long avowed. However, his attention shifting yet again, he turned to one last field in which he would make a revolutionary contribution. In 1891 he established the Kelmscott Press, which over the next seven years would publish 66 exquisitely produced books. These included many of his own works but also classics such as an edition of the works of Chaucer, the 'Kelmscott Chaucer', perhaps his greatest achievement in art, with illustrations by his oldest friend, Edward Burne-Jones (*see* page 148). Morris died at Kelmscott House in Hammersmith on 3 October 1896. His body was conveyed to Kelmscott Manor by train and buried in the churchyard in the village, beneath a tombstone designed by another lifelong friend, the architect Philip Webb.

CREATED

Kelmscott

MEDIUM

Printed page (from *The Life of William Morris* by John William Mackail) reproducing a drawing

Edmund Hort New (1871–1931) (illustrator)

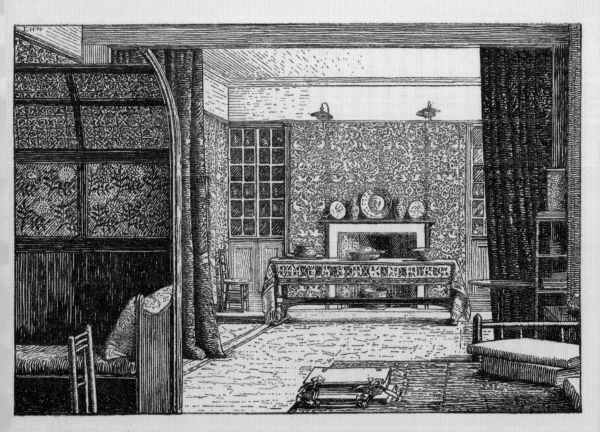

THE DRAWING-ROOM, KELMSCOTT HOUSE, HAMMERSMITH.

William Morris

Inspiration
& Influences

Halley's Comet and Harold receiving bad news, *Bayeux Tapestry, c.* 1070

Morris encountered the *Bayeux Tapestry* while travelling in northern France with Burne-Jones in the summer of 1855. He described it as 'very quaint and rude' – 'rude' in the old-fashioned sense of unstudied or unrefined. This was the quality he found most lacking in Classical art and in European art in general since the Renaissance, a period he described disparagingly as the 'New Birth'. A superb, lifelong storyteller in both poetry and prose, he revered tapestry above all the other weaving arts – in part for the narrative qualities it shared with painting – and he was equally inspired on that same trip by the supreme medieval examples of the art form that he found in the Hôtel (now the Musée) de Cluny in Paris, which holds one of the world's great collections of art from the Middle Ages. For Morris, the medieval period was a golden age in which art was integral to the lives of ordinary people, through the items they used and the places in which they worshipped, not some high cultural ornament for the exclusive delectation of a ruling class. The group of women who are thought to have embroidered the Bayeux Tapestry was a model of artistic production he would try to replicate in his own company, Morris & Co.

CREATED

Kent

MEDIUM

Wool embroidery on linen

RELATED WORKS

Överhogdal tapestries, Överhogdal, Sweden, 1040–1170

English workers, probably in Kent (eleventh century)

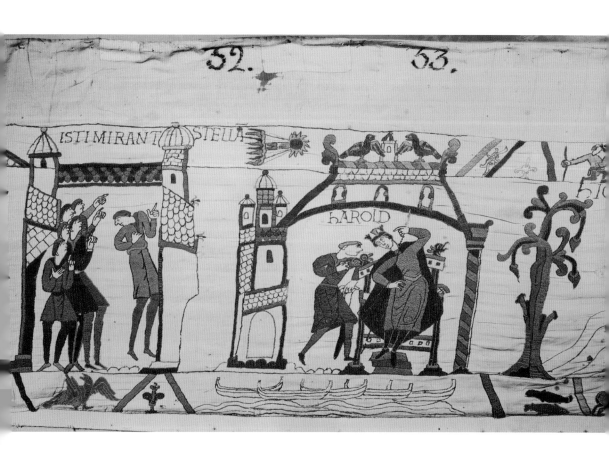

52. 53.

ISTI MIRANT STELLA

HAROLD

The Flight Into Egypt, window in Beauvais Cathedral, thirteenth century

Courtesy of Beauvais Cathedral, Beauvais, France/Bridgeman Images

As a boy visiting Canterbury Cathedral, Morris thought he had entered the gates of heaven. In 1855, his tour of the Gothic cathedrals of northern France sent him into raptures, with the unusual, unfinished cathedral of Beauvais among those that moved him most. He and Burne-Jones attended High Mass in the cathedral on Sunday, with each one profoundly affected by the sights and sounds of the Mass and the sublimity of its setting. Even so, it was on this trip that both men made the firm decision to renounce their earlier intention to enter the priesthood; Burne-Jones to become a painter and Morris an architect and, in time, an atheist as well. At Chartres, Morris seems to have been more affected by the cathedral's statues than by its more famous stained glass, despite the widespread destruction of English stained glass that took place during the Reformation and then again during the English Civil War, which would have made these French examples a revelation. However, there is no doubt that the vivid colour of the glass that the two of them encountered in the churches and cathedrals of northern France, as well as the approach to narrative of the medieval glass artists, was a seminal influence on their own approach to the medium over the coming decades.

CREATED

Beauvais

MEDIUM

Stained glass

RELATED WORKS

Great East Window, York Minster, early fifteenth century

French school (thirteenth century)

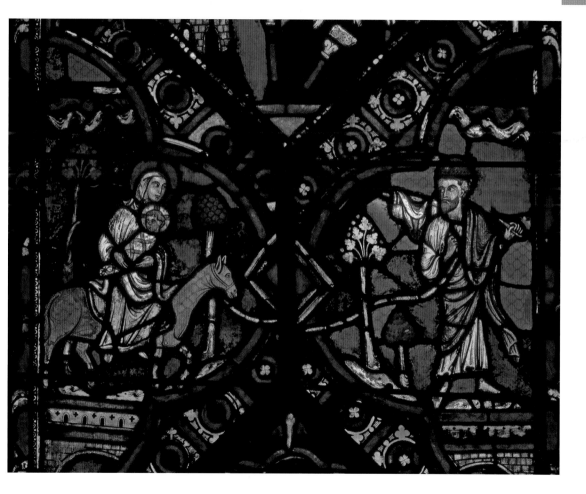

Illustration from the Icelandic sagas, the *Flateyjarbók*, fourteenth century

Courtesy of Árni Magnússon Institute, Reykjavik, Iceland/Werner Forman Archive/Bridgeman Images

Morris was deeply affected by Icelandic culture: first by the ancient sagas, which he had read in translation during the 1860s; then through Eirikr Magnússon, with whom he became good friends, the two of them meeting several times a week in the early 1870s for Morris to learn the language and then collaborate on the first translation of these stories into English (*see* page 58); and finally in the two journeys he made to Iceland, in 1871 and 1873 (*see* page 62). His deep affinity with the barren land and its culture was in part a reaction to the betrayal of a marriage and a friendship by his wife Jane and the painter Rossetti, who until then had profoundly influenced his thinking. However, the resilience he found among the Icelandic people he encountered on those journeys across that cold and barren land – he describes it as 'the most romantic of all deserts' – also made Victorian society and the art it produced seem objectively decadent. As an egalitarian, pre-industrial society which had not passed through the cultural revolution of the Renaissance, Iceland also suggested an alternative model for how a society might be organized – one that bore at least some resemblance to the medieval period that Morris held up, somewhat romantically, as a paragon of social harmony.

CREATED

Iceland

MEDIUM

Illuminated manuscript

RELATED WORKS

The Rochefoucauld Grail, fourteenth century

Icelandic school (fourteenth century)

Battle of Crécy from the Hundred Years' War, from *Froissart's Chronicles*, 1346

Like stained glass and tapestry, the illuminated manuscript was an art form which, having been largely forgotten, was gradually rediscovered during the Victorian period, in part because of Morris's own efforts. England had lost many of its most significant examples of the form during the cultural destruction of the Reformation, but the collection of manuscripts preserved at the Bodleian Library was rich enough to warrant the many hours of study Morris gave it as an Oxford undergraduate in the mid-1850s. A few years later, in 1857, he made his own first attempts at the form while sharing rooms with Burne-Jones in Red Lion Square; one of these was a folktale by the Brothers Grimm. In subsequent years, manuscripts such as the version of *Froissart's Chronicles* in the collection of the British Library, just a short walk from both Red Lion Square and the Firm's base in Queen Square, became an habitual source of study. This immersion in the world of the hand-crafted, as opposed to the printed, book bore rich fruit in the 1870s when Morris produced his own books of illuminated calligraphy, with more sophisticated coloured illustrations by Burne-Jones and Charles Fairfax Murray (1849–1919) being a feature of some of the books.

CREATED

France/Belgium

MEDIUM

Illuminated manuscript

RELATED WORKS

Grimani Breviary, c. 1510

Jean Froissart (c. 1337–c. 1405)

grans seignurs que chun vouloit
moustrer sa puissance. Si nest
nul homme combien qil fust
present a la route qui sceust
ne peust ymaginer ne recor
der la verite. Et specialement
de la partie des fraucois tant
y eut voure arroy et vertite
ordonnance en leurs grans
couroys qui estoient sans
nombre. Et ce que ie scay
de leurs besoignes z ordin
nances et ce que ie diuise
ray et determineray en ce

lautr de lay sceu et apris
le plus pur moult vaillans
hommes dingleterre saiges
et dysceres tant cheualiers
comme aultres qui moult
ententifuement auserent
leur conuenant. Et aussi
pur les gens de messe ichun
de hynnault qui furent
touspurs delez le Roy
yble de france. Cy pse de la
bataille de crecy entre le roy de
france et le roy dingleterre.

The Boar and Bear Hunt tapestry from *The Devonshire Hunting Tapestries,* 1425–50

Courtesy of Victoria and Albert Museum, London, UK/Bridgeman Images

This tapestry is one of a series of four panels depicting different types of hunt. It is now in the collection of the Victoria and Albert Museum but during Morris's lifetime it would still have hung in Hardwick Hall, a large Elizabethan house in Derbyshire, now in the care of the National Trust. At Kelmscott Manor in Oxfordshire, the Elizabethan house which Morris and his family used as a holiday retreat, he hung on the walls of one room a series of four later tapestries from the seventeenth century, copying the practice of earlier times, when the thick woven cloth served both decorative and insulating functions. In fact, although tapestry was one of the last disciplines he would master, Morris was aware of them from an early age. On a walk in Epping Forest, not far from his childhood home, he discovered Elizabeth I's Hunting Lodge (*see* page 13), a largely forgotten building whose ancient proportions and method of construction enchanted him, convincing him of the prime place of architecture among the plastic arts. However, venturing inside the building he found original tapestries, with a design of plants and leaves, still hanging in the upper room in which three centuries earlier they had first been placed.

CREATED

Arras

MEDIUM

Woven wool

RELATED WORKS

The Lady and the Unicorn, fifteenth century

Probably Arras school (fifteenth century)

The Ghent Altarpiece (central panel), 1432

Courtesy of St Bavo Cathedral, Ghent, Belgium/© Lukas – Art in Flanders VZW/Bridgeman Images

Morris first encountered the work of the Early Netherlandish masters, the Van Eyck brothers, Jan (*c.* 1390–1441) and Hubert (1385/90–1426), when he visited Bruges and Ghent on his first holiday in the Low Countries in the summer of 1854. Two years later he repeated the trip, and then in 1869 Morris and Jane stopped in Ghent to look at the Van Eycks' great masterpiece, the *Ghent Altarpiece*, on the way to the spa retreat of Bad Ems. It was following the 1856 visit that he decided to adopt Jan van Eyck's distinctive signature 'ALS IK KAN' as his own motto, 'If I Can'. *The Ghent Altarpiece*, also known as *The Adoration of the Mystic Lamb*, was a revolutionary work, the first picture painted using oil-based paint. Its level of detail would have been familiar to scholars of illuminated manuscripts, but needed the new medium of oil paint to achieve at this scale. That the Van Eycks lived at a pivotal moment in art history can be observed in another work, the *Turin-Milan Hours*, an illuminated manuscript to which the brothers are thought to have contributed: ten of its illuminated miniatures are signed with a variation of Jan's famous motto.

CREATED

Ghent

MEDIUM

Oil on panel

RELATED WORKS

The Beaune Altarpiece by Rogier van der Weyden, *c.* 1445–50

Hubert van Eyck (1385/90–1426) and **Jan van Eyck** (*c.* 1390–1441)

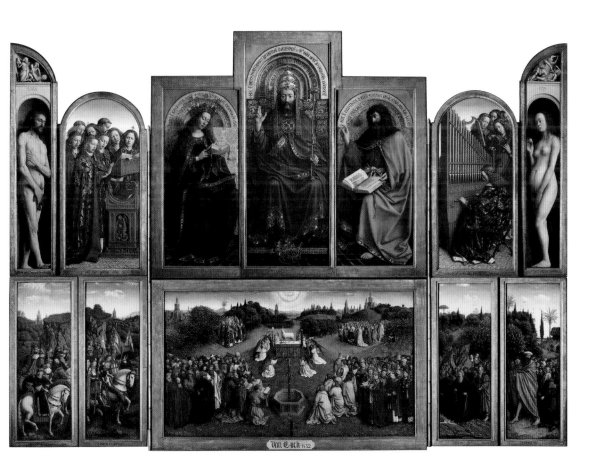

Knight, Death and the Devil, 1513

Morris and Burne-Jones discovered this famous woodcut by Albrecht Dürer (1471–1528) in their first year at the University of Oxford, as the frontispiece to *The Heir of Redclyffe* (1853), a novel by Charlotte Mary Yonge (1823–1901). They were fascinated by the detail of Dürer's print, poring over it for hours on end to understand how it was achieved, learning lessons that surely came to fruition 40 years later in Burne-Jones's woodblock illustrations for the 'Kelmscott Chaucer'. Yonge's novel promoted the values of the Oxford Movement, to which Morris and Burne-Jones were strongly drawn in their first year at Oxford. The passing of the Roman Catholic Relief Act in 1829 had further liberated Catholics in England from the pariah status they had had to endure since the Reformation in the mid-sixteenth century. The Oxford Movement comprised a group of Anglicans who argued for a reinstatement of long-abandoned aspects of the liturgy into Anglican worship, which led to the growth of Anglo-Catholicism over the following decades. The surge of interest in the medieval period at this time, and the rise to prominence of the Gothic Revival style of architecture, coincided with this attempt to recover traditions of English religious worship and cultural production which had been brutally rejected following Henry VIII's break with the Church of Rome.

CREATED

Nuremberg

MEDIUM

Copperplate engraving

RELATED WORKS

Ecce Homo by Martin Schongauer, 1514

Albrecht Dürer (1471–1528)

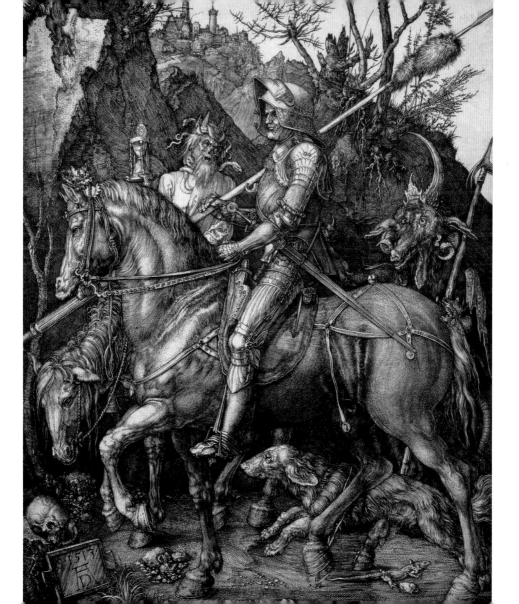

Ardabil carpet, 1539–40

Morris had a long association with the South Kensington Museum, designing The Green Dining Room in 1866 (*see* page 44) and in the following decade acting as adviser to the museum – his official title was Art Referee – in areas of art in which he was a leading expert. Victorian England began a love affair with Persian carpets that has endured in Britain to this day. By the mid-1870s, Morris had developed a deep interest in carpets; in 1878, while in Venice, he bought two more Persian carpets for his own home. Returning from the same trip, while in Paris he continued to seek out further examples, which he would take home and analyse through the period of investigation and research that preceded the intense activity in which he mastered each new medium. By 1892, when this supreme example of the Persian carpet was put up for sale, for the huge sum of £2,000, by the Manchester carpet firm that owned it, Morris was one of the leading makers of hand-knotted carpets in Britain. Classic Morris designs, such as the *Holland Park* and *Bullerswood* carpets, are among the finest English carpets of their time, and owe a clear debt to the intricate complexity of the Persian aesthetic.

CREATED

Tabriz

MEDIUM

Hand-woven carpet

RELATED WORKS

The second *Ardabil* carpet, with which this one makes a pair

Persian school (sixteenth century)

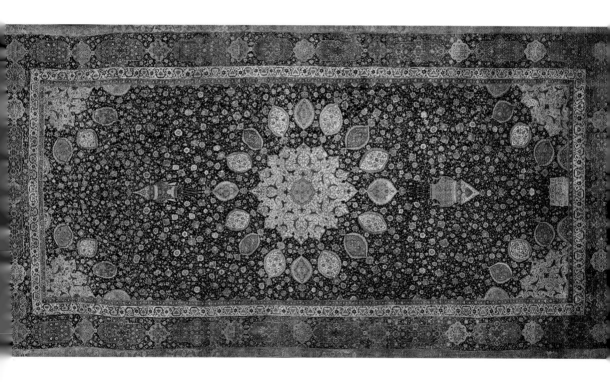

Six varieties of Iris from *The Herball or Generall Historie of Plantes*, 1597

Courtesy of Linnean Society, London, UK/Bridgeman Images

As a boy in rural Walthamstow, Morris immersed himself in nature, both in the field and in the mind: one of his favourite books, at that young age as it remained throughout his life, was the *Great Herball or Generall Historie of Plants* (1597) by the Elizabethan botanist John Gerard (1545–1612). Morris was drawn to plants in his designs in part because he drew them so well. Although affinity with nature was increasingly less the case for the Victorian urban middle classes who bought his patterned textiles and wallpapers, Morris took from Ruskin what he already knew from his own early experiences: the importance of nature as the most reliable source of inspiration, the one that lay closest to the lives that people lived or wanted to live. Unlike the more formal, stylized patterns of other Victorian designers, such as Augustus Pugin or Owen Jones (1809–74), his patterns – especially simple, early ones like *Trellis* (*see* page 166) and *Fruit* (*see* page 46) – were radical simply for letting nature be natural. Later, in patterns like *Acanthus* (*see* page 174) or *Honeysuckle* (*see* pages 180, 240), Morris managed to combine strongly observed naturalistic plant forms with complex, densely interwoven patterning, but the total effect, rather than abstract, is luxuriant and overgrown, the intensified naturalism of an earthly paradise.

CREATED

London

MEDIUM

Printed pages

RELATED WORKS

Paradisi in Sole, Paradisus Terrestris by John Parkinson, 1629

John Gerard (1545–1612)

1 ¶ The description.

THe Flower de-luce of Florence, whose rootes in shops and generally euery where, are called *Ireos, or Orrice*, (whereof sweete waters, sweete powders, and such like are made,) is altogether like vnto the common Flower de-luce, sauing that the flowers of this *Ireos* are of a white colour, and the rootes exceeding sweete of smell, and the other of no smell at all.

2 The white Flower-de-luce is like vnto the Florentine Flower de-luce in rootes, flaggie leaues and stalkes, but they differ in that, that this *Iris* hath his flower of a bleake white colour, declining to yellownes, and the rootes haue not any smell at all, but the other is very sweet, as we haue said.

3 *Iris Dalmatica maior.*
Great Flower de-luce of Dalmatia.

4 *Iris Dalmatica minor.*
Small Dalmatica Iris.

¶ The description.

3 The great Flower de-luce of Dalmatia, hath leaues much broader, thicker and more closely compact together then any of the other, and set in order like wings, or the fins of a whale fish, greene toward the top, and of a shining purple colour toward the bottome, comes to the ground among which riseth vp a stalke of flower knee high, as my selfe did measure oft in my garden, vpon doth grow faire large flowers of a light blew colour.

4 The small Flower de-luce of Dalmatia is in shew like to the precedent, but rather a slender plant, *Iris Biflora*, being both of one stature, small and dwarfe plants in respect of the greater.

5 *Iris Biflora.*
Twice flowring Flower de-luce.

6 *Iris Violacea.*
Violet Flower de-luce.

7 *Iris Pannonica.*
Portingale Flower de-luce.

9 *Iris Camerarij.*
Germane Flower de-luce.

The West Porch of Rouen Cathedral, date unknown

© William Morris Gallery, London Borough of Waltham Forest

Among the cathedrals of northern France that Morris visited on his three tours of the region in the mid-1850s, Rouen represented the pinnacle of the achievements of Gothic architecture, which for him, as for John Ruskin, was 'a complete and logical style with no longer anything to apologize for, claiming homage from the intellect, as well as the imagination of men'. This statement from Morris's 1889 lecture 'Gothic Architecture' refers explicitly to Salisbury Cathedral, and he writes of England and France as being 'the architectural countries par excellence' during the early medieval period; this was followed by the loss of a quality he calls 'exaltation', a process that for Morris began with the Black Death in the mid-fourteenth century. He explicitly associates the vigour of the Gothic style with the professional and economic autonomy of the craftsmen who made it, 'the handicraftsmen' who had combined 'into guilds of craft, and were claiming their freedom from legal and arbitrary oppression, and a share in the government of the towns'. Finding Rouen Cathedral to be such an integral part of the town whose people built it, and whom it served, no doubt contributed to Morris's high estimation of the building itself, as the social and the aesthetic became increasingly inseparable in his mind.

CREATED

Rouen

MEDIUM

Pencil, sepia and watercolour on paper

RELATED WORKS

Rouen Cathedral by Joseph Mallord William Turner, *c.* 1832

John Ruskin (1819–1900)

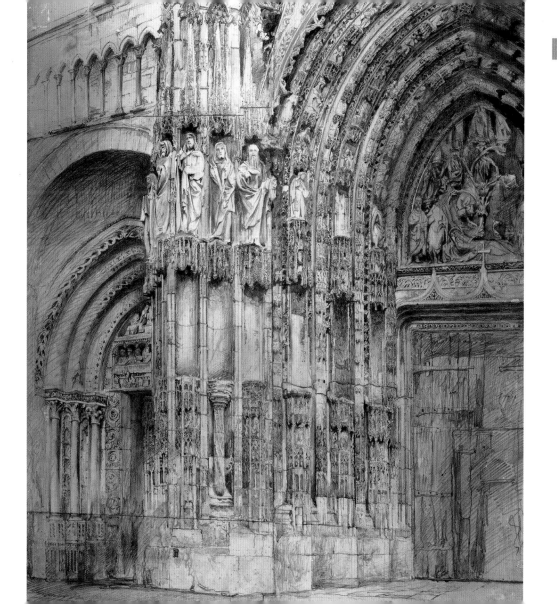

Part of the Cathedral of St Lo, Normandy (Plate II from *The Seven Lamps of Architecture*), 1849

Courtesy of De Agostini Picture Library/Bridgeman Images

The key to Morris's core beliefs, Ruskin's essay 'The Nature of Gothic', also lays out an aesthetic programme intrinsic to the huge body of design work that Morris produced over the course of his life. Above all, Ruskin identifies six 'characteristic or moral elements of Gothic' which seem more or less integral to Morris's own aesthetic values when placed in context with the prevailing values of Victorian England. Most important of these is what he calls 'Savageness' or 'Rudeness', a quality present in the architecture of northern Europe, which he contrasts with the refinement and Classicism of the south. This opposition, which today seems extreme, was nonetheless central to Morris's thinking. The word 'Gothic', Ruskin insists, was originally meant in reproach and in time became 'a term of unmitigated contempt'. However, Ruskin embraces the word and its connotations, saying that the 'rude and wild' architecture of the north is something to be celebrated precisely for those qualities. It is the same inversion of 'civilized' values later made by the modernists at the turn of the twentieth century, a lesson that Morris absorbed very deeply, seeing in the refinement of European styles since the Renaissance a want of vigour and robustness that was both an aesthetic failing and a moral one.

CREATED

Probably northern France

MEDIUM

Book plate of drawing

RELATED WORKS

The Porch, Rheims Cathedral by Samuel Prout, *c.* 1840

John Ruskin (1819–1900)

Ca' Bernardo, Capital of Window Shafts, from *Examples of the Architecture of Venice*, 1851

Courtesy of Private Collection/The Stapleton Collection/Bridgeman Images

Morris despised the crude aesthetics of industrial modernity and the alienating division of labour at the heart of the industrial process. In his mind, the denial of agency and creative sovereignty in the work that the majority of people were forced to do led inevitably to that loss of aesthetic quality. This revulsion for the artistic production of his own time and the conditions that caused the degradation, as well as his commitment to hand-working and to nature, were to a large extent learnt from or at least confirmed by Ruskin. The pre-eminent Victorian writer on art, it was precisely because he cared about art so much that he gradually became one of his own society's fiercest social critics. In his 1882 essay 'The Lesser Arts', writing about the importance of the pleasure an object should give to both its user and its maker, Morris explicitly acknowledges the debt to Ruskin, describing the older man's chapter 'The Nature of Gothic', from Volume II of *The Stones of Venice* (1853), as 'the truest and the most eloquent words that can possibly be said on the subject'. 'The Nature of Gothic' is the foundation on which Morris built his own body of thought about art and society.

CREATED

Venice

MEDIUM

Colour lithograph

RELATED WORKS

The Doge's Palace, Venice by Samuel Prout

John Ruskin (1891–1900)

Work, 1852–65

Morris first met Ford Madox Brown upon moving to London in 1856, when he and Burne-Jones fell in with artists associated with the Pre-Raphaelite Brotherhood. Although never as great an influence on Morris as Rossetti, Brown was nonetheless a good friend and one of the founding partners in Morris, Marshall, Faulkner & Co. At the outset, he was the oldest and most experienced of all the young artists who worked on commissions the Firm managed to secure, and through most of the 1860s he continued to produce painted furniture, tiles, textiles and stained glass for the company, such as his *Shipwreck of St Paul* window (1874) for Llandaff Cathedral in Wales and painted panels for the newly built church of St Martin-on-the-Hill in Scarborough. Brown was also a painter of considerable gifts and ambition, along with a social awareness he shared with other Pre-Raphaelites, such as William Holman Hunt (1827–1910), and with Morris. This is evident in classic paintings such as *The Last of England* (1855), on the subject of working-class emigration, and *Work*, his panoptic survey of the complexities of class in mid-Victorian society.

CREATED

London

MEDIUM

Oil on canvas

RELATED WORKS

The Awakening Conscience by William Holman Hunt, 1853

Ford Madox Brown (1821–93)

April Love, 1855–56

Courtesy of akg-images/Erich Lessing

Arthur Hughes (1832–1915) was one of the Pre-Raphaelite painters whom Morris met when he moved to London in 1856. That same summer Morris saw Hughes's *April Love* at the Royal Academy Summer Exhibition, fell for it, and instructed Burne-Jones to buy it immediately before someone else did. The following year, Hughes was part of the group, including Morris, who painted the murals in the debating hall of the Oxford Union (*see page 28*), along with Hungerford Pollen (1820–1902), the oldest among the group, and the only one with previous experience as a muralist; Spencer Stanhope (1829–1908) and Valentine Prinsep (1838–1904), two painters associated with the Pre-Raphaelites; Rossetti and Burne-Jones. Although he was often the butt of others' jokes, Morris thrived in male company and revelled in the camaraderie that developed as they worked on the ill-fated project. Prinsep is said to have remarked that Morris 'was the essence of good nature, and stood chaff (the jokes at his expense) with extraordinary tolerance'. A few years later, Hughes seems to have been a short-lived and unenthusiastic partner at the inception of the Firm in 1861, and designed one of the stained-glass windows for Harden Grange the following year. However, it was not long before he decided that the venture was not for him.

CREATED

London

MEDIUM

Oil on canvas

RELATED WORKS

Autumn Leaves by John Everett Millais, 1856

Arthur Hughes (1832–1915)

Persian No. 2 from The Grammar of Ornament, 1856

Owen Jones was the foremost design theorist and one of the finest designers of mid-Victorian England. As a young man he embarked on the Grand Tour, and in Greece discovered the ground-breaking evidence that Classical buildings and sculptures had originally been coloured. Eventually ending up at the Alhambra in Granada, Spain, Jones was astounded by the decorative genius of the Moorish artists who created it. He spent six months there, assiduously copying the myriad patterns he found, which became the basis of his practice as a decorator when he returned to England. The subsequent publication of his Alhambra studies led to his involvement as a designer and a superintendent of works, initially with the Great Exhibition and then with the South Kensington Museum, which later became the V&A. In 1856, Jones published *The Grammar of Ornament*, which is still in print today. Across dozens of colour pages, the book gives detailed examples from the ornamental styles of numerous world traditions, and those of the East in particular. The work was both a revelation and a key reference source for Morris, the great pattern designer of his age.

CREATED

London

MEDIUM

Illustrated pattern book

RELATED WORKS

The Stones of Venice by John Ruskin, 1851–53

Owen Jones (1809–74)

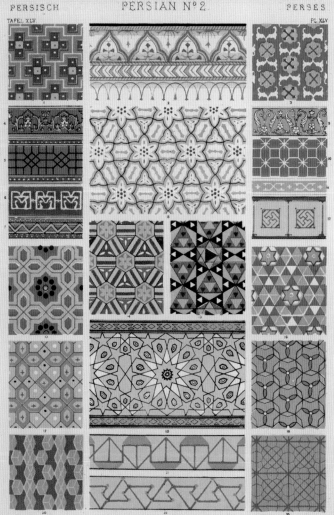

123

Settle in the drawing room at Red House, *c.* 1856–65

Courtesy of National Trust Photolibrary/Andreas von Einsiedel/Bridgeman Images

The settle at Red House came from Morris's digs at Red Lion Square. The minstrels' gallery was added once the gargantuan piece of furniture had been hauled up the stairs to the drawing room. Georgiana Burne-Jones later recalled that this upper gallery was where plays or music were performed for the group of friends who gathered most frequently at the house: the Burne-Joneses, Rossetti and Elizabeth Siddal, and Charles Faulkner and his sisters Kate (1841–98) and Lucy (1839–1910), both of whom later worked for the Firm and became significant designers in the Arts and Crafts Movement (*see* page 192). The mural to either side of the settle was painted by Burne-Jones and depicts the 'Tale of Sir Degrevaunt', a story from the fifteenth century. Morris's dream for Red House was to create an ideal commune of kindred spirits, inspired by the monastic communities of the Middle Ages, although in this case including women alongside men. Although the dream remained largely unfulfilled, abandoned after only a few years, it proved a model for later residential artistic colonies, from the craft communities of the Arts and Crafts Movement to the Bloomsbury Group at Charleston House in Sussex, where an early twentieth-century circle of friends, similar to the one at Red House, transformed a country-house interior through hedonic decoration.

CREATED

London and Bexleyheath

MEDIUM

Pine, iron, brass, paint

RELATED WORKS

Hooded settle by Philip Webb, 1859

Sir Launcelot in the Queen's Chamber, 1857

Courtesy of Birmingham Museums and Art Gallery/Bridgeman Images

Morris's friendship with Rossetti – charismatic, older and more worldly than Morris – was among the most important of his life. Even before they met him, Morris and Burne-Jones were already under his spell, as his work confirmed their own instincts. Of all the Pre-Raphaelites, Rossetti was the most keen not only on the aesthetic values of pre-Renaissance art but on the world from which it emerged, which so enthralled them, too. For his part, once he had met them Rossetti was equally impressed, describing the pair sincerely as 'men of real genius'. By then, Rossetti had been for years in a relationship with Elizabeth Siddal, so when he and Burne-Jones set eyes upon Jane Burden at a theatre in Oxford, although clearly impressed by Jane's languorous beauty, he did not pursue her. This image, however, from the same year, seems to foretell his later seduction of Jane. Morris, naïve and nervous with women, was overwhelmed by Jane and would soon ask her to marry him. However, he seems unconsciously to have understood the trouble ahead from an early stage, with himself in the Arthurian role of cuckold. In 1858, he published the collection *The Defence of Guenevere and Other Poems*, in whose titular poem Arthur's queen argues for the strength of her passion in the context of the loveless prison of her marriage.

CREATED

London

MEDIUM

Pen and ink, watercolour on paper

RELATED WORKS

Arthur's Tomb, Sir Launcelot Parting from Guenevere by Dante Gabriel Rossetti, 1854

Dante Gabriel Rossetti (1828–82)

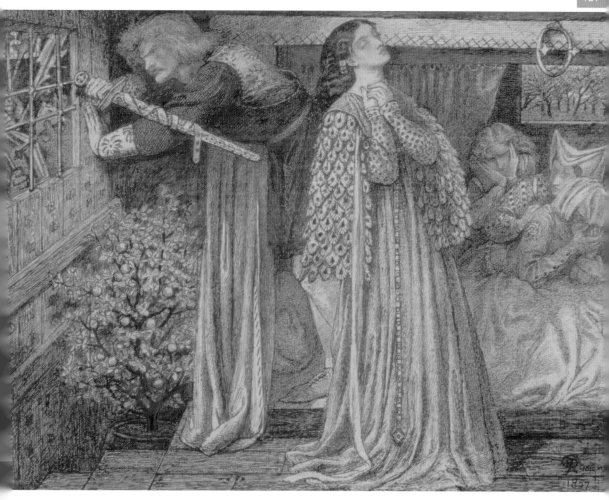

St Catherine embroidery, c. 1860

Courtesy of Kelmscott Manor, Oxfordshire, UK/Bridgeman Images

Although fundamentally unhappy, the Morrises' marriage does at times seem to have been companionable; there are stories of the two of them engaged together in unpicking existing embroideries which Morris had acquired, so that he could understand how they were made. Jane was from humble roots, but Morris was far from alone among his male circle in marrying a woman from out of his class, though Jane does seem to have used the amount of leisure her marriage to Morris afforded her to develop the talents expected of her social status, becoming an accomplished pianist and learning Italian and French to a fairly good standard. She already had some experience in needlework and in the 1870s would take charge of the embroidery team at Morris & Co. This image of St Catherine was one of a series of six that Morris designed based on characters from a poem called 'The Legend of Goode Wimmen' by Geoffrey Chaucer (c. 1343–1400). The original scheme, which Morris intended would hang around the walls of the drawing room at Red House, envisaged 12 such figures, including women from Antiquity as well as the Christian martyr St Catherine. A threefold screen from the series also exists, embroidered by Jane's sister Bessie (b. c. 1842), depicting Lucretia, Hippolyte and Helen.

CREATED

Bexleyheath

MEDIUM

Embroidery: brick stitches on appliquéd velvet

RELATED WORKS

Threefold screen with embroidered panels depicting heroines by William Morris, worked by Bessie Burden, c. 1860

Jane Morris (1839–1914)

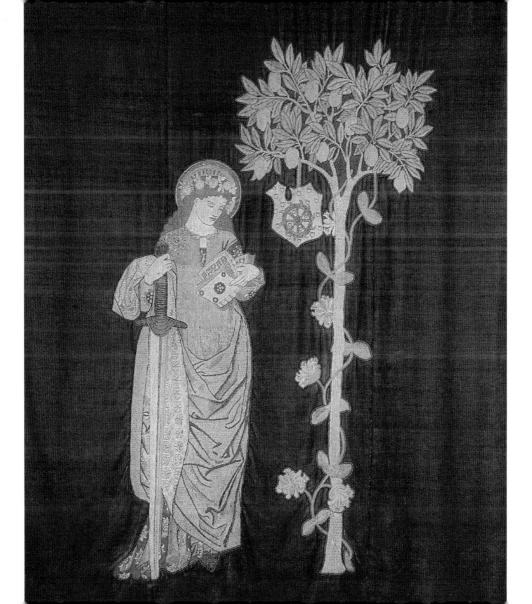

King René's Honeymoon cabinet, 1861–62

Courtesy of Victoria and Albert Museum, London, UK/Bridgeman Images

The International Exhibition of 1862 took place on a site opposite the South Kensington Museum, where the Natural History Museum and Science Museum now stand. The Firm was well represented in all the types of work they could offer in what was only their second year of trading, including stained glass, embroideries, jewellery, painted tiles and painted furniture, such as the decorated panels of this large and rather eccentric cabinet, which the architect John Pollard Seddon (1827–1906) designed for his own office. The theme of imaginary incidents from the life of King René of Anjou (1409–80), a celebrated patron of the arts, was suggested by Ford Madox Brown, who also designed the panel on Architecture. The Painting and Sculpture panels were by Burne-Jones, the Music and Gardening panels by Rossetti, Embroidery by Prinsep, and four other panels were by artists unknown, making ten in total. Morris worked on the background decoration. The Firm's exhibits, with their overt medievalism, were met with a certain amount of mockery, this piece of furniture in particular being singled out. 'Six hundred years have passed since the style of yon cabinet was in vogue,' wrote one reviewer. 'On such a faldstool as this the good St Louis may have prayed.'

CREATED

London

MEDIUM

Painted oak furniture

RELATED WORKS

Ladies and Animals decorated sideboard by Edward Burne-Jones, *c.* 1860

John Pollard Seddon (1827–1906)

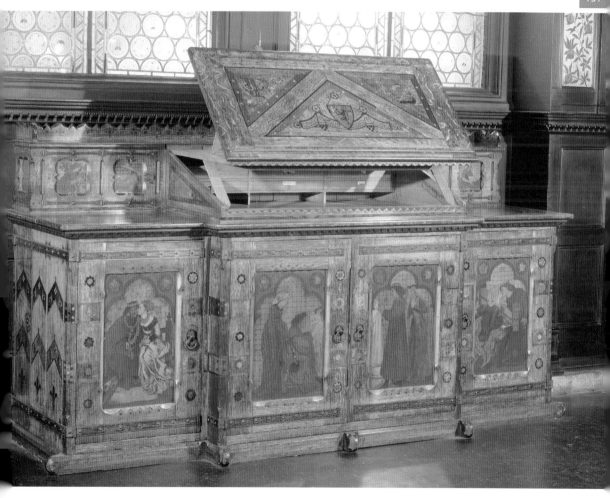

St George cabinet, 1861–62

Courtesy of Victoria and Albert Museum, London, UK/Bridgeman Images

Another piece that featured in the Firm's display at the International Exhibition was this cabinet designed by Philip Webb, with scenes painted by Morris using Jane as the model for the rescued princess. Webb designed a lot of furniture for the Firm during the 1860s – long tables, round tables and chairs, as well as decorated chests, sideboards and settles. Specific pieces include the long oak dining table at Red House and another, smaller round table of medieval appearance; the decorated settle, originally designed for Red House, that became a template for similar settles sold by Morris & Co.; and the imposing floor-to-ceiling dresser in the dining room at Red House, painted a deep vermilion colour known as dragon's blood, a name with obvious medieval overtones. However, Webb's curiosity for design was as dauntless as that of his great friend, and his creative output also includes classic glassware, painted tiles and stained glass, and a pair of copper candlesticks he designed for Red House. As if this was not enough, he was also very skilled at painting animals, with many of the animals in later Morris & Co. designs being Webb's own creatures.

CREATED

London

MEDIUM

Oak furniture with painted panels

RELATED WORKS

Jewel casket by Philip Webb, Dante Gabriel Rossetti and Elizabeth Siddal, 1859

Philip Webb (1831–1915) and **William Morris** (1834–96)

Sleeping Beauty (detail from set of tiles illustrating the *Briar Rose* tale), 1862–65

Courtesy of Ashmolean Museum, University of Oxford, UK/Bridgeman Images

During the Firm's early days at Red Lion Square, a furnace was built in the basement, in what had once been a kitchen, where glass and tiles were fired. Morris was an admirer of Delft tiles – they can be seen around the fireplace in the dining room at Red House – and some of his later tile designs make explicit reference to the Dutch style in their classic blue and white patterns. When it came to his own production, Morris used plain white tiles imported from Holland, which were hand-coloured using enamel paint and then fired in the furnace. Various designers, including William De Morgan and Kate Faulkner, designed tiles for Morris & Co. in later years. This panel of tiles, comprising eight scenes from *Sleeping Beauty* – two are seen here – was designed by Burne-Jones and Morris but hand-painted by Faulkner, who was still a very young artist at this point. The panel was commissioned by the painter Myles Birket Foster (1825–99) for his newly built house, 'The Hill', in Witley, Surrey. The whole panel was surrounded by a Delft-style, blue-and-white swan pattern, most probably designed by Morris himself.

CREATED

London

MEDIUM

Painted ceramic tiles

RELATED WORKS

Beauty and the Beast tiles by Edward Burne-Jones, 1863

Edward Burne-Jones (1833–98)

Adjustable-back chair with *Bird* furnishing textile, *c.* 1870

Courtesy of Victoria and Albert Museum, London, UK/Bridgeman Images

Although known as the *Morris* chair, this iconic reclining chair was in fact designed by Webb, in 1866, from a sketch provided by George Warington Taylor, the Firm's business manager in the later 1860s (*see* page 44). Warington Taylor seems to have had considerable commercial acumen and is credited with turning around the fortunes of Morris, Marshall, Faulkner & Co. in this period, in part through popular designs like the *Morris* chair. He appears to have sketched it from an example he saw in the workshop of a carpenter in the village of Herstmonceux in Sussex. Possibly the world's first example with an adjustable back, chairs based on this same simple design are still being manufactured today, although its height of popularity came between 1890 and 1930, after the chair had spawned numerous imitations all over the world, including notable versions by Liberty of London and American furniture maker Gustav Stickley (1858–1942). Key to its success was the chair's reclining back which, along with the padded arms and back cushion, emphasized comfort to an expanding middle class. The chair was manufactured in both ebonized wood and mahogany, in a range of upholstering fabrics including Utrecht velvet (*see* page 54) or, as here, a furnishing textile with Morris's classic *Bird* design.

CREATED

London

MEDIUM

Ebonized wood with woven wool

RELATED WORKS

Saville Chair by George Jack, *c.* 1890

Philip Webb (1831–1915)

Lily wallpaper, c. 1874

Courtesy of Private Collection/Bridgeman Images

The inspiration for this famous pattern is thought to have been a wall hanging illustrated in one of the royal tents depicted in the version of *Froissart's Chronicles* that Morris consulted in the British Library on his frequent visits there. His first attempt to render his own version of the pattern was the *Daisy* wall hanging, which he designed and Jane and others embroidered, for Red House in 1860. The *Chronicles* are a history of the violent events of the Hundred Years' War, from the deposing of Edward II of England in 1327, a decade before the conflict began, to the period when Froissart was writing his history at the end of the fourteenth century, when the war was still more than half a century from being over. Jean Froissart (*c.* 1337–*c.* 1405) was a court historian, a poet and the author of the *Chronicles*. This huge work is credited with a brief revival of the chivalric ideal towards the end of the Middle Ages, and exists today in more than 150 manuscript versions, a good many of which are illuminated by different artists of the period. In addition to the inspiration it gave him for patterns, Morris found in the *Chronicles* material for a number of the poems that make up *The Defence of Guenevere and Other Poems*.

CREATED

London

MEDIUM

Wallpaper

RELATED WORKS

Carnation by Kate Faulkner, 1880

Dido Stabbing Herself, opening of Book IV of Virgil's *Aeneid*, 1876

As a poet, Morris was primarily a storyteller, with an astonishing facility that he often dismissed but which enabled him to write *The Earthly Paradise*, the work on which his literary reputation rested in his lifetime, over a two-year period in which he was simultaneously engaged on design projects for the Firm. Aside from a raw gift, this prolixity surely has its roots in his passion from a very young age for epic stories. These included, at different stages of his life, the historical romances of Sir Walter Scott, Sir Thomas Malory's *Le Morte d'Arthur* and the Old Norse sagas of medieval Iceland. His translations of first *The Aeneid*, in 1876, and then Homer's *Odyssey* some ten years later, reflect his own lifelong love of those works. The earlier translation came about after Morris had given up an attempt to produce an illuminated manuscript of Virgil's great work, when for once it proved to be too much; only six of the 12 books of the original work were ever transcribed. For most people, the idea of immediately embarking on a translation of the original Latin verse whose transcription had become such a burden would seem bizarre, but Morris plunged right in with typical gusto, and within months the translation was finished.

CREATED

London

MEDIUM

Illuminated manuscript

RELATED WORKS

The Odes of Horace, 1874

AT REGINA GRAVI IAM
DUDUM SAUCIA CURA
VULNUS ALIT VENIS, ET
CÆCO CARPITUR IGNI.
MULTA VIRI VIRTUS AN
IMO, MULTUSQUE RE
CURSAT GENTIS HONOS;
HÆRENT INFIXI PECTO
RE VULTUS VERBAQUE;
NEC PLACIDAM MEM
BRIS DAT CURA QUIETEM.

African Marigold furnishing textile, 1876

African Marigold reflects Morris's predilection from the mid-1870s onwards for mirrored, symmetrical patterns. His thinking may well have been influenced by the symmetries of the Persian carpets which had become such an interest for him (*see* page 108), as well as the weaving he had begun to explore, where the use of a loom favoured symmetrical designs. Having by then mastered so many different disciplines in the visual and literary arts, his efforts in one often exerted an influence on another. *African Marigold* was one of the designs he produced during the period he was working with Thomas Wardle's dyeing works in Leek (*see* page 68). For some reason, it seems not to have been printed until 1881, and the fabric that came back to Morris in the early months of that year was so far from matching the samples he had been sent that he rejected each new batch that arrived, describing them to Wardle in no uncertain terms as being 'no better than caricatures of my careful work'. It was this continuing crisis in quality control from suppliers like Wardle that persuaded Morris to establish his own works close to London. Later that year he found the ideal site at Merton Abbey, a series of wooden buildings which had once been a Huguenot silk-weaving factory (*see* pages 82, 144).

CREATED

London

MEDIUM

Printed cotton

RELATED WORKS

Fleur-de-Lis wallpaper by Augustus Welby Pugin, 1845–50

Wandle furnishing textile, 1884

This is one of a series of textiles inspired by tributaries of the River Thames, which Morris designed soon after the move to Merton Abbey. The former silk-weaving factory to which Morris brought his dyeing and weaving, stained glass, tapestry and carpet manufacture comprised three wooden sheds built on both sides of the River Wandle, connected by a wooden bridge. An idyllic scene, it fed Morris's vision of establishing a medieval-style workshop that could offer a high-quality alternative to mass-produced Victorian decorative products, while also allowing the men and women who produced it the kind of agency once enjoyed by the medieval craftsman. The seven other fabrics in the river series of which the *Wandle* textile was a part were *Windrush*, *Evenlode* (*see* page 206), *Kennet*, *Wey* (*see* page 82), *Medway*, *Lea* and *Cray* (*see* page 244). All were tributaries of the Thames, the father river on which from the early 1870s until the end of his life he rented first one house, Kelmscott Manor, not far from the source of the river, and then another, Kelmscott House, at Hammersmith on what was then the western edge of London. The river journey between the two places that is central to the story in Morris's novel, *News from Nowhere*, echoes similar journeys he made in the 1880s between one house and the other.

CREATED

London

MEDIUM

Printed cotton

RELATED WORKS

Daffodil by John Henry Dearle, *c.* 1891

The Arming and Departure of the Knights, 1895–96

Courtesy of Birmingham Museums and Art Gallery/Bridgeman Images

Sir Thomas Malory's *Le Morte d'Arthur* had become hugely popular after being rediscovered by Sir Walter Scott in the late eighteenth century. By the time Morris and Burne-Jones went up to Oxford in 1852, Arthurianism was nearing its zenith, and in different ways both men were tied to its myths and values their entire lives. The ideals of chivalry in Malory's Arthurian stories appealed to Morris's highly moral worldview and informed his attitude to women, a factor which may have contributed to Jane's evident dissatisfaction with the marriage, resulting in affairs with Rossetti (*see* pages 52, 54, 62) and the poet Lothario, Wilfrid Scawen Blunt (1840–1922). Burne-Jones, too, continued to be haunted by the Arthurian legends, so in 1890, with both men nearing the end of their lives, when commissioned by the oil industry pioneer William Knox D'Arcy (1849–1917) to make a series of tapestries for his Gothic Revival house – Stanmore Hall, just to the west of London – they turned again to these seminal myths of England, and to the most exalted of all, the Legend of the Holy Grail. As had been the case with the early stained-glass windows, Burne-Jones designed the figures while Morris took care of the heraldry, and the foreground foliage was by John Henry Dearle.

CREATED

Merton Abbey, London

MEDIUM

Woven wool and silk on a cotton warp

RELATED WORKS

The Story of Abraham by Pieter van Aelst III, 1540–43

Edward Burne-Jones (1833–98), **William Morris** (1834–96) and **John Henry Dearle** (1859–98)

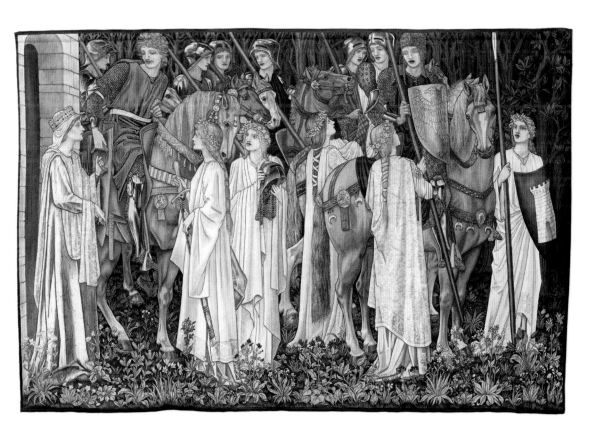

Title page and frontispiece from *The Works of Geoffrey Chaucer*, 1896

Courtesy of Fitzwilliam Museum, University of Cambridge, UK/Bridgeman Images

Chaucer was one of Morris's lifelong heroes, a presence hovering over some of the most significant decisions he ever made. It was entirely deliberate that the site on which he chose to build Red House was close to Roman Watling Street, today the busy A2 but, more importantly, the medieval route along which the motley collection of pilgrims travel, telling stories to pass the time, in *The Canterbury Tales*. In that regard, Burne-Jones saw the two men as fellow travellers: 'Chaucer is very much the same sort of person as Morris,' he once remarked, 'unless he can begin his tale at the beginning and go steadily on to the end, he's bothered.' So the greatest work of the father of English literature was a natural model for Morris to adopt when planning the structure of *The Earthly Paradise*, his most significant cycle of poems, but with Norse sailors fleeing the Black Death and searching for paradise in place of English pilgrims going to atone for the murder of the martyred Thomas Becket. The 'Kelmscott Chaucer' was the last and most important of the exquisitely produced books that Morris published through the Kelmscott Press – a final artistic tribute to a major guiding spirit in Morris's life.

CREATED

London

MEDIUM

Illustrated book

RELATED WORKS

The Pilgrim's Progress, Essex House Press, 1899

Edward Burne-Jones (1833–98)

the works of Geoffrey Chaucer now newly imprinted.

HERE BEGINNETH THE TALES OF CANTERBURY AND FIRST THE PROLOGUE THEREOF

Whan that Aprille with his shoures soote
The droghte of March hath perced to the roote,
And bathed every veyne in swich licour,
Of which vertu engendred is the flour;
Whan Zephirus eek with his swete breeth
Inspired hath in every holt and heeth
The tendre croppes, and the yonge sonne
Hath in the Ram his halfe cours yronne,
And smale fowles maken melodye,
That slepen al the nyght with open eye,
So priketh hem nature in hir corages;
Thanne longen folk to goon on pilgrimages,
And palmeres for to seken straunge strondes,
To ferne halwes, kowthe in sondry londes;
And specially, from every shires ende
Of Engelond, to Caunterbury they wende,
The hooly blisful martir for to seke,
That hem hath holpen whan that they were
seeke.

Bifil that in that seson on a day,
In Southwerk at the Tabard as I lay,
Redy to wenden on my pilgrymage
To Caunterbury with ful devout corage,
At nyght were come into that hostelrye
Wel nyne and twenty in a compaignye,
Of sondry folk, by aventure yfalle
In felaweshipe, and pilgrimes were they alle,
That toward Caunterbury wolden ryde.

Pages from *A Note by William Morris on his Aims in Founding the Kelmscott Press*, 1898

Courtesy of University of South Carolina

In this brief introduction to the short history of the Kelmscott Press, Morris makes clear that his inspiration at the end of his life is much the same as it was at the beginning. 'I have always been a great admirer of the calligraphy of the Middle Ages,' he writes, '& of the earlier printing which took its place. As to the fifteenth-century books, I had noticed that they were always beautiful by the force of the mere typography.' His models are thus firmly pre-industrial in this, as in everything else he did. After having thoroughly researched the subject, and having chosen to print on a paper similar to 'a Bolognese paper of about 1473', he adopts a Roman type of the kind perfected by a single source, namely, 'the great Venetian printers of the fifteenth century, of whom Nicolas Jensen produced the completest & most Roman characters from 1470 to 1476'. To this he adds a Gothic fount, a script which he admits is commonly regarded as unreadable. However, this is a charge he feels cannot be levelled at the Gothic scripts 'from the first two decades of printing' by 'Schoeffer of Mainz, Mentelin at Strasburg, and Günther Zainer at Augsburg' (*see* page 216). From such rigorous research came the abundant inspiration that flows through everything Morris did.

CREATED

London

MEDIUM

Wood engraving and letterpress on paper

RELATED WORKS

'How I Became a Socialist' by William Morris, 1894

✿PSYCHE BORNE OFF BY ZE-
PHYRUS, DRAWN BY EDWARD
BURNE-JONES & ENGRAVED
BY WILLIAM MORRIS

NOTE BY WILLIAM MORRIS ON HIS AIMS IN FOUNDING THE KELMSCOTT PRESS.✿✿

I BEGAN printing books with the hope of producing some which would have a definite claim to beauty, while at the same time they should be easy to read and should not dazzle the eye, or trouble the intellect of the reader by eccentricity of form in the letters. I have always been a great admirer of the calligraphy of the Middle Ages, & of the earlier printing which took its place. As to the fifteenth-century books, I had noticed that they were always beautiful by force of the mere typography, even without the added ornament, with which many of them are so lavishly supplied. And it was the essence of my undertaking to produce books which it would be a pleasure to look upon as pieces of printing and arrangement of type. Looking at my adventure from this point of view then, I found I had to consider chiefly the following things: the paper, the form of the type, the relative spacing of the letters, the words, and the

William Morris

Media & Techniques

The Prioress's Tale wardrobe, 1859

Courtesy of Ashmolean Museum, University of Oxford, UK/Bridgeman Images

Morris and his circle began painting furniture for their own use in the late 1850s. This wardrobe was designed by Webb and painted by Burne-Jones in 1857, and was given to the Morrises as a wedding present when they married in 1859. It was placed in their bedroom at Red House, where most of the furniture was painted, and then later in the drawing room at Kelmscott House in Hammersmith. The vividly coloured scenes on the exterior are taken from 'The Prioress's Tale' in Chaucer's *Canterbury Tales*, one of Morris's favourite works of literature, with Jane as the model for the Virgin Mary. It seems that Morris could not resist adding to the piece himself at a later date, as the interior is painted with unfinished tableaux, including figures set against decorative backgrounds. When Morris and his friends started Morris, Marshall, Faulkner & Co. in 1861, painted furniture was one of the main product lines they offered, and the following year, at the 1862 International Exhibition in South Kensington, painted pieces of furniture such as the *King René's Honeymoon* cabinet (*see* page 130) were the most eye-catching parts of their display.

CREATED

London

MEDIUM

Oil on oak panel

RELATED WORKS

King René's Honeymoon cabinet by John Pollard Seddon, 1862

Philip Webb (1831–1915) and **Edward Burne-Jones** (1833–98)

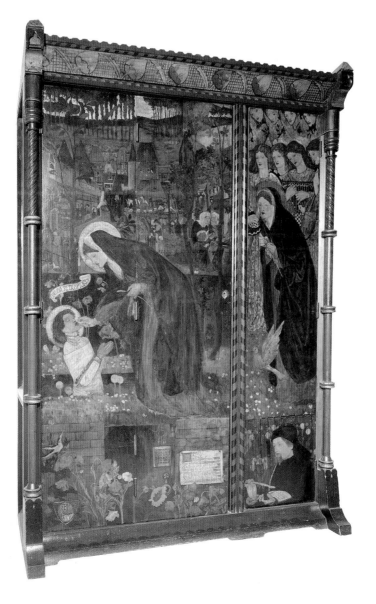

Penelope embroidery, *c.* 1860

Courtesy of Kelmscott Manor, Oxfordshire, UK/Bridgeman Images

This embroidery, worked by Morris's sister-in-law, Bessie Burden, was one of 12 planned for the decorative scheme of heroines from history and myth, based on Chaucer's 'The Legend of Goode Wimmen', which Morris intended should hang on the walls of the drawing room at Red House (*see* page 32). Designed in 1860, the scheme was never finished, although in one of his notebooks there are sketches for the overall design, with the 12 figures framed with trees and a border of flowers. Ten of the figures are known to have been completed – as designs or as finished embroideries or, in the case of *Penelope*, as both. In keeping with the subject matter, like the other completed figures in the series, this one was embroidered using a traditional late medieval technique, worked first on linen, then cut out and applied to a background of woollen serge. The woman who worked it, Bessie Burden, became one of the most skilled embroiderers of her generation and was later employed by the newly formed School of Art Needlework (now the Royal School of Needlework). Here she taught the crewelwork stitching that was used in this design, in particular the cushion stitch, then known as a tapestry stitch and later renamed the Burden stitch in recognition of her mastery.

CREATED

London

MEDIUM

Embroidery on serge

RELATED WORKS

St Catherine embroidery by William and Jane Morris, *c.* 1860

Bessie Burden (1842–1924)

Cartoon for *The Ascension*, c. 1861

It was the promise of commissions from the young architect G.F. Bodley that encouraged the group of young artists who had recently completed the Oxford Murals to think of setting up the firm of Morris, Marshall, Faulkner & Co. It was during this period, in the early 1860s, that the vogue for building Gothic Revival churches and restoring other Gothic structures reached its height. Bodley was establishing himself as a church architect, and the commission for a suite of stained-glass windows for All Saints Church, Selsley, near Stroud in Gloucestershire, was the first secured by the Firm (*see* page 36), with some critics now regarding it as the best of all their ventures in the medium. The overall design for the Selsley scheme is thought to have been by Philip Webb, with individual windows designed by various members of the group: Rossetti, Burne-Jones and Brown each taking two; Webb and Morris jointly designing the various scenes of creation in the west rose window; and Morris individually designing three windows, including this one in the apse. For these designs he studied some of the best examples of medieval stained glass extant in Britain, the windows of the chapel of Merton College, Oxford.

CREATED

London

MEDIUM

Pen and ink on paper

RELATED WORKS

Cartoon for *The Sermon on the Mount* by Dante Gabriel Rossetti, 1862

The Three Marys at the Sepulchre, 1862

For Morris, the apogee of stained-glass design was the late fourteenth and early fifteenth centuries, from which period the windows of York Minster were the best surviving examples in England, even in Morris's time. He eschewed the technique of painting on clear or white glass, practised, for instance, by Sir Joshua Reynolds (1723–92) in the previous century. Instead, he favoured the mosaic enamel method used by the medieval glassmakers, in which different-shaped pieces of coloured glass, overpainted with details of drapery or facial features, were assembled into a picture using intricate leadwork. By and large, not only the technique but also the composition of the Firm's stained glass, particularly in many of the early church commissions, was based on medieval examples such as Morris and Burne-Jones had seen at Chartres and the other great cathedrals on their journeys in northern France during the mid-1850s. A key source of knowledge was a work by the barrister and historian of stained glass, Charles Winston (1814–64), called *An Inquiry into the Difference of Style Observable in Ancient Glass Painting*. Published in 1847, this book coincided with the Gothic Revival in architecture, contributing to the gradual rebirth of interest in the medium in England, which had been gathering pace for decades.

CREATED

London

MEDIUM

Stained glass

RELATED WORKS

Christ Preaching by Dante Gabriel Rossetti, *c.* 1870

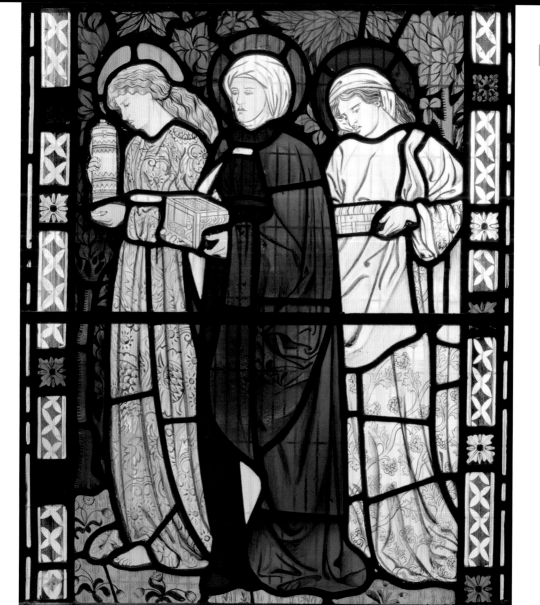

The Death of Sir Tristan, from *The Story of Tristan and Isolde*, 1862

Courtesy of Bradford Art Galleries and Museums, West Yorkshire, UK/Bridgeman Images

The list of artists working for the Firm who made windows for Harden Grange in West Yorkshire is even longer than for All Saints Church in Selsley that same year. Morris, Rossetti, Burne-Jones, Brown, Prinsep and Hughes all produced at least one image each out of the suite of 13 windows commissioned by the wealthy industrialist Walter Dunlop for Harden Grange, his country seat in Bingley, north of Bradford. As the firm's first big secular commission, it drew on the famous French medieval romance which inspired the Arthurian legends that were central to Pre-Raphaelite thinking and to Morris's own early work in various mediums. In creating his windows, Morris broadly followed the techniques used by medieval makers of stained glass. Once the shape of the window opening had been established, an artist – in this case it was Brown – would make a preparatory drawing or cartoon. Next, vividly coloured pot metals would be chosen to make the coloured glass for the different parts of the mosaic into which the cartoon was divided, following which a glass-painter would transfer the cartoon onto the coloured glass. Then the glass would be fired and the various pieces joined together by means of lead cames, or strips, before these were finally soldered together to make the image.

CREATED

London, England, UK

MEDIUM

Stained glass

RELATED WORKS

Sir Tristan Leaving Ireland with Isolde the Fair by Val Prinsep, 1861

Ford Madox Brown (1821–93)

How Sir Tristram & King Mark were made at one again by King Arthur: means, & how nevertheless King Mark slew Sir Tristram by treachery as he sat harping to La Belle Isoude & Isoude died the third day after

Geoffrey Chaucer tile, 1863

Courtesy of Victoria and Albert Museum, London, UK/The Stapleton Collection/Bridgeman Images

Tiles were one of the first successful product lines retailed by the Firm. Designed by Burne-Jones, we know from the hand-written inscription on the back of the tile that Morris himself was responsible for the enamelling. One of only a few tiles he did, no doubt the subject matter was a strong incentive, Chaucer being one of his favourite writers. Intriguingly, the model for the figure was Rossetti, another who made tile designs during this period. The tile design was originally executed for a stained-glass roundel for The Hill, the house of Myles Birket Foster, which the Firm was engaged in decorating from 1862–64. As with the other tiles it produced and sold, the design was executed on a Dutch pre-fired and -glazed plain white blank, which was then decorated by one of the Firm's artists. There was a lot of experimenting with glazes in its tile production, many of which did not work, in part because tiles were routinely fired along with stained glass, which affected the quality of the former. These problems apparently persisted until 1870, when the ceramicist William De Morgan was able to offer a greater range of reliable colours less prone to bubbling or being lost during the firing process.

CREATED

London

MEDIUM

Painted ceramic tile

RELATED WORKS

Imago Philomela de Atheni Martyris by Edward Burne-Jones, 1862

Edward Burne-Jones (1833–98)

Trellis wallpaper, 1864

Morris was quick to realize that his great visual artistic gifts lay in his ability as a pattern maker. *Trellis*, his first wallpaper design, was inspired by the trellises in the garden at Red House through which roses climbed. The two years' delay from the design of this wallpaper to its eventual production resulted from the difficulties Morris experienced in trying to print it himself, using transparent oil colours and etched zinc plates. It was a method Morris himself had devised, but when it did not work, he handed over production to the firm of Jeffrey & Co., an established wallpaper manufacturer based in Islington, who printed the paper using the conventional technique of cut woodblocks and distemper colours. The results were an eventual success, though only after Morris had been typically relentless in his critique, on one occasion deciding to throw away an entire set of printing blocks and start again because he was not satisfied. This version of *Trellis*, with the blue background, was one that Morris hung in his own bedroom at Kelmscott House after moving there in 1879. It was also used by Morris & Co. in some of their decorative schemes at other houses, such as at Standen in Sussex, which was built and decorated in the early 1890s.

CREATED

London

MEDIUM

Wallpaper

RELATED WORKS

Wallpaper frieze by Walter Crane, *c.* 1875–90

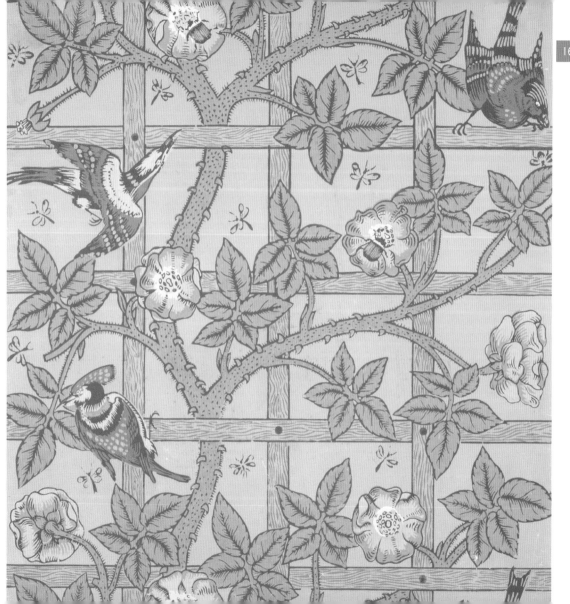

Sussex chair, 1864–65

This kind of chair had been a popular design between 1790 and 1820, when it was made with a rush seat and an imitation bamboo frame, painted black or red. It seems to have fallen out of fashion by the time Morris had moved into Red House, where red or black Sussex chairs were staple items of furniture nonetheless. The Burne-Joneses also seem to have had similar chairs made for them – in black and with rush seats – but it seems that they only became an item that the Firm manufactured (possibly to a design by Webb) when its incoming manager, George Warington Taylor, recognized their commercial potential at a time when the company desperately needed a product it could shift in large numbers. According to the Firm's own catalogue, the chair 'was not his (Morris's) own invention, but was copied with trifling improvements from an old chair of village manufacture picked up in Sussex'. Whether or not this was true, the Sussex chair became synonymous with the vernacular aesthetic associated with Morris & Co. In time, the Sussex range of chairs offered by the company included corner stools, chairs without arms, high-legged chairs and even a three-seater settle.

CREATED

London

MEDIUM

Ash, stained black, with rush seat

RELATED WORKS

Ladderback chair by Ernest Gimson, *c.* 1895

Printing block for *Tulip* textile, 1875

Courtesy of Private Collection/The Stapleton Collection/Bridgeman Images

Having decided to move into the field of printed textiles, Morris resolved to use the old technique of block-printing, as was already the case with his wallpapers, rather than the modern commercial method of engraved rollers, which most of the leading commercial manufacturers had adopted. Morris had first approached Thomas Clarkson of the Bannister Hall Print Works near Preston in Lancashire in 1868, initially to reprint historical designs by others whose blocks were still available, which would then be sold through the Firm's shop at 26 Queen Square. However, Clarkson's use of modern synthetic aniline dyes produced garish colours that Morris loathed, and they also had a tendency to bleed when washed, or else to fade and change colour. This led Morris to find a new relationship, with Thomas Wardle's dyeworks in Leek (*see* page 68). *Tulip* was one of the first four Morris designs printed by Wardle (*see* page 68). The individual blocks used to register each colour in Morris's pattern would have been made by Wardle's block cutter, to whom the pattern was sent. However, although Morris favoured block-printing and natural dyestuffs, his main reason for doing so was the quality of the end result, and in other aspects of the dyeing process he would use advanced dye-setting agents or mordants, such as alum, to achieve reliable colour-fastness.

CREATED

Leek

MEDIUM

Wooden block for fabric printing

RELATED WORKS

Wooden blocks for *Grafton* wallpaper, *c.* 1883

Embroidery design, *c.* 1875

Morris first became interested in embroidery whilst working in the Oxford office of G.E. Street straight after university (*see* page 14), where ecclesiastical embroideries were among the range of design items offered by a practice specializing in Gothic Revival church architecture. Street himself co-wrote a book called *Ecclesiastical Embroidery* and gave lectures on the subject; his influence on the young Morris was considerable. Even after leaving the practice, Morris's interest in embroidery was strong enough to have a wooden embroidery frame made so that he could learn the technique. It was this thorough immersion in the technical process of a particular medium, to the point where he had mastered it, which enabled him to be so idiomatic in his designs for each one, whether embroidery or carpet-weaving or book production; Morris was as much a maker as he was a designer. However, the only embroidery he is known to have created entirely on his own was the *If I Can* hanging from 1857 (*see* page 26), and by the mid-1870s when this design was created, Morris & Co. was employing a dedicated team specifically for this work. This design was part of a series Morris created for the Royal School of Needlework, founded in 1872, where his sister-in-law, Bessie Burden, was a teacher (*see* page 156).

CREATED

London

MEDIUM

Pencil, pen and ink, and watercolour

RELATED WORKS

Unfinished panel depicting a pomegranate tree, *c.* 1860

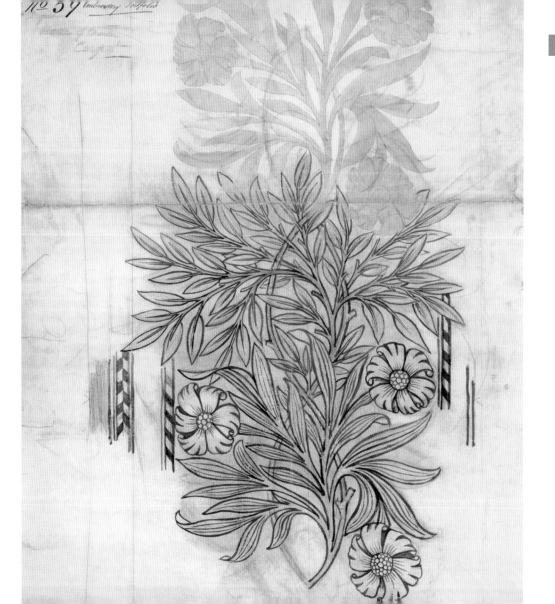

Acanthus wallpaper, 1875

Courtesy of Private Collection/Bridgeman Images

The *Acanthus* design is one of the most celebrated among Morris's vast output. Acanthus leaves are also possibly the most recognizable ornamental motifs in Western art. They spread from the capitals of the Corinthian columns of Ancient Greece to top the columns of buildings all over Christendom and to fill the margins of illuminated manuscripts during the Middle Ages. They also fulfil the same function in Morris's own illuminated manuscripts from the same period in which *Acanthus* was created, as well as in later designs for the illustrated books of the Kelmscott Press. *Acanthus* conveys an illusion of depth more readily perhaps than any other of his wallpaper designs. This is partly through the rich and varied use of naturalistic colour – bright colours suggesting foreground leaves, darker ones suggesting those in the background – and partly through the overlapping layers of leaves, superbly well observed by Morris's practised botanical eye, which also twist around themselves with a dreamlike realism. This sense of vivid life is conveyed with a painterly subtlety through the use of 15 separate colours, more than for any previous Morris design. This complexity of colour range and pattern meant 30 separate blocks were needed for printing, making it a paper that only the most affluent could afford.

CREATED

London

MEDIUM

Wallpaper

RELATED WORKS

Leicester wallpaper by John Henry Dearle, 1911

Marigold wallpaper, 1875

Courtesy of Private Collection/Bridgeman Images

Marigold was one of 17 wallpaper designs that Morris completed between 1872 and 1876, which are commonly regarded as the finest he ever did, with a balance of pattern and naturalistic detail that achieves a hypnotic realism. The monochromatic patterns of the various Marigold colourways make it among the flattest of the group, but even this design conveys the feeling of tangible natural life that he had tried to achieve as a less experienced designer in the mid-1860s. His three early papers from that period – *Trellis* (*see* page 166), *Daisy* (*see* page 40) and *Fruit* (*see* page 46) – though now seen as classics themselves, had not been all that popular when they first appeared, so for commercial reasons it was not until the following decade that he returned to the medium. By then, naturalism had become more fashionable, influenced by Japanese woodblock prints or motifs that other designers had adapted from Renaissance scrollwork. Although no doubt he would have found it far too decadent, in the final decade of the century, the looping, luxuriant naturalism of Morris's patterns of this period would be a significant influence on the languorous sensuality of Art Nouveau. That Morris did not move any further in that direction owed as much to temperament as it did to the ceaseless curiosity that made him so productive in so many fields.

CREATED

London

MEDIUM

Wallpaper

RELATED WORKS

Loop Trail wallpaper by Kate Faulkner, 1877

Chrysanthemum wallpaper, 1876

Chrysanthemum is another of the richly coloured wallpaper patterns of the mid-1870s combining the beauty and robustness of nature. It was a theme – or perhaps a state of mind – that reflects Morris's own delight and self-confidence in the world around him and his effect upon it, the harmonious fluency and agency with which he moved within each discipline and between one and another. In a lecture called 'The Lesser Arts', delivered in 1877, the year after this design was made, Morris talks of the decorative arts as being the birthright of all men and women. 'These arts, I have said, are part of a great system invented for the expression of a man's delight in beauty: all peoples and times have used them; they have been the joy of free nations, and the solace of oppressed nations; religion has used and elevated them, has abused and degraded them; they are connected with all history, and are clear teachers of it; and, best of all, they are the sweeteners of human labour, both to the handicraftsman, whose life is spent working in them, and to people in general who are influenced by the sight of them at every turn of the day's work: they make our toil happy, our rest fruitful.' Morris's vision is one of holistic joy.

CREATED

London

MEDIUM

Wallpaper

RELATED WORKS

Iris wallpaper by John Henry Dearle, 1892

Honeysuckle furnishing textile, 1876

This marvellous pattern was one of the inspired textile designs Morris printed at Thomas Wardle's Hencroft Works in Leek in the years 1875–78. Morris saw the old techniques of dyeing as an art, and therefore modern industrial methods as the cause of its decline as an art. He hated the strident colours produced by modern aniline dyes, derived from coal tar, and was determined, as with every discipline he mastered, to rediscover old techniques to achieve better results. It was during these years that he made regular trips to Leek, literally to get his hands dirty. Having already immersed himself in the subject, trying out various dyestuffs at home in Queen Square during the previous couple of years, upon arriving at the Leek works he literally plunged in, staining his arms up to his elbows from working in the vats, using the same dyestuffs he had already tried: indigo to get blue; walnut roots or shells for brown; yellow weld, the wild mignonette, otherwise known as dyer's weed, for yellow; and cochineal and kermes, two dyes derived from insects, as well as madder, for red. He was never happy with the blue he got here, a failure that contributed, after a few frustrating years, to his decision to end the relationship with Wardle.

CREATED

London

MEDIUM

Printed textile

RELATED WORKS

Eden by John Henry Dearle, 1902

Pimpernel wallpaper, 1876

Pimpernel was one of the clutch of luxuriant designs from the mid-1870s, and another that made use of the mirror symmetry that had come to fascinate Morris around that time. He hung the wallpaper in his own dining room at Kelmscott House, creating a dreamlike environment made more exotic by a portrait of his wife, painted by Rossetti, which hung over the fireplace, as well as a rare Persian carpet that was draped from the ceiling; the latter was an idea Morris took from an exhibition of Eastern art he had seen in London in 1878, the year before he took on the lease to Kelmscott House. In his lecture 'The Beauty of Life', given in 1880, Morris spoke of beauty, as he so often did, as 'a positive necessity of life, if we are to live as nature meant us to; that is, unless we are content to be less than men'. Industrial modernity, for Morris, had divided the work of craftsmen, which had once been intrinsically beautiful, into 'works of art and non-works of art'; it had done this through mechanization, alienating men and women from the holistic pleasure of making useful and also beautiful objects from start to finish, and thus, he feared, from being able to appreciate them, too.

CREATED

London

MEDIUM

Wallpaper

RELATED WORKS

Single Stem wallpaper by John Henry Dearle, 1905

Rose wallpaper, 1877

Courtesy of Private Collection/Bridgeman Images

Morris saw a successful wallpaper pattern as balancing the desire for colour and variety with the need for structure. In his lecture 'Some Hints on Pattern Designing', from 1881, he writes of seeking 'to mask the construction of our pattern enough to prevent people from counting the repeats of our pattern, while we manage to lull their curiosity to trace it out'. It is a penetrating insight into how we live within the environments we create, often only half-aware of that familiar interaction. Morris clearly saw decoration as a playful diversion for the mind, which anyone who has lived with a patterned wallpaper for any length of time will immediately recognize. He speaks further of the need 'to be careful to cover our ground equably', and if 'we are successful in these last two things' – disguise and temptation on the one hand, an even treatment of the pattern on the other – 'we shall attain a look of satisfying mystery, which is essential in all patterned goods, and which must be done by the designer'. In this regard, he advises that 'the colour above all things should be modest', aware that his papers were primarily to be lived with – looked at only in passing, while at the same time not drawing attention to themselves.

CREATED

London

MEDIUM

Wallpaper

RELATED WORKS

Sweet Briar wallpaper by John Henry Dearle, 1917

Bower wallpaper, 1877

Courtesy of Private Collection/The Stapleton Collection/Bridgeman Images

Throughout his life, in his poetry, his later prose, and his art and design across so many disciplines, Morris had striven to convey his vision of the possibilities of life, the earthly paradise of his most popular poetic cycle. Unlike the Norse adventurers in that work, Morris seems to have both found and understood it, not only in his life, in the idyllic setting of Kelmscott Manor and, before that, the brief artistic fellowship of Red House, but also consistently in his work. *Bower*, with its suggestion of summer shade and enclosure within some private garden paradise, is a prime example of an imagined, natural heaven on earth, its evenly placed patterns of foliage and flowers a vision of ideal, sacred nature, using an almost symbolic visual language akin to that of a Persian carpet. Like a veil of beauty drawn across the ugly face of much of Victorian England, Morris's saturated patterns, at their best, do more than simply decorate a room; they connect the interior world – of a house and a mind – to the exterior world of which men and women are an integral part, whether they notice or not.

CREATED

London

MEDIUM

Wallpaper

RELATED WORKS

Seaweed wallpaper by John Henry Dearle, 1901

Cabbage and Vine (or *Acanthus and Vine*) tapestry, 1879

Courtesy of Kelmscott Manor, Oxfordshire, UK/Bridgeman Images

This was Morris's first attempt at tapestry weaving, but as usual the evident quality was arrived at after a long period of experimenting with the tapestry loom he first set up in his room in 1878. Starting with a cartoon of the finished design, which includes the acanthus leaf that was a favourite motif, Morris worked on the piece for 516 hours between 10 May and 17 September 1879, the day it was finished. He seems deliberately to have chosen the rather washed-out colours of this tapestry, perhaps in an attempt to make the piece seem more antique than it obviously was. This early design is a mirror image, but Morris, the fine artist *manqué*, revered tapestry above all the other weaving arts precisely because it broke the shackles of patterning altogether; the one form of weaving that could rival painting in its ability convincingly to depict the world. In his essay, 'Some Hints on Pattern Designing' from 1881, he writes of the primitive tapestry loom as 'a tool rather than a machine'. He views this lack of mechanical sophistication as liberating the weaver's imagination, so that 'you really may almost turn your wall into a rose-hedge or a deep forest', if you so wish to do.

CREATED

London

MEDIUM

Woven wool and silk on a cotton warp

RELATED WORKS

Cock Pheasant tapestry by John Henry Dearle

Dove and Rose furnishing textile, 1879

In 1877, having spent several years acquiring a deep knowledge of the subject – as usual, both in theory and practice – Morris brought to London a French silk weaver from Lyon, called Louis Bazin (*see* page 80), to help establish a viable commercial weaving concern as part of the Morris & Co. portfolio. At the time – two years later, that this silk and woollen double cloth was woven, still a further two years before the opening of Merton Abbey – Morris was outsourcing the work to the Scottish manufacturer Alexander Morton & Co. As was often the case with similar work done for him by outside contractors, Morris was not entirely happy with the standard he received, with colour-fastness being a recurrent problem. However, it was clearly sufficient to merit the creation of several different colourways, with a pink and blue version being the most popular. Although he did successfully use it as an upholstery fabric on one of his own chairs, Morris would only recommend it to his customers and clients as suitable for curtains and hangings. From 1881, production of this and other textiles was brought in-house to Merton Abbey.

CREATED

London

MEDIUM

Silk and wool double cloth

RELATED WORKS

Squirrel furnishing fabric by John Henry Dearle, *c.* 1898

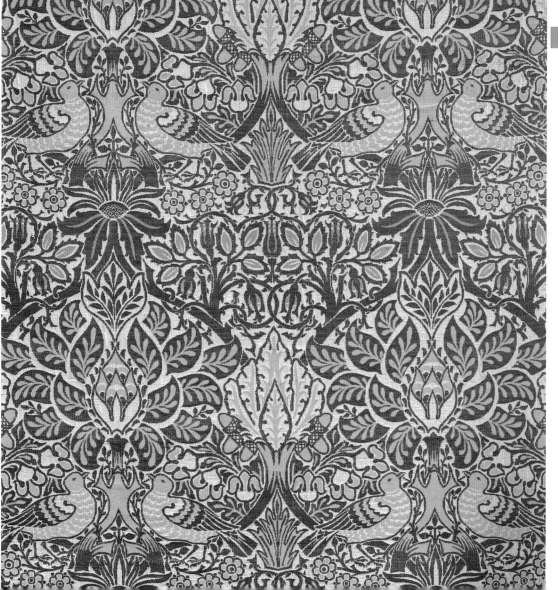

Mallow wallpaper, 1879

Courtesy of Private Collection/Bridgeman Images

With Morris now absorbed by weaving and dyeing, and seemingly satisfied with the wallpaper designs he himself had produced over the previous few years, he was happy enough to let others contribute their own ideas to the Firm's growing range. By 1877, Kate Faulkner had been doing work for Morris's company for well over a decade; he felt comfortable inviting her to design wallpapers as well as tiles for Morris & Co. This design is similar to other, single-colour patterns – *Acorn*, *Sunflower* – designed by Morris at around the same time, and was registered with them as a group. Being simpler to produce, these papers retailed at half the price of more elaborate papers from the same period, such as *Chrysanthemum* (*see* page 178) and *Bower* (*see* page 186). Kate Faulkner was the sister of Charles Faulkner, a friend of Morris's from Oxford who became a professor of mathematics at the university but had been one of the founding partners of Morris, Marshall, Faulkner & Co., as well as its first financial manager. Kate produced work in a wide variety of media, including embroidery, gesso painting, tile painting, wood engraving and china painting, as well as textile and wallpaper design. Kate and Charles's sister, Lucy Faulkner Orrinsmith, was also a designer, who is known for her painted tiles.

CREATED

London

MEDIUM

Wallpaper

RELATED WORKS

Sunflower wallpaper by William Morris, 1877–78

Kate Faulkner (1841–98)

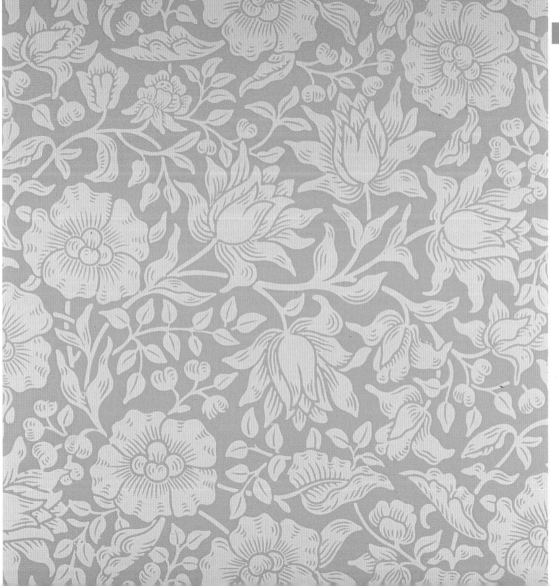

Peacock and Vine furnishing textile, *c.* 1880–1900

Courtesy of Private Collection/© The Fine Art Society, London, UK/Bridgeman Images

Morris had discovered his passion for embroidery from seeing the altar frontals of the new churches designed by the firm of G.E. Street, for whom he worked as a young man just down from the University of Oxford. He and Webb, who first met at Street's firm, had designed church embroidery for similar commissions during the early years of Morris, Marshall, Faulkner & Co. for churches in Clapham in London and Godalming in Surrey, as well as Llandaff Cathedral in Cardiff. Embroidery remained a staple item in the catalogue of Morris & Co., which, in the 1870s and '80s, offered extremely complex secular designs as patterns that customers themselves could embroider at their leisure. In a couple of famous cases, patient clients, in taking up the challenge of these phenomenally complex embroideries, spent years and even decades completing the work. This one was apparently also provided in kit form, taking the *Vine* pattern from Morris's wallpaper of the early 1870s and adding a peacock – a very fashionable bird at the time – designed by Webb. The bird is an example of crewelwork, a kind of surface embroidery, using crewel wool (a fine wool), that reached its height of popularity during the seventeenth century.

CREATED

London

MEDIUM

Crewelwork on linen

RELATED WORKS

Altar frontal for St-Martin-on-the-Hill, Scarborough, probably by William Morris, 1862

William Morris (1834–96) and **Philip Webb** (1831–1915)

Chintz printing by hand, Merton Abbey, 1881 or later

Courtesy of Private Collection/The Stapleton Collection/Bridgeman Images

There were three wooden sheds at Merton Abbey, two on one side of the River Wandle, with the other one, on the opposite bank, accessed by a bridge. It was on the upper floor of this third shed that Morris set up his fabric-printing workshop once the relationship with Wardle of Leek had come to an end (*see* page 180). In this photograph, the printing tables are set up along one well-lit side of the building. Behind each man is a wheeled trolley set on tracks that run the whole length of the shed. To register each part of a pattern, the printer would turn and press the printing block for that colour into the dye pad with that colour sitting inside the trolley. He would then lay it in position and rap it with the handle of a mallet to impress the colour into the cloth. Both before and after this process, the cloths would be washed in the River Wandle, sliding quietly between the sheds. When the weather allowed, the prints were placed in the open air to allow the ground colour to lighten again after dyeing, a process known as 'crofting'; sometimes great skeins of colourful chintz would be strewn about the meadows surrounding the works, all drying and bleaching in the sun.

CREATED

Merton Abbey, London

MEDIUM

Black and white photograph

Unknown photographer

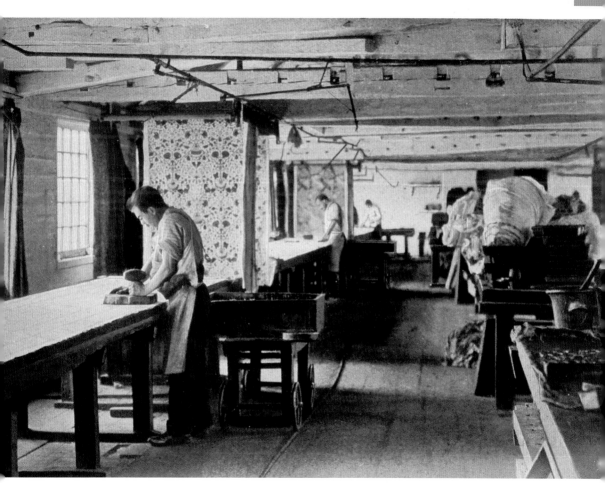

Anemone furnishing textile, 1881

Courtesy of Private Collection/Bridgeman Images

In his lecture 'Some Hints on Pattern Designing', given the same year he designed the *Anemone* textile, Morris articulates his philosophy of pattern design with typical precision. 'Ornamental pattern-work', he says, 'to be raised above the contempt of reasonable men, must possess three qualities: beauty, imagination, and order', with the third an essential requirement, without which 'neither the beauty nor the imagination could be made visible'. He talks of the 'conventionalizing of nature' integral to the process of pattern designing, in which 'order invents certain beautiful and natural forms, which, appealing to a reasonable and imaginative person, will remind him not only of the part of nature which, to his mind at least, they represent, but also of much that lies beyond that part'. Later in the same lecture, he gives clear instructions for how to achieve this, declaring that 'Definite form bounded by a firm outline is a necessity for all ornament,' and that 'Rational growth is necessary to all patterns, or at least the hint of such growth; and in recurring patterns, at least, the noblest are those where one thing grows visibly and necessarily out of another.'

CREATED

London

MEDIUM

Printed cotton

RELATED WORKS

Shannon textile by John Henry Dearle, after 1892

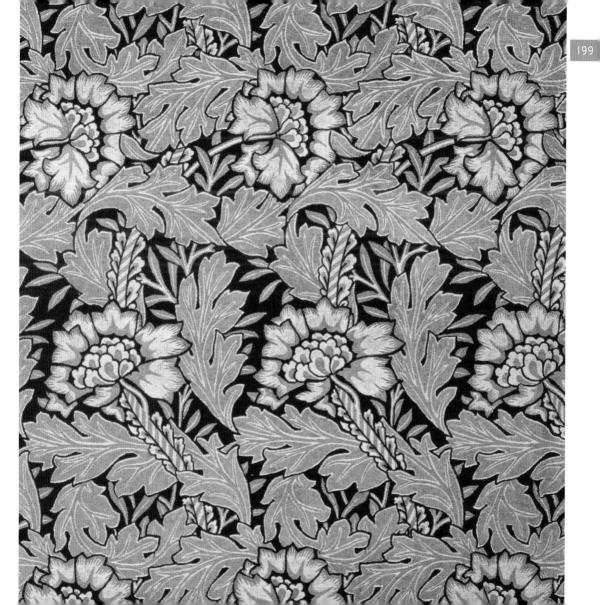

St James's wallpaper, 1881

One notable early commission for the Firm had been to redecorate the Armoury and Tapestry Room at St James's Palace in London in 1866, a Gothic scheme devised by Webb, in keeping with both the setting and the Firm's medievalist reputation at the time. Thirteen years later, Morris & Co. was asked to return to the palace to carry out substantial redecorations of its public spaces. Morris divided the largest and loftiest of these, the Grand Staircase, into lower and upper stages, designing a resplendent new paper featuring his favoured acanthus leaves for the upper stage. Two widths of paper were needed to display the entire pattern, while the length of one vertical repeat ran to over 1 m (3 ft) and required two blocks to print each colour. In all, 68 separate blocks were needed to print the pattern, making it by far the most complex wallpaper pattern Morris ever designed. The process of design and redecoration was completed in just a few months and led to commissions to redecorate a suite of State Apartments, at least one of which, the Banqueting or Waterloo Room, was hung with a varnished, red colourway of the same magnificent paper. Later sold to the public, at 32 shillings and sixpence a roll it was also the company's most expensive paper.

CREATED

London

MEDIUM

Wallpaper

RELATED WORKS

Poppy wallpaper by William Morris, 1880

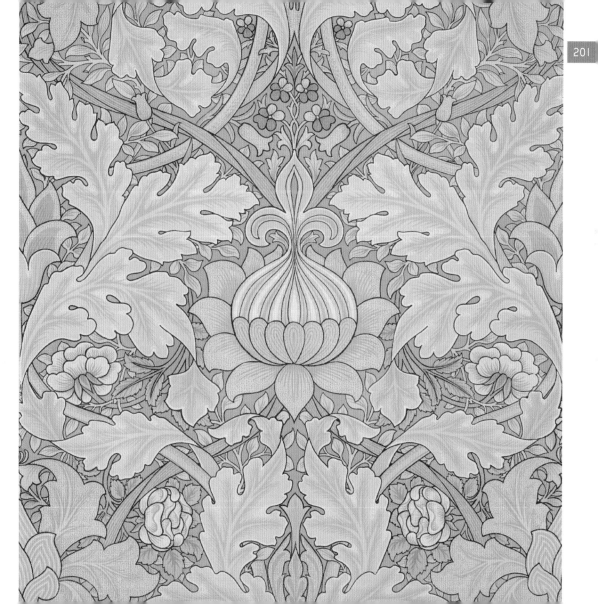

Christchurch wallpaper, 1882

Courtesy of Private Collection/The Stapleton Collection/Bridgeman Images

One of Morris's great strengths as a designer was his hard-won, hands-on understanding of each medium, which helped him design patterns that worked idiomatically in each one. In his lecture 'Some Hints on Pattern Designing' from 1881, he writes that, 'A pattern which would make a very good paperhanging would often look dull and uninteresting as a chintz pattern.' Such a clear vision of the tactile and visual qualities of different mediums is why Morris did not transfer designs from one to another, no matter how successful they might have been in their original format. This fairly flat-patterned wallpaper, designed not long after the move to Merton Abbey, might have been one that did not respond well to being rendered in another medium. Although these days manufacturers reproduce Morris designs – long out of copyright – in whatever medium they can sell them, Morris would surely have disapproved. Wallpaper sits flat on the wall and thus is more exposed to close scrutiny than a furnishing fabric that wraps around a chair, or a curtain that folds against itself. Thus, in wallpaper, for Morris, it was important to disguise the structure of the pattern so as not to disturb the overall effect of what was a large expanse of flat, decorated surface.

CREATED

London

MEDIUM

Wallpaper

RELATED WORKS

Willow Bough wallpaper by William Morris, 1887

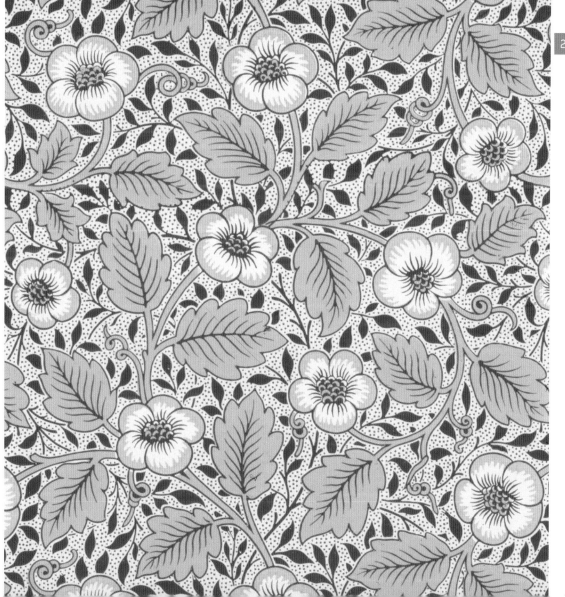

Design for *Rose* textile, 1883

Courtesy of Private Collection/The Stapleton Collection/Bridgeman Images

This design, another mirror pattern, was one of the first batch of chintzes Morris printed at Merton Abbey. In the lecture 'Some Hints on Pattern Designing', given some two years earlier, Morris sets out his thinking at that point in his life on what made an effective pattern for chintz, listing motifs which had been a feature of his earliest design, the *Trellis* wallpaper (*see* pages 38, 166), with its similar component elements of small birds and roses: 'The naïvest of flowers with which you may do anything that is not ugly; birds and animals, no less naïve, all made up of spots and stripes and flecks of broken colour, these seem the sort of thing we ask for. You cannot well go wrong so long as you avoid commonplace, and keep somewhat on the daylight side of nightmare.' Comparing this design with *Trellis* across the distance of two decades, it is clear how different his treatment of those same naïve elements now is. There is deliberate dispelling of the naturalistic illusion of the earlier design: rather than holding up a mirror to nature, this paper is a mirror of itself; but also the density of the pattern-making hints at what he means by 'the daylight side of nightmare', the maturity of vision Morris has slowly achieved over time.

CREATED

London

MEDIUM

Pencil and watercolour on paper

RELATED WORKS

Design for *Windrush* textile, 1881–83

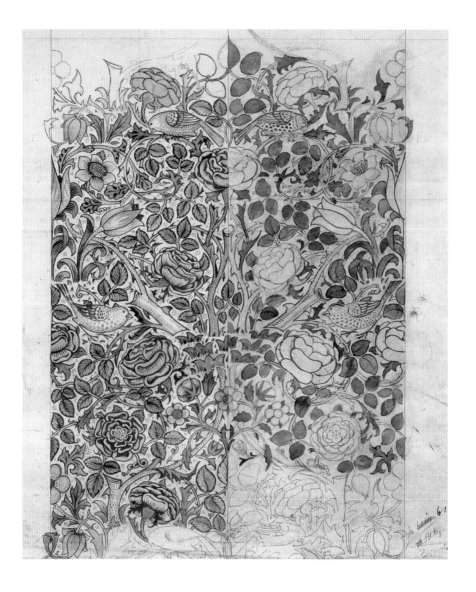

Evenlode furnishing textile, 1883

Courtesy of Private Collection/Bridgeman Images

The *Evenlode* textile was one of a group of at least eight designs from the years 1883–85 based on tributaries of the Thames, part of a larger group of 19 new chintz patterns registered between May 1882 and September 1885. Seventeen of these, including *Evenlode*, were designed to be printed using the indigo discharge method, which Thomas Wardle had never mastered and whose failure was part of the reason for Morris ending that relationship in the late 1870s (*see* page 180). Now with his own dyeworks at Merton Abbey, he was able to spend the time and exert the control needed to master the process. An ancient, Eastern technique, it allowed a depth of colour and a precision of detail that Morris wanted for his own fabrics. Reversing the usual practice of printing the required colours onto plain cloth, with the indigo discharge method, the whole cloth is immersed in a vat of indigo to dye it a dark-blue colour. Then the pattern is created by block-printing those areas not intended to be dark blue with bleaching agents (either a full solution for white or a weakened one for half-blue or light blue). After being half-dried and warmed, the cloth is then prepared for the next colour, which is block-printed with a mordant in the relevant areas.

CREATED

London

MEDIUM

Printed cotton

RELATED WORKS

Cherwell textile by John Henry Dearle, 1887

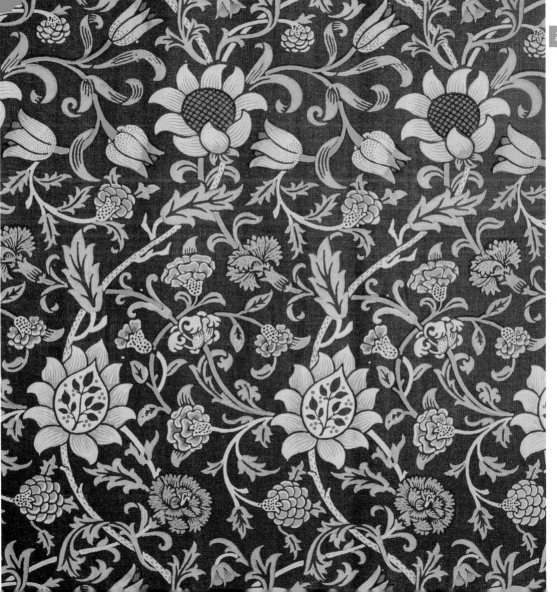

Pomona tapestry, 1885

Courtesy of Whitworth Art Gallery, The University of Manchester, UK/Bridgeman Images

Six different versions of this tapestry were made, of which this one was the first and the largest to be woven. An irrepressible autodidact, Morris claimed to have taught himself to weave tapestries with the help of an eighteenth-century manual. Although the art form had gone into decline several centuries earlier, there were still two well-established techniques in his day: the *basse lisse*, where the weaver works at a horizontal frame; and the *haute lisse*, in which they work at an upright frame from the back of the tapestry, looking through the threads at a mirror in which the slowly forming image is reflected. The design of Morris's tapestries was carried out jointly with Burne-Jones, who drew the figures within a general compositional scheme. Morris would add the foliage and the borders to make the cartoon from which the tapestry was woven. *Pomona* was made at Merton Abbey by three promising young apprentices: William Knight, William Sleath and John Martin. The other versions appeared much later, in the first two decades of the twentieth century – evidence of a significant new market for tapestries, albeit smaller ones, among a growing middle class.

CREATED

Merton Abbey, London

MEDIUM

Woven wool and silk on a cotton warp

RELATED WORKS

Hen Pheasant tapestry by John Henry Dearle

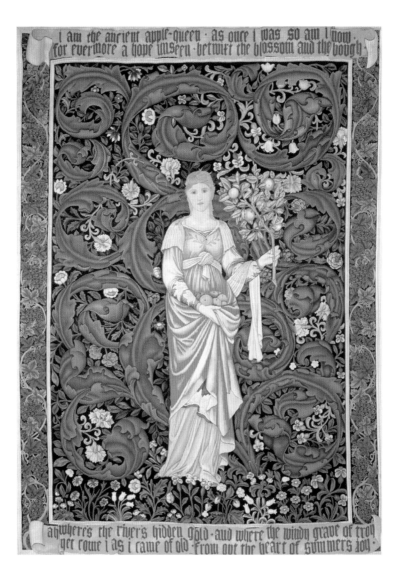

Typeface designs for decorated capitals, 1880s or 1890s

Courtesy of Flame Tree Publishing Ltd

Morris was both a writer and a designer, so starting his own press to create books whose visual beauty would be as compelling as their literary content served to unify those two distinct spheres of his creative life in a similar way to the illuminated manuscripts of classic works whose calligraphy he had executed in the mid-1870s. The first book printed by the Kelmscott Press, the publisher he established in 1891, was his own story, *The Glittering Plain*, for which he devised a new kind of roman type – which he called 'Golden' – in which he sought to emulate the supreme qualities of beauty and legibility he found in early printed books from the late fifteenth century. He describes the examples from the period that he most admired by comparing them with the form of art – architecture – which he placed above all others, stating in 'On the Woodcuts of Gothic Books', a lecture from 1892, that 'the only work of art which surpasses a complete Medieval book is a complete Medieval building'. However, the labour involved was considerable, requiring the creation of more than 80 characters, including upper- and lower-case letters, numerals and punctuation marks, with a consistent geometry that also had to work with all the different combinations of letters and marks that language entails.

CREATED

London

MEDIUM

Woodcut and black type on paper

RELATED WORKS

Gill Sans typeface by Eric Gill, 1927–30

Hammersmith carpet, *c.* 1890

Morris & Co. began selling affordable, machine-woven carpets – Axminster, Kidderminster and Wilton carpets made to Morris's designs – in the mid-1870s. However, he had long admired hand-knotted carpets from the East and, by then, such was his expert knowledge that the South Kensington Museum relied on Morris to advise them in their own acquisitions in this field. In 1877, in trying to create a Western equivalent to the sublime patterns of Eastern carpet design, he began to weave carpets experimentally on a small handloom set up in his bedroom in Queen Square. As with every other technique he mastered, he was soon imparting that knowledge to people he employed, so that they could execute the increasingly elaborate carpet designs that took shape in his mind over the next decade. In this case, in 1879, the coach house and stable at his newly rented property in Hammersmith, Kelmscott House, were converted into weaving sheds where at least six women sat working at 3.7 m (12 ft) wide looms on the handmade carpets – he called them Hammersmith carpets – that Morris designed. Two years later, carpet weaving was one of several operations that were moved to Merton Abbey, where the extra space allowed larger looms to be constructed and thus larger carpets to be woven.

CREATED

Merton Abbey, London

MEDIUM

Hand-knotted carpet

RELATED WORKS

Redcar carpet by William Morris, 1881

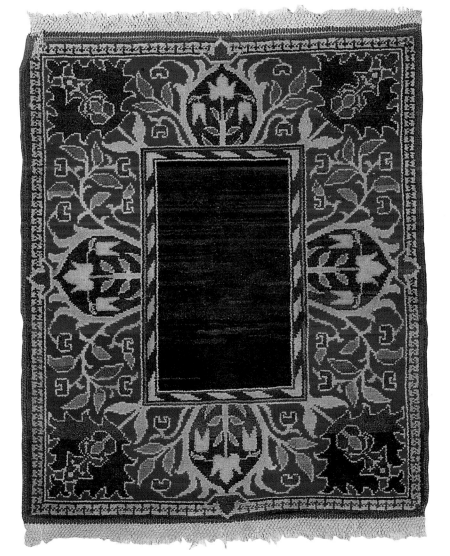

The Attainment, 1892–95 (this version executed 1895–96)

Courtesy of Birmingham Museums and Art Gallery/Bridgeman Images

The *Holy Grail* series of tapestries, designed and woven for Stanmore Hall in Middlesex, was the biggest commission in the medium that Morris & Co. ever received, and the most significant tapestry series of the nineteenth century. This huge project, depicting life-size figures from the Grail story, was designed and woven over a three-year period, 1892–95, with Morris and Burne-Jones supervising the nine Merton weavers who undertook the work. The individual tapestries were 2.4 m (8 ft) high, with the longest, *The Attainment*, a Herculean labour some 7 m (23 ft) from one side to the other. As Morris put it proudly to one reporter when this was shown at the Arts and Crafts Exhibition in 1893, this tapestry alone 'occupied three persons, as many as can sit comfortably across the warp, for two years. The people who made it, and this is by far the most interesting thing about it, are boys, at least they're grown up by this time, entirely trained in our own shop. It is really free hand work, remember, not slavishly copying a pattern ... and they came to us with no knowledge of drawing whatever, and have learnt every single thing they know under our training.' Such thorough instruction of everyone who worked for him was key to the company's success.

CREATED

Merton Abbey

MEDIUM

Woven wool and silk on a cotton warp

RELATED WORKS

The Failure of Sir Gawain and Sir Ewain to Achieve the Holy Grail by Morris, Edward Burne-Jones and John Henry Dearle, 1892–95

Edward Burne-Jones (1833–98), **William Morris** (1834–96) and **John Henry Dearle** (1859–1932)

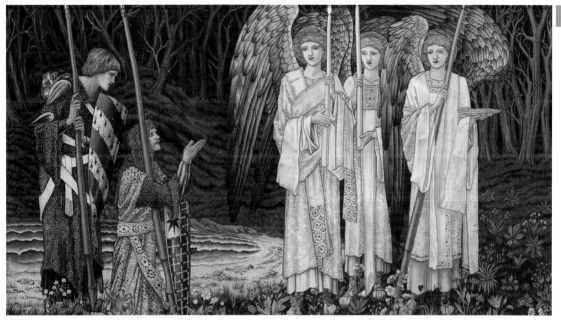

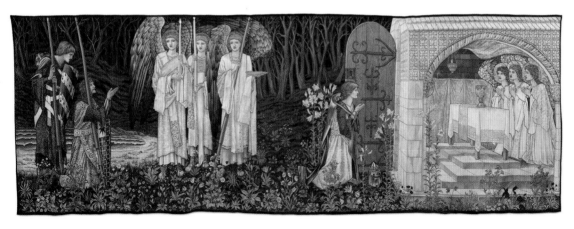

Pages from *The Works of Geoffrey Chaucer (The Story of Troilus and Criseyde)*, 1896

Courtesy of Flame Tree Publishing Ltd

Morris's first roman type design was based on types used in Venice in 1476 by the French printers Nicolas Jenson (1420–80) and Jacobus Rubeus (Jacques le Rouge). Assisted by his friend, the engraver and printer Emery Walker (1851–1933), an expert in typography who lived just along the river at Hammersmith, Morris studied incunabula (early printed books) and manuscripts, from which he quickly developed unshakeable convictions about what kind of typeface was both beautiful and legible. Jenson's roman type stood out among those from a time that, for Morris, was a Golden Age, preceding a slow degeneration in all the book arts which had happened over the centuries that followed. To create the new Golden type for *The Glittering Plain*, the first book printed by the Kelmscott Press (*see* page 210), Morris photographed and enlarged Jenson's letters. Then, for the second book he created another type, a Gothic script called 'Troy' that was based on scripts from the mid-1470s by three German printers – Peter Schöffer (1425–1503) of Mainz, Johannes Mentelin of Strasburg (1410–78) and Günther Zainer (d. 1478) of Augsburg – along with a third type, a smaller version of Troy which he called Chaucer type, in honour of an author the edition of whose works would be Morris's greatest achievement in the medium.

CREATED

Hammersmith, London

MEDIUM

Woodcut and black type on paper

RELATED WORKS

Rubáiyát of Omar Khayyám of Naishápur, illustrated by Charles Robert Ashbee, Essex House Press, 1903

Ye holden regne and hous in unitee;
Ye soothfast cause of frendship been
also;
Ye knowe al thilke covered qualitee
Of thinges which that folk on wondren so,
Whan they can not construe how it may jo,
She loveth him, or why he loveth here;
As why this fish, and nought that, cometh
to were.

Ye folk a lawe han set in universe,
And this knowe I by hem that loveres be,
That whoso stryveth with yow hath the
werse:
Now, lady bright, for thy benignitee,
At reverence of hem that serven thee,
Whos clerk I am, so techeth me devyse
Som joye of that is felt in thy servyse.

Ye in my naked herte sentement
Inhelde, and do me shewe of thy swetnesse.
Calliope, thy vois be now present,
For now is nede; seestow not my destresse,
How I mot telle anonright the gladnesse
Of Troilus, to Venus heryinge?
To which gladnes, who nede hath, God him
bringe!
Explicit prohemium Tercii Libri.

Incipit Liber Tercius.

LAY al this mene whyle Troilus,
Recordinge his lessoun in this manere:
Ma fey! thought he, thus wole I seye and
thus;
Thus wole I pleyne un-to my lady dere;
That word is good, and this shal be my chere;
This nil I not foryeten in no wyse.
God leve him werken as he gan devyse.

And Lord, so that his herte gan to quappe,
Heringe hir come, and shorte for to syke!
And Pandarus, that ladde hir by the lappe,
Com ner, and gan in at the curtin pyke,
And seyde: God do bote on alle syke!
See, who is here yow comen to visyte;
Lo, here is she that is your deeth to wyte.

Therwith it semed as he wepte almost:
A ha, quod Troilus so rewfully,
Wher me wo, O mighty God, thou wost!
Who is at there? I see nought trewely.
Sire, quod Criseyde, it is Pandare and I.

Ech for to winne love in sondry ages,
In sondry londes, sondry ben usages.

And forthy if it happe in any wyse,
That here be any lovere in this place
That herkeneth, as the story wol devyse,
How Troilus com to his lady grace,
And thenketh, so nolde I nat love purchace,
Or wondreth on his speche and his doinge,
I noot; but it is me no wonderinge;

For every wight which that to Rome went,
Halt nat o path, or alwey o manere;
Eek in som lond were al the gamen shent,
If that they ferde in love as men don here,
As thus, in open doing or in chere,
In visitinge, in forme, or seyde hir sawes;
Forthy men seyn, ech contree hath his lawes.

Eek scarsly been ther in this place three
That han in love seyd tyh and doon in al;
For to thy purpos this may lyken thee,
And thee right nought, yet al is seyd or shal;
Eek some men grave in tree, som in stoon
wal,
As it bitit; but sin I have begonne,
Myn auctor shal I folwen, if I conne.
Explicit prohemium Secundi Libri.

Incipit Liber Secundus.

IN May, that moder is of
monthes glade,
That fresshe floures, blewe, and whyte, and
rede,
Ben quike agayn, that
winter dede made,
And ful of bawme is
fletinge every mede;
Whan Phebus doth his
brighte bemes sprede
Right in the whyte Bole, it so bitidde
As I shal singe, on Mayes day the thridde,

That Pandarus, for al his wyse speche,
Felt eek his part of loves shottes kene,
That, coude he never so wel of loving preche,
It made his hewe aday ful ofte grene;
So shoop it, that him fil that day a tene
In love, for which in wo to bedde he wente,
And made, er it was day, ful many a wente.

The swalwe Progne, with a sorowful lay,
Whan morwe com, gan make hir weymentinge,
Why she forshapen was; and ever lay
Pandare abedde, half in a slomeringe,
Til she so neigh him made hir chiteringe

William Morris

Politics & Society

Pages from the *Life and Death of Jason*, 1867

Courtesy of Flame Tree Publishing Ltd

During his time at the University of Oxford, the writings of John Ruskin, especially the chapter 'The Nature of Gothic' from *The Stones of Venice*, profoundly influenced Morris's ideas about the purpose and dignity of labour, and how the quality of art was linked directly to the freedom of the artist or craftsman to work as they pleased. This had been the case in the Middle Ages, the period whose artistic production and whose social model both Ruskin and Morris held up as a nonpareil. Even at the end of his life, in his preface to the Kelmscott Press edition of *The Nature of Gothic*, published as a stand-alone volume in 1892, Ruskin's historical analysis is still central to Morris's own thinking: 'For the lesson that Ruskin here teaches us,' he writes, 'is that art is the expression of man's pleasure in labour; that it is possible for man to rejoice in his work, for, strange as it may seem to us to-day, there have been times when he did rejoice in it; and lastly, that unless man's work once again becomes a pleasure to him, the token of which change will be that beauty is once again a natural and necessary accompaniment of productive labour, all but the worthless must toil in pain, and therefore live in pain.'

CREATED

Hammersmith, London

MEDIUM

Woodcut and black type on paper

RELATED WORKS

Seven Poems and Two Translations by Alfred, Lord Tennyson, The Doves Press, 1902

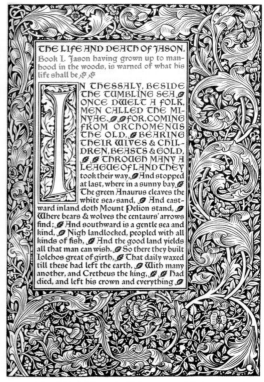

THE LIFE AND DEATH OF JASON.
Book I. Jason having grown up to man-
hood in the woods, is warned of what his
life shall be.

IN THESSALY, BESIDE
THE TUMBLING SEA
ONCE DWELT A FOLK,
MEN CALLED THE MI-
NYÆ, FOR, COMING
FROM ORCHOMENUS
THE OLD, BEARING
THEIR WIVES & CHIL-
DREN, BEASTS & GOLD,
THROUGH MANY A
LEAGUE OF LAND THEY
took their way, And stopped
at last, where in a sunny bay
The green Anaurus cleaves the
white sea-sand, And east-
ward inland doth Mount Pelion stand,
Where bears & wolves the centaurs' arrows
find; And southward is a gentle sea and
kind, Nigh landlocked, peopled with all
kinds of fish, And the good land yields
all that man can wish. So there they built
Iolchos great of girth, That daily waxed
till these had left the earth, With many
another, and Cretheus the king, Had
died, and left his crown and everything

Acanthus wallpaper, 1875

The issue that first brought Morris into active politics was the Eastern Question, the long-running tension between Russia and the Ottoman Empire which had already caused the Crimean War in the mid-1850s. In 1875 (the year of this design, *see* also page 174), it flared up again when the Turks brutally suppressed a rebellion in Ottoman-controlled Bulgaria, with reports reaching Britain that some 80 towns and villages had been destroyed and 15,000 people massacred. The Tory government of Benjamin Disraeli (1804–81) sided with the Turks, outraging intellectuals across Europe and bringing condemnation from the British Liberal party under former Prime Minister William Ewart Gladstone (1809–98). Morris was moved to join the newly formed Eastern Question Association (EQA) to fight Disraeli's policy, and in November 1876 he became its treasurer. On 24 April 1877, Russia declared war on Turkey, and while intellectuals such as Ruskin, Robert Browning (1812–89) and Charles Darwin (1809–82) had come out against the Turkish atrocities, Disraeli stood firmly by Britain's Ottoman ally. Morris was sufficiently enraged that on 11 May he issued his manifesto, 'To the Working Men of England', in which he exhorts his readers to recognize the duplicity of those advocating war, as he puts it, 'the bitterness of hatred against freedom and progress that lies at the hearts of a certain part of the richer classes in this country'.

CREATED

London

MEDIUM

Wallpaper

RELATED WORKS

Granville wallpaper by John Henry Dearle, 1896

Chrysanthemum wallpaper, 1876

Courtesy of Private Collection/Bridgeman Images

Morris's commitment to social causes, like his commitment to artistic disciplines, was protean. At the same time as he was ramping up his 'Stop the War' campaigning during what was also a prolific period for the creation of classic patterns (such as *Chrysanthemum*, *see also* page 178), he was also throwing himself at another issue on which he held passionate, forthright opinions. In early March 1877, reading of a planned restoration of Tewkesbury Abbey in Gloucestershire by Sir George Gilbert Scott (1811–78), Morris sent a letter of protest to the leading literary magazine, the *Athenaeum*, condemning the practice of restoration, which had become increasingly popular among Gothic Revival architects like Scott. They believed that through precise historical analysis, it was possible to reconstruct a building whose structure had decayed, so that it looked as it would have done, supposedly, when built. Morris was appalled by the impending threat to 'Tewkesbury Minster', as he called it, and on 22 March inaugurated the Society for the Protection of Ancient Buildings (SPAB), with himself as secretary, and with committee members George Wardle and Philip Webb. By early the following month, Morris had drafted a manifesto articulating the basic principles that still underpin our ideas of architectural conservation today, which led to the creation of the National Trust.

CREATED

London

MEDIUM

Wallpaper

RELATED WORKS

Birds, Squirrel, Acorn and Oak Leaf wallpaper by Charles Francis Annesley Voysey, 1924

Peacock and Dragon furnishing textile, 1878

Courtesy of Private Collection/The Fine Art Society and Francesca Galloway/Bridgeman Images

Morris was prepared to swim with the tide when it suited him, as in this pattern, using popular motifs such as the peacock in some of his designs. Equally, his strong moral values and finely tuned aesthetic sensibility sometimes brought him into conflict with prevailing norms. For example, the principle of architectural restoration was so widely accepted that among the strongest objections to Morris's 1877 'Manifesto of the Society for the Protection of Ancient Buildings' came from the Anglican clergy themselves, who, in line with the prevailing doctrine of the time, valued the re-creation of a past style over careful preservation of the original fabric on purely historical and aesthetic grounds. Morris's manifesto couldn't have been more at odds with this view, stating that 'those who make the changes wrought in our day under the name of Restoration, while professing to bring back a building to the best time of its history, have no guide but each his own individual whim to point out to them what is admirable and what contemptible ... and in short, a feeble and lifeless forgery is the final result of all the wasted labour'. Morris backed up his excoriating words with action that would cost him a significant amount of business, decreeing that from then on Morris & Co. would refuse any commission for stained glass for any building that was being or had been restored.

CREATED

London

MEDIUM

Woven wool panel with original trim

RELATED WORKS

New Persian furnishing textile by John Henry Dearle, *c.* 1905

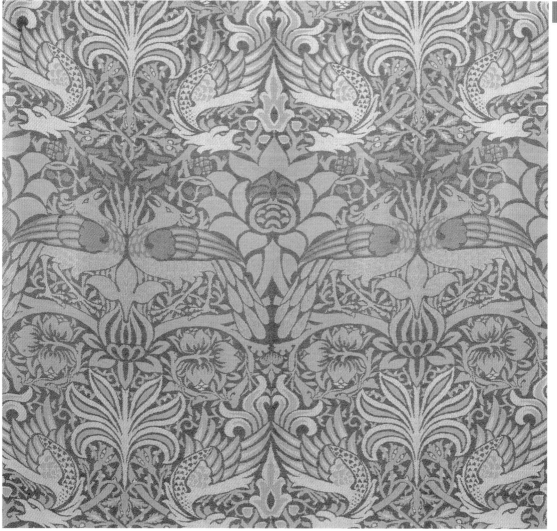

Small *Hammersmith* rug, *c.* 1878–79

Courtesy of Private Collection/Bridgeman Images

At the same time as the patterned carpets of the East were inspiring him to make this rug, the politics of the same region were provoking a more fundamental change in outlook. In early January 1878, war between Russia and Turkey looked very likely, and with Britain threatening to join the Ottoman side, the Eastern Question Association – which Morris supported out of his own pocket – organized a public demonstration at Exeter Hall on the Strand in London. At the suggestion of Henry Broadhurst (1840–1911), one of the organizers of the meeting, Morris, the 'idle singer' of *The Earthly Paradise*, composed a rousing song to the working men of the city, 'Wake, London Lads', beginning a tradition within what would become the Labour movement which endures to this day. The lyrics are boldly pacifist and anti-imperialist, exhorting the 'lads' of the title to 'Look through the fog of unjust wars and let our poor hearts learn.' However, with international tension further escalating and with the popular mood in Britain caught up in anti-Russian feeling, the resistance of the Liberals under Gladstone fell apart and with it the resolve of the Eastern Question Association. In the end war was averted, but Morris, a lifelong Liberal voter, had had his eyes opened by the whole affair. His journey over the next few years would move him towards a class politics his artistic beliefs had hinted at for more than two decades.

CREATED

London

MEDIUM

Woollen pile on a worsted warp

RELATED WORKS

Carbrook carpet by William Morris, 1881–83

'How I Became a Socialist' pamphlet cover, 1894

© The William Morris Society

Following the collapse of the Eastern Question Association, Morris joined its successor, the National Liberal League, and in 1879 became its treasurer. A working-class organization, it helped the Liberals to victory in the general election of 1880, reinstalling Gladstone at No. 10 Downing Street. However, the policies of the new administration were autocratic and imperialistic. The Irish Coercion Act, in particular, granted the authorities of the Crown in Ireland the right to intern people without trial under suspicion of being involved in the Land War, a decades-long period of civil unrest in the country during the late nineteenth century. This authoritarian move disgusted Morris, who resigned from the National Liberal League in the early months of 1882. Disillusioned with parliamentary radicalism, he began to cast around for new ideas, reading ever more widely among the revolutionary literature of the time, including *Underground Russia* by Sergius Stepniak (1851–95), a Russian revolutionary whose acquaintance he made. However, it was only when he read an attack on socialism by the Liberal philosopher John Stuart Mill (1806–73) – as he writes in his 1894 essay, 'How I Became a Socialist' – that he realized 'that Socialism was necessary', and that he was personally ready 'to join any body who distinctly called themselves Socialists'.

CREATED

London

MEDIUM

Printed paper

RELATED WORKS

The Communist Manifesto by Karl Marx and Friedrich Engels, 1848

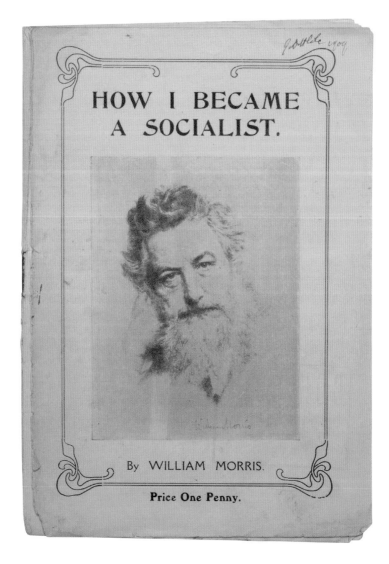

HOW I BECAME
A SOCIALIST.

By WILLIAM MORRIS.

Price One Penny.

Bird and Vine curtain, 1879

Courtesy of John Hammond/The National Trust Photolibrary/Alamy Stock Photo

In the late 1870s, a hugely productive period in which he was simultaneously turning out classic designs like this one, Morris's appetite for political activity inspired in him a new desire to set out ideas about art and society which had underpinned his thinking for decades without ever being formally articulated. Partly for the public and partly for himself, he began giving lectures on subjects he cared about. At first these bouts of public speaking caused him agonies of embarrassment, but his new passion to communicate a political vision was as great as had been his passion for making beautiful patterns and objects, because the two stemmed from a single motivation: the desire to help people live better lives. For Morris, these were not the same thing as more materially affluent lives, as he makes clear in 'The Beauty of Life', a lecture given in Birmingham in 1879, in which he said that 'the latest danger which civilization is threatened with ... (is) a danger of her own breeding: that men in struggling towards the complete attainment of all the luxuries of life for the strongest portion of their race should deprive their whole race of all the beauty of life: a danger that the strongest and wisest of mankind, in striving to attain to a complete mastery over nature, should destroy her simplest and widest-spread gifts'. Such sentiments now seem eerily prophetic.

CREATED

London

MEDIUM

Woven wool

RELATED WORKS

Elmcote curtain by John Henry Dearle, *c.* 1900

Design for a tapestry depicting *Acanthus and Peacocks*, 1879–81

Courtesy of Private Collection/The Stapleton Collection/Bridgeman Images

For Morris, as for Ruskin, there was an unbreakable link between the pleasure a person experiences in seeing an artwork and the pleasure derived by the craftsman in creating it. In fact, for Morris, the pleasure of the craftsman *was* the artwork, its quality of art as opposed to mere manufacture. The fundamental nature of that relationship is clearly articulated in 'The Art of the People', another lecture from 1879. 'That thing which I understand by real art,' he says, 'is the expression by man of pleasure in labour. I do not believe he can be happy in his labour without expressing that happiness; and especially is this so when he is at work at anything in which he specially excels.' He sees this ability to derive pleasure from labour as gifted to us by nature; just as men labour and take pleasure in it, so, too, 'does the dog take pleasure in hunting, and the horse in running, and the bird in flying'. Only with industrial civilization has this basic equation been replaced by 'that enormous amount of pleasureless work', he says, telling his audience, 'it is necessary to the further progress of civilisation that men should turn their thoughts to some means of limiting, and in the end of doing away with, degrading labour'. Being a preparatory design, the work shown here brings us particularly close to the pleasure that Morris himself experienced in creative work.

CREATED

London

MEDIUM

Pencil, ink and watercolour on paper

RELATED WORKS

Design for *Acanthus and Vine* tapestry, 1879

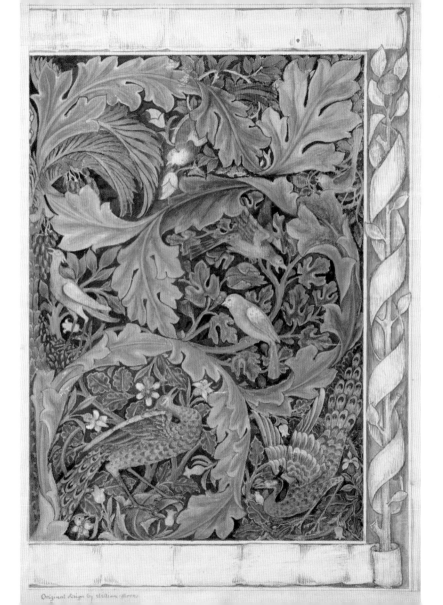

Original design by William Morris

Writhing Tree, East Window, 1880

Courtesy of St Martin's Church, Brampton, Cumbria, UK/Photo © Alastair Carew-Cox/Bridgeman Images

In the early 1880s, Morris's growing despair at the parlous condition of British society began to reshape his ideas of what an effective political remedy might look like. In 'Art and the Beauty of the Earth', a lecture given in the Potteries in 1881, he evokes the 'brutal and reckless faces and figures' that pass by outside his window along the river path in Hammersmith; 'fierce wrath takes possession of me,' he says, 'till I remember, as I hope I mostly do, that it was my good luck only of being born respectable and rich, that has put me on this side of the window among delightful books and lovely works of art'. His answer to the social divide and inequality he depicts so vividly is 'rebellion'; a radical idea for someone of his class, it is a solution he insists needed to happen — and quickly, too — as he sees clearly the causal connection from economic oppression and cultural deprivation to violence, even war. 'No, the rebellion will come,' he says, 'and will be victorious, don't doubt that; only if we wait till the tyranny is firmly established, our rebellion will have to be a Nihilistic one; every help would be gone save deadly anger and the hope that comes of despair.'

CREATED

London

MEDIUM

Stained glass

RELATED WORKS

The Passage of the Red Sea, Kirkcaldy Old Kirk, by Edward Burne-Jones, 1886

William Morris (1834–96) and **Edward Burne-Jones** (1833–98)

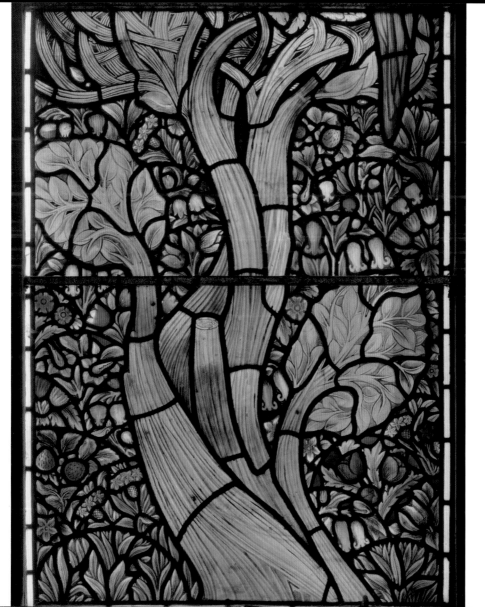

Kennet furnishing textile, 1883

Courtesy of Private Collection/Bridgeman Images

In January 1883, the same year in which he created several of the patterns, such as this one, in his series based on tributaries of the Thames, after attending a number of their meetings over the previous few months, Morris joined the Democratic Federation, at the time the only socialist organization in England, and only in existence itself since 1881. It was headed by Henry Mayers Hyndman (1842–1921), a one-time conservative who had been converted to socialism after reading Karl Marx's *The Communist Manifesto*, and who was steering the nascent political party through discussions on social reforms such as the provision of free education and the nationalization of privately owned land. In the early months of 1883, Morris also read Marx, not the *Manifesto* but his magnum opus, *Das Kapital* (in French, as the work was not yet published in English). In 'How I Became a Socialist', his brief biographical essay written a decade later, he admits to suffering 'agonies of confusion of the brain over reading the pure economics of the great work'. However, his outlook was transformed by his reading nonetheless, and also by conversations with men such as Hyndman and Ernest Belfort Bax (1854–1926), an historian with whom he would also later write a number of important socialist texts (*see* page 274), including a serialized history of Europe from a socialist perspective.

CREATED

Merton Abbey, London

MEDIUM

Printed cotton

RELATED WORKS

Trent printed fabric by John Henry Dearle, 1888

Honeysuckle wallpaper, 1883

Having had his own instincts profoundly confirmed by his reading of Marx, Morris saw the isolating influence of the capitalist system behind everything in society. Even our notions of beauty are corrupted by its distortion of values, as he makes clear in 'Art under Plutocracy', a lecture first given in November 1883. He tells his audience that 'in the times when art was abundant and healthy, all men were more or less artists', but that now, 'many men of talent and some few of genius are engaged ... in producing works of Intellectual art, paintings and sculpture chiefly'. These men, he insists, 'must be divided into two sections, the first composed of men who would in any age of the world have held a high place in their craft; the second of men who hold their position of gentleman-artist ... by the accident of their birth'. What this second group produce, he says, 'seems to me of little value to the world ... yet they are mostly not to be blamed for it personally ... They are, in fact, good decorative workmen spoiled by a system which compels them to ambitious individualist effort.' Morris had eschewed intellectual art himself at an early stage in his career, and in doing so attained that high level of skill in so many craft disciplines that is evident in superb designs like this wallpaper produced that same year.

CREATED

Merton Abbey, London

MEDIUM

Wallpaper

RELATED WORKS

Double Bough wallpaper by John Henry Dearle, *c.* 1900

The Strawberry Thief furnishing textile, 1883

Courtesy of William Morris Gallery, London Borough of Waltham Forest

In 1883, Morris created this classic pattern inspired by a thrush creeping under the protective netting of his strawberry patch at Kelmscott Manor. That same year, he read Marx's *Das Kapital* and was decisively converted to socialism. In 'Art, Wealth and Riches', the first lecture Morris gave after this Damascene moment, he explains the title at the outset by invoking the once widely understood etymological difference between 'wealth as signifying the means of living a decent life, and riches the means of exercising dominion over other people'. In a confrontational address at the Manchester Royal Institution in March 1883, he asked his audience, 'Which shall art belong to, wealth or riches? Whose servant shall she be? or rather, shall she be the slave of riches, or the friend and helpmate of wealth?' The lecture is informed by his own first-hand experience as an artist-entrepreneur of having to pander, as he had once put it, 'to the swinish luxury of the rich', notwithstanding his sincere desire to produce good design for all. Declaring himself 'discontented with the present conditions of art', here he takes aim at a system which allows art and the ordinary people who in previous ages would have made as well as appreciated it to have become so degraded. And he proceeds to set out all the deeply felt desires for equality that in the twentieth century became commonplace political nostrums – the basis of a fair society with, so Morris hoped, a genuine popular art.

CREATED

Merton Abbey, London

MEDIUM

Printed cotton

RELATED WORKS

Rosebud printed fabric by John Henry Dearle, c. 1905

Cray furnishing textile, 1884

As with the EQA, Morris was soon appointed treasurer of the Democratic Federation, and again this owed much to the financial support he personally gave to the group. However, he also became a dedicated campaigner, writing articles for its magazine, *Justice*, which was edited by Hyndman himself, and composing more chants or songs to be sung at their regular meetings. He even stood on street corners in London's West End, selling copies of the magazine, buoyed by a sense that socialism was a cause whose time had come. As is often the case, however, with people supposedly united in a common political aim, the means of attaining it became the subject of increasingly fractious dispute, with Morris and his group advocating revolutionary action, and Hyndman and his faction promoting the parliamentary route of legislative reform. The disagreements boiled over in 1884 when, at the annual conference of the Federation (now renamed the Social Democratic Federation – SDF), Morris's group forced Hyndman to step aside as president, although he still retained his post as editor of *Justice*. Hyndman's allies staged a counterattack on Morris and his people, and although Morris forced a vote on Hyndman's leadership, which Morris won, at the end of the year the designer-turned-campaigner quit the Federation to form a rival party with a far more radical plan. In the midst of so much political intrigue, he was still managing to turn out superb patterns such as this textile from his series inspired by tributaries of the Thames.

CREATED

Merton Abbey, London

MEDIUM

Printed cotton

RELATED WORKS

Severn printed fabric by John Henry Dearle, 1887–90

Wild Tulip wallpaper, 1884

Through 1884, alongside designs such as this one for his now thriving business, Morris wrote various articles for *Justice*, the magazine of the Democratic Federation. In these shorter pieces for an avowedly socialist publication, Morris is much more explicit in his assault on privilege, condemning both parliamentary parties, but more controversially attacking the complacency of well-meaning people of his own class. In a piece entitled 'Appeal to the Just', published on 11 October, he singles out bourgeois families who 'are themselves comfortable in condition; and, in truth, have never quite realised that there is any class which is "uncomfortable," or in plain words overworked, half-starved, and laden with deadly anxieties'. He tells this affluent class that the working class 'are now being educated ... enough to enable them to read the words of those who are discontented like themselves', warning them that before too long, 'this discontented class may be a danger to their comfort and refinement'. However, he predicts that the vague if well-meaning remedies of the conscientious bourgeois 'will be utterly useless, as by then the people will be so discontented that they will no longer believe in their being intended to remedy their lot'. It is a chastening vision of a future that did indeed arise in the following decades and may well happen again.

CREATED

Merton Abbey, London

MEDIUM

Wallpaper

RELATED WORKS

Harebell wallpaper by John Henry Dearle, 1911

'Useful Work Versus Useless Toil' pamphlet, 1884

© The William Morris Society

Morris became increasingly contemptuous of what he saw as the dishonesty of his own class and the system that was rigged in their favour. In 'Useful Work Versus Useless Toil', an essay published in 1884, he rails against 'the trading, manufacturing, and professional people of our society', insisting that 'by far the greater part of them, though they work, do not produce'. Production for Morris meant actually making things that were useful or beautiful, which for him made whole swathes of the professional middle class mere 'hangers-on'. 'They do not work for the public,' he claims, 'but a privileged class: they are the parasites of property, sometimes, as in the case of lawyers, undisguisedly so; sometimes, as the doctors and others above mentioned, professing to be useful, but too often of no use save as supporters of the system of folly, fraud, and tyranny of which they form a part.' Moreover, the motivation for these professionals was, in his view, 'not the production of utilities, but the gaining of a position either for themselves or their children in which they will not have to work at all', through which they assume 'the proud position of being obvious burdens on the community'. An incendiary critique, it shows the bitter depths of Morris's disillusion with the capitalist system.

CREATED

London

MEDIUM

Printed paper

RELATED WORKS

'The Nature of Gothic' from *The Stones of Venice* by John Ruskin, 1851–53

USEFUL WORK

VERSUS

USELESS TOIL.

BY

WILLIAM MORRIS.

PRICE ONE PENNY.

LONDON :
SOCIALIST LEAGUE PRINTERY,
273, HACKNEY ROAD, N.E.
1891.

The Hammersmith branch of the Socialist League, 1885

For the whole of his adult life, Morris had been in flight from his bourgeois background – in the choice of his marriage partner, in his loathing of the 'swinish luxury of the rich' (*see* page 242) who were such a large part of his client base, and now in determined, ideological opposition to the parliamentary system by which his nation was governed. Taking Marx at his word, he rejected parliamentary politics – a causal factor in his schism with the SDF – in favour of violent revolution as well as educating and organizing the working class whose interests he now sought to champion. In December 1884, he formed the Socialist League, for which he and Belfort Bax wrote an unabashedly Marxist 'Manifesto'. This uncompromising document called for 'a change which would destroy the distinctions of classes and nationalities'. It would have unnerved the bourgeois clients who commissioned Morris to beautify their homes to read the merchant-designer writing about 'the possessing-class, or non-producers', who 'can only live as a class on the unpaid labour of the producers (the workers)', just as we know that it irked him that despite his best efforts even his cheapest wares were beyond the pockets of those producers. However, he meant every word and over the next few years strove mightily to realize his vision of a fairer world.

CREATED

London

MEDIUM

Black and white photograph

Unknown photographer

Flora tapestry, 1885

Courtesy of Whitworth Art Gallery, The University of Manchester, UK/Bridgeman Images

Morris's lectures and essays routinely start with an historical overview on the subject that concerns him, to show his audience that how things currently are is not how they were in the past or had to be in the future. In 'Art and Socialism', a lecture first delivered in early 1884, Morris begins with the proposition that 'whereas there have been times in the world's history when Art held the supremacy over Commerce; when Art was a good deal, and Commerce, as we understand the word, was a very little; so now on the contrary it will be admitted by all, I fancy, that Commerce has become of very great importance and Art of very little'. Given that Morris was highly successful in both fields, his audience would not have demurred at such a claim. Addressing the problem that 'modern civilisation in its haste to gain a very inequitably divided material prosperity has entirely suppressed popular Art', he says that 'in losing an Art that was done by and for the people', those same people had lost what should have been 'the solace of their labour'. The solution was a socialist society promoting 'Association instead of Competition, Social order instead of Individualist anarchy', giving rise to a new era of popular art. Alas, tapestries such as this one were affordable only to a limited clientele, as the dominance of commerce consistently brought Morris into economic conflict with his own ideals.

CREATED

Merton Abbey, London

MEDIUM

Woven wool and silk on a cotton warp

RELATED WORKS

The Forest tapestry by William Morris, Edward Burne-Jones and John Henry Dearle, 1887

William Morris (1834–96), Edward Burne-Jones (1833–98) and John Henry Dearle (1859–1932)

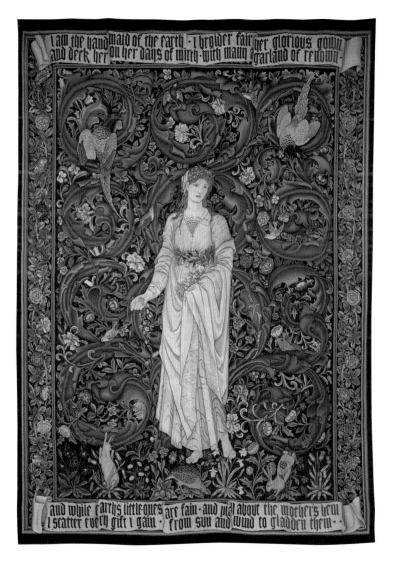

The chintz-printing room, Merton Abbey, 1899

Visitors to the Morris & Co. works at Merton Abbey noticed how much nicer the environment and working conditions were than at other factories of the time. Morris's workers were also better paid than those doing comparable work in other places. One of his heroes was the Welsh mill owner and social reformer Robert Owen (1771–1858), whose New Lanark textile mill in the early nineteenth century had set a standard for decent working and living conditions that challenged the miserable, 'race to the bottom' practices that were normal among mill owners at the time. In a trio of articles for *Justice*, entitled 'A Factory As It Might Be', published between April and July 1884, Morris sets out a vision of the ideal factory which might almost be describing the semi-rural idyll he created at Merton Abbey: a factory of beautiful buildings 'in a pleasant place', which, 'besides turning out goods useful to the community, will provide for its own workers work light in duration, and not oppressive in kind, education in childhood and youth. Serious occupation, amusing relaxation, and mere rest for the leisure of the workers, and withal that beauty of surroundings, and the power of producing beauty which are sure to be claimed by those who have leisure, education, and serious occupation.'

CREATED

London

MEDIUM

Printed page (from *The Life of William Morris* by John William Mackail) reproducing a drawing

Edmund Hort New (1871–1931) (illustrator)

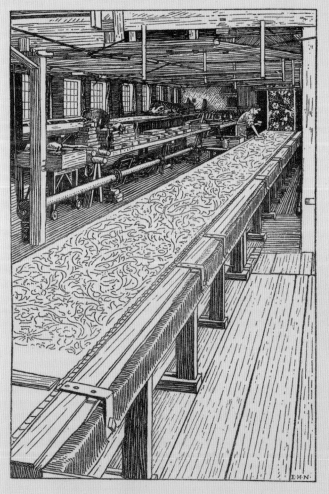

THE CHINTZ-PRINTING ROOM, MERTON ABBEY.

Fritillary wallpaper, 1885

In 'Art and Labour', a lecture given in Glasgow in December 1884, not long before this wallpaper design was conceived, Morris lays out the historic condition of labour, from the chattel slavery of the Classical world to the autonomy and pleasure in labour of the medieval craftsman, to the wage slavery of the modern industrial worker, whom, being 'free to starve', he regards as even more wretched than the chattel slave of ancient Athens or Rome. Recognizing that the modern workman has low expectations of life, Morris addresses him directly, spelling out the conditions necessary for the pleasant life to which he feels every man has a basic right. First is the right 'to live in a pleasant house in a pleasant place', which 'under the profit-grinding system' he says is nigh-on impossible. Second is the right for each to be 'educated according to their capacity, and not according to the amount of money their parents happen to possess'. Third is 'due leisure', the condition of which is 'that the duration of the day's work must be legally limited'. None of these were basic rights or expectations among the working class in the *laissez-faire* world of 1884. All became so over the following century, although, as Morris's historical analysis makes clear, genuine social progress can retreat as well as advance.

CREATED

Merton Abbey, London

MEDIUM

Wallpaper

RELATED WORKS

Foliage wallpaper by John Henry Dearle, 1899

Garden Tulip wallpaper, 1885

Courtesy of Private Collection/Bridgeman Images

'How We Live and How We Might Live', a lecture Morris first gave in November 1884, represents a further expansion of the vision he had been laying out in essays and lectures over several years, in which he pierces the oppressive fog of late Victorian capitalism to glimpse the good society of the future, to which he would give full character in his later novel *News from Nowhere*. 'Fear and Hope,' he says, 'are the names of the two great passions which rule the race of man', whose manipulation enables the present system of perpetual war 'or competition' – of 'rival nations' for territory, 'rival firms' for market domination, and 'rival men' for livelihood – keeping all in a perpetual state of anxiety, driven 'blindly, foolishly ... as if some phantom of the ceaseless pursuit of food which was once the master of the savage was still haunting the civilized man'. However, given the choice he spells out between fear and hope, Morris chooses the simplicity of hope, an irrefutable vision of what makes for a 'decent life': 'a healthy body'; 'an active mind in sympathy with the past, the present, and the future'; 'occupation fit for a healthy body and an active mind'; and 'a beautiful world to live in'. Backing up that last aspiration were designs like this one, created the following year.

CREATED

Merton Abbey, London

MEDIUM

Wallpaper

RELATED WORKS

Norwich wallpaper by John Henry Dearle, 1889

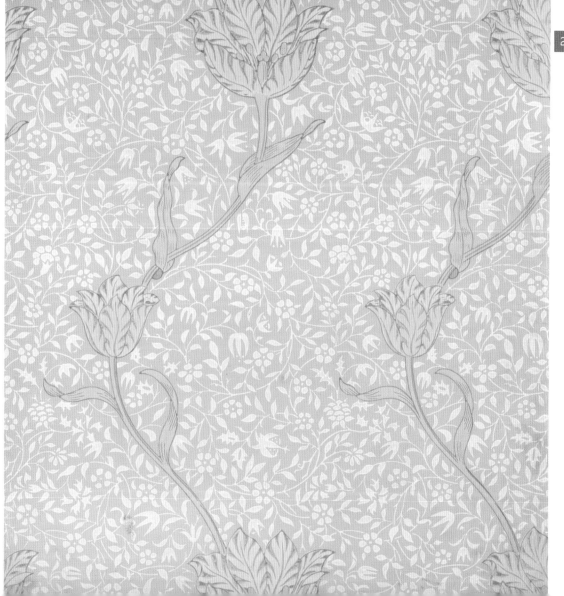

The Woodpecker tapestry, 1885

With customary energy and vigour, in early 1885 Morris threw himself into the activities of the organization he had founded, the Socialist League, attending committee meetings, speaking at open-air events in the East End organized by the League and lecturing all over the country to try and instil the vital consciousness of class without which revolution would never happen. In February, he also started the League's own paper, *Commonweal*, which would become by far the most important English socialist newspaper of the following decade, and for which Morris would write or co-write some 400 individual pieces in the five years he was editor, between 1885 and 1890. These included 'The Manifesto of the Socialist League' for the very first issue, as well as essays, reviews and a column on current events called 'Notes on News'. *Commonweal* also featured pieces by some of the leading socialist thinkers, including Friedrich Engels (1820–95), co-author of *The Communist Manifesto* almost 40 years earlier, and the young George Bernard Shaw (1856–1950), a regular in Morris's intimate circle of the time. As with the SDF's *Justice*, Morris would be seen around the centre of London, wearing sandwich boards and selling copies of the newspaper to any member of the public who took an interest. For most people, so much political activity would have been an exhausting schedule, but he still found time and energy to design exquisite tapestries such as this one.

CREATED

Merton Abbey, London

MEDIUM

Tapestry

RELATED WORKS

Tree Portière tapestry by John Henry Dearle, *c.* 1909

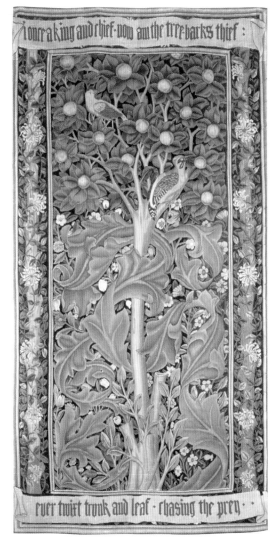

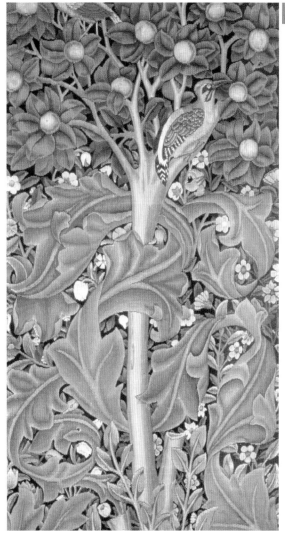

Lea furnishing textile, 1885

Throughout 1885, the year in which Morris added this design to his series inspired by tributaries of the Thames, police in London used deliberately intimidating methods to break up the meetings of socialist groups. On 20 September, in defence of freedom of speech, a crowd some 10,000-strong came together at Dod Street in Stepney, East London, to be addressed by speakers from both the SDF and its rival, the Socialist League. Police arrested eight people, who appeared in court the following day, where Morris stood bail. A kerfuffle broke out, Morris was arrested for disturbance and then immediately pardoned by the magistrate, ostensibly because of the renowned designer's social standing. Then the following winter, on 8 February 1886, a mass riot at a meeting of unemployed men in Trafalgar Square, which Morris did not attend, grew quickly out of control. There was widespread damage and looting of West End shops, with Morris's own Oxford Street store fortunate to avoid being targeted. However, such was his opposition to the 'profit-grinding' capitalist system in which he felt obliged to participate that Morris approved of the violence, writing to a friend that 'any opposition to law and order in the streets is of use to us, *if the price is not too high*'. In the end, personal experience of the reality of violence would test that conviction to exhaustion before two more years had passed.

CREATED

Merton Abbey, London

MEDIUM

Printed cotton

RELATED WORKS

Florence printed velveteen by John Henry Dearle, *c.* 1890

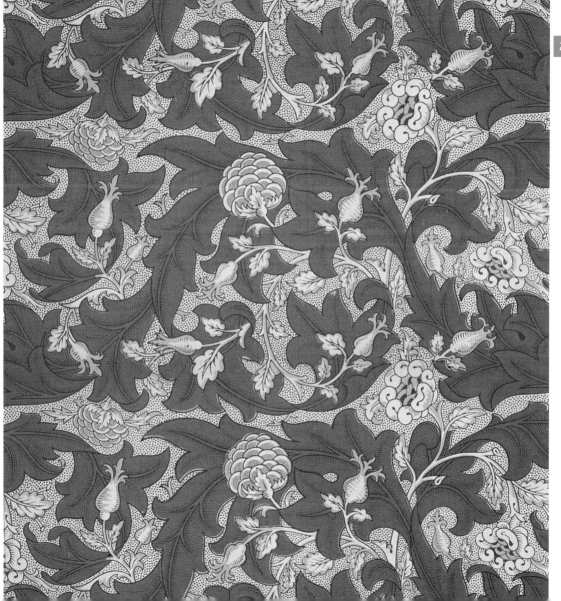

Design for *Avon Chintz, c.* 1886

Courtesy of William Morris Gallery, Walthamstow, UK/Bridgeman Images

Being editor of *Commonweal* gave Morris the chance to put across his ideas in print in the full range of literary forms he had mastered. So, from January 1885 to May 1886, around the time this textile pattern was conceived, he published a cycle of narrative poems entitled *The Pilgrims of Hope*. Morris's poetry was so well regarded that in 1877 he had been offered the Chair of Poetry at Oxford, but declined. In 1892, upon the death of Tennyson, he would also turn down the post of Poet Laureate. However, here, in place of the mythical escapism of *The Earthly Paradise* which had made his name, Morris's new cycle is set amid events of recent history – the Paris Commune of 1871 – when for a brief period, a socialist, revolutionary government took control of the French capital. However, poetry in *Commonweal* was mixed with hard analysis such as 'Socialism From The Root Up', the 23-part Marxian history that Morris co-wrote with Belfort Bax, serialized over a two-year period from May 1886. And from November 1886 until January the following year came the 12 chapters of *A Dream of John Ball*, his time-travelling novella about a rebel priest in The Peasants' Revolt of 1381, who in preaching to the serfs about the injustice they endure echoes the role that Morris had chosen for himself.

CREATED

London

MEDIUM

Pen and ink with watercolour on paper

RELATED WORKS

Design for *Evenlode* printed textile, 1883

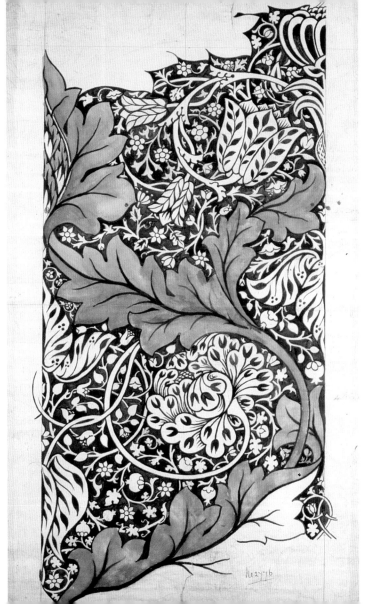

Bloody Sunday, 1887

From January to April 1887, during what by his own standards was already a period of frenetic political and creative activity, Morris kept what he called a 'Socialist Diary', only abandoning it presumably because this new undertaking was too much even for him. However, for three months we get fascinating glimpses of the private thoughts of this very public figure, whose every utterance was otherwise intended for the widest possible audience. His commitment to the socialist revolution is fierce, but in one entry even Morris shows signs of class bias, despairing of those he is trying to persuade, commenting that the audience for one lecture 'seem to me a very discouraging set of men', and that 'The frightful ignorance and impressibility of the average English workman floors me at times.' These were private doubts, which did not deflect him from the urgent need for revolution or from endorsing the insurrectionary means to bring it about. However, with unrest in England having continued throughout 1886 and the following year, and with police tactics becoming ever more brutal, on 13 November 1887 – in a peaceful mass protest in London known as Bloody Sunday (*see* also page 88) – Morris was personally caught up in events that would shake his conviction about the effectiveness of extra-parliamentary methods.

CREATED

London

MEDIUM

Wood engraving

RELATED WORKS

The Peterloo Massacre by George Cruikshank, 1819

Unknown contemporary engraver

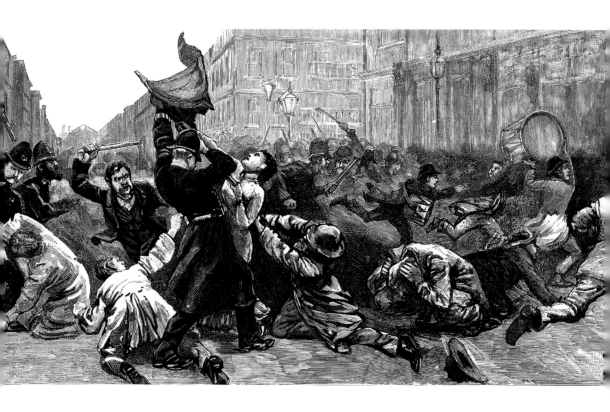

Foliage tapestry, c. 1887

This paradisical design gives no hint of the social and political tumult in which Morris became embroiled during the course of 1887. In 'The Policy of Abstention', a lecture given in July at a meeting of the Hammersmith branch of the Socialist League, Morris calls himself a communist and in that vein makes an explicit attack on the idea of meritocracy: the belief that to those with the greatest gifts or capacity should go the greatest share of rewards. He rejects the notion that an individual should work quite naturally for a better future for themselves and their family, saying that 'the due exercise of one's energies for the common good and capacity for personal use we say form the only claims for the possession of wealth, and the right of property, the only safeguard against fresh privilege'. It is an idea of labour and social action based on selflessness – one that we know sat uneasily on the lips of a man born to privilege himself, who in adult life became a businessman supposedly obliged to adopt the model of 'profit-grinding' he so despised. He declares 'the aim of Socialism to be equality of condition', anchored in notions of significant redistribution and the state provision of basic material rights that almost no one espouses any longer to this extent, either between countries or within them, as nations have gradually slid back to the economic model of Morris's day.

CREATED

Merton Abbey, London

MEDIUM

Tapestry

RELATED WORKS

Acanthus and Vine tapestry, 1879

Willow Bough wallpaper, 1887

In his 1885 lecture 'The Hopes of Civilization', Morris conjures a vision of medieval England, which for all its obvious flaws seems preferable to the same country 400 years later. In Morris's reckoning, although in the Middle Ages 'the robbery of the workers, thought necessary then as now to the very existence of the State, was carried out quite crudely without any concealment or excuse by arbitrary taxation or open violence: on the other hand, life was easy, and common necessaries plenteous; the holidays of the Church were holidays in the modern sense of the word, downright play-days, and there were ninety-six obligatory ones: nor were the people tame and sheep-like, but as rough-handed and bold a set of good fellows as ever rubbed through life under the sun.' Echoing the arcadian vision evoked by designs such as this classic wallpaper, he imagines an English Golden Age: 'the many chases and great woods, the stretches of common tillage and common pasture quite unenclosed; ... the scarcity of bridges, and people using ferries instead, or fords where they could; the little towns, well bechurched, often walled; the villages just where they are now ... but better and more populous', and much else besides. And, with a hint of despair, he wonders what English people in the future, descendants of those alive in his own time, will make of his society.

CREATED

Merton Abbey, London

MEDIUM

Wallpaper

RELATED WORKS

Oak Tree wallpaper by John Henry Dearle, 1896

Golden Bough furnishing textile, 1888

Morris saw wealth as waste – money spent by people who had too much of it on mere luxuries whose production was itself a waste of labour that could be put to more productive use, when so many in his own society lacked the bare necessities of life. In his 1888 lecture 'True and False Society', given the same year as this textile was designed, he skewers what he sees as the phoney refinement of the Victorian bourgeoisie, whom in his day job he was obliged to serve: 'apart from reasonable comfort and real refinement' he says, ' there is... a vast amount of sham wealth and sham service created by our miserable system of rich and poor, which makes no human being the happier, on the one hand, while on the other it withdraws vast numbers of workers from the production of real utilities, and so casts a heavy additional burden of labour on those who are producing them.... I hold that this sham wealth is not merely a negative evil ... but a positive one. It seems to me that the refined society of to-day is distinguished from all others by a kind of gloomy cowardice.... He who runs may read the record of the unhappy rich not less than that of the unhappy poor in the futility of their amusements, and the degradation of their art and literature.'

CREATED

Merton Abbey, London

MEDIUM

Woven silk and linen

RELATED WORKS

Crown Imperial woven fabric by William Morris, 1876

John Henry Dearle (1859–1932)

Carpet for Wightwick Manor, *c.* 1890s

Courtesy of Andreas Von Einsiedel/The National Trust Photolibrary/Alamy Stock Photo

The brutal suppression of the protest of Bloody Sunday by more than 2,000 police and a regiment of cavalry, resulting in hundreds of injuries among protestors, had a chilling effect on the appetite among British socialists for direct action. As a result, key members who now favoured the parliamentary route to power resigned from the Socialist League over the next few years, including whole branches, such as Bloomsbury, and Morris's intellectual partner, Ernest Belfort Box. At the same time, the League was infiltrated by anarchists whose refusal of all but the most extreme tactics outdid even Morris's revolutionary zeal. In 1890, this faction gained control of the organization's ruling council and removed Morris from his position as editor of *Commonweal*. A month or two later, the 100 or so members of the Hammersmith branch which had always met at Kelmscott House – by far the largest group – promptly withdrew from the League, just as Morris withdrew the financial support he had always given, which by this point amounted to some £500 per annum. The organization staggered on, but *Commonweal* was now run by people who openly advocated murder, and when they did so in print in 1892, the editor, the anarchist David Nicholls, was tried and sentenced to 18 months' hard labour.

CREATED

Merton Abbey, London

MEDIUM

Hand-knotted woollen pile on cotton warp

RELATED WORKS

Rounton Grange carpet by William Morris, *c.* 1881–82

Socialist banner, 1890s

Courtesy of William Morris Gallery, London Borough of Waltham Forest

With Morris's local branch still loyal to him, a decision was made to rename it the Hammersmith Socialist Society under a 'Statement of Principles' which Morris himself drafted in December 1890. These set out the basic tenets of socialism and include an explicit rebuke to the anarchists who had wrecked the Socialist League: 'The idea put forward by some who attack present society, of the complete independence of every individual, that is, for freedom without society, is not merely impossible of realization, but, when looked into, turns out to be inconceivable.' Recognizing the need for a pragmatic, unified socialist force, the Hammersmith Socialist Society voted to join forces with the Fabian Society and the SDF, still under Hyndman. Yet another document of founding principles was drawn up – 'The Manifesto of the English Socialists' – in this case by Morris, Hyndman and George Bernard Shaw, but by then the Independent Labour Party (ILP) had already been formed by similar organizations in the north of England, and in late 1892 three of its candidates were elected to Parliament. The future of socialism in Britain lay with them, as Morris was quick to recognize. For their part, acknowledging his own enormous contribution to the movement, the ILP invited Morris to take a leading role in the party, which he declined.

CREATED

London

MEDIUM

Painted and embroidered silk

RELATED WORKS

Banner of the Hammersmith Socialist Society by William Morris, 1890s

William Morris (1834–96) **and Edward Burne-Jones** (1833–98)

Kelmscott Manor in the frontispiece to *News from Nowhere*, 1893

Courtesy of Private Collection/Bridgeman Images

Morris's utopian novel *News from Nowhere* was serialized in *Commonweal* throughout 1890. In one sense a summary of his political thinking of the previous decade, in the novel this is integrated within the kind of fluent narrative which had characterized his writing throughout his life. The story is set in London and the Thames Valley, its protagonist, William Guest, an obvious proxy for Morris, with his membership of 'the League' and a home on the Thames at Hammersmith. Waking one morning to find himself in familiar surroundings, it soon occurs to him that something has changed. The men and women he meets are dressed like people from the fourteenth century and are happy and kind, quite unlike the majority from his own time, the industrial, capitalist late nineteenth century. Slowly, he sees that he has travelled through time, though not, despite appearances, to some idyllic moment in the past but to an ideal future rooted in the best aspects of life in the medieval period. No one is poor or works too hard, though there is enough food for all. Women and men are equal. Everyone shares in the labour that must be done, meaning no one need do much of it, leaving most of their time free for the pleasant practice of handicrafts and other stimulating pursuits.

CREATED

London, England, UK

MEDIUM

Woodcut

RELATED WORKS

The Prayerbook of Edward VII (title page and frontispiece) by Charles Robert Ashbee, Essex House Press, 1903

Charles March Gere (1869–1957) and **William Morris** (1834–96) (lettering and border)

THIS IS THE PICTURE OF THE OLD HOUSE BY THE THAMES TO WHICH THE PEOPLE OF THIS STORY WENT ❧ HEREAFTER FOLLOWS THE BOOK IT-SELF WHICH IS CALLED NEWS FROM NOWHERE OR AN EPOCH OF REST & IS WRITTEN BY WILLIAM MORRIS ❧❀

Pages from *The Earthly Paradise*, 1896–97

Courtesy of The University of South Carolina

In the last part of *News from Nowhere*, published like works such as *The Earthly Paradise* by his own Kelmscott Press, the main protagonist travels upriver by rowing boat to the upper reaches of the Thames, to a 'many-gabled old house', whose exterior he describes in rapturous terms. Morris is clearly writing of his own bucolic Shangri-La, Kelmscott Manor, as many interior details also match the décor which over the years he had added to the house. However, the harmonious society to which the protagonist has literally and politically awoken, which it gradually occurs to him is in the twenty-second century, was not achieved without a fight. Before embarking on his river journey, he is taken to meet one of the few in the new world who concerns himself with history – a man named Old Hammond, who lives amidst the faded grandeur of what was once the British Museum. In answer to the protagonist's questions, Hammond spends multiple chapters describing the happy social conditions of this future England rooted in the past – a pre-industrial proto-communist society with all the best attributes of the medieval period. However, in the novel's central chapter, 'How the Change Came', he then describes the violent revolution from the mid-twentieth century which brought about the new peace – the kind of uprising that Morris, like Marx, believed was the necessary agent of fundamental social change.

CREATED

London

MEDIUM

Original limp vellum, green linen ties

RELATED WORKS

Illustrations by Charles Robert Ashbee for *Prometheus Unbound* by Percy Bysshe Shelley (Essex House Press), 1904

THE DOOM OF KING ACRISIUS.
ARGUMENT. ✿ ACRISIUS, KING OF
ARGOS, BEING WARNED BY AN
ORACLE THAT THE SON OF HIS
DAUGHTER DANAE SHOULD SLAY
HIM, SHUT HER UP IN A BRAZEN
TOWER BUILT FOR THAT END BE-
SIDE THE SEA: THERE, THOUGH
NO MAN COULD COME NIGH HER,
🌿 SHE NEVERTHELESS BORE A
SON TO JOVE, AND SHE AND HER
NEW-BORN SON, SET ADRIFT ON
THE SEA, CAME TO THE ISLAND
OF SERIPHOS. THENCE HER SON,
GROWN TO MANHOOD, SET OUT
TO WIN THE GORGON'S HEAD, &
ACCOMPLISHED THAT END BY
THE HELP OF MINERVA; & AFTER-
WARDS RESCUED ANDROMEDA,
DAUGHTER OF CEPHEUS, FROM A
TERRIBLE DOOM, AND WEDDED
HER. COMING BACK TO SERIPHOS
HE TOOK HIS MOTHER THENCE,
& MADE FOR ARGOS, BUT BY STRESS
OF WEATHER CAME TO THESSALY,
& THERE, AT LARISSA, ACCOM-
PLISHED THE PROPHECY, BY UN-
WITTINGLY SLAYING ACRISIUS.
IN THE END HE FOUNDED THE
CITY OF MYCENÆ, & DIED THERE.

NOW of the King Ac-
risius shall ye hear,
🌿 Who thinking he
could free his life from
fear 🌿 Did that which
brought but death on
him at last. 🌿 In Ar-
gos did he reign in days
long past, 🌿 And had
one daughter, fair as
man could see,
Called in the ancient stories Danaë;
But as her fairness day by day grew more,
Unto his ears came wandering words of lore,
Which bade him wot that either soon or late
He should be taken in the toils of fate,
And by the fruit of his own daughter's womb
Be slain at last, and set within his tomb;
And therefore heavy sorrow on him fell,
That she whom he was bound to love so well
Must henceforth be his deadliest dread & woe.

LONG time he pondered what
were best to do;
And whiles he thought that he
would send her forth
To wed some king far in the snowy north,
And whiles that by great gifts of goods & gold
Some lying prophet might be bought and sold
To swear his daughter he must sacrifice,
If he would yet find favour in the eyes

A Garland for May Day, 1895

This poster was produced by Morris's friend Walter Crane (1845–1915), one of the great book illustrators of his day and a committed socialist who drew cartoons for *Commonweal*, *Justice* and another socialist paper, the *Clarion*. In an article entitled 'May Day', which appeared in *Justice* on International Workers' Day in 1896, Morris once again condemns capitalism as a system of profit and waste. However, for Morris, as for Marx, the struggle for socialism had to be international in outlook to succeed, so Morris identifies the global ways in which capitalism undermines 'the spread of Socialism all over the civilized world'. Morris was a man of his own time as well as a future-seeking visionary, so his choice of words reflects the ignorance of his society. However, there is no doubting his solidarity with the workers of the world when he points out that, 'the whole capitalist world is stretching out long arms towards the barbarous world and grabbing and clutching in eager competition at countries whose inhabitants don't want them; nay, in many cases, would rather die in battle, like the valiant men they are, than have them'. And he exhorts all men to 'produce no more for profit but for *use*, for *happiness*, for LIFE'.

CREATED

London

MEDIUM

Lithograph

RELATED WORKS

The Capitalist Vampire lithograph by Walter Crane, 1904

Walter Crane (1845–1915)

THE CAUSE OF LABOUR IS THE HOPE OF THE WORLD

SOLIDARITY OF LABOUR

THE SOCIALIST IDEAL

WORKMEN OF ALL COUNTRIES UNITE

PRODUCE & ENJOY ART

HOPE IN WORK & JOY IN LEISURE

PRODUCTION FOR USE NOT FOR PROFIT

COOPERATION & EMULATION NOT COMPETITION

NO CHILD-TOILERS

SHORTEN WORKING DAY & LENGTHEN LIFE

THE PLOUGH IS A BETTER BACKBONE THAN THE FACTORY

ENGLAND SHOULD FEED HER OWN PEOPLE

NO PEOPLE CAN BE FREE WHILE DEPENDENT FOR THEIR BREAD

THE LAND FOR THE PEOPLE

MERRIE ENGLAND

· A · GARLAND · FOR · MAY · DAY · 1895 ·

· DEDICATED · TO · THE · WORKERS · BY · WALTER · CRANE ·

Binding by Doves Bindery for the Kelmscott Chaucer, 1896

Courtesy of Fitzwilliam Museum, University of Cambridge, UK/Bridgeman Images

When Morris died on 3 October 1896 – just months after publication of the 'Kelmscott Chaucer', perhaps his greatest artistic achievement – he was widely mourned by friends and those in the many fields in which he had made an indelible mark. The newspapers reflected the public's view of him still, as a poet, even getting on for three decades since publication of *The Earthly Paradise*, the work which earned him that reputation. His work as a designer was also mentioned, though even then it was still overshadowed by his early writing. His politics, so completely out of step with the England of his time – of almost any time – were dismissed as mere 'sentimental Socialism' of a kind that was of little use to the working people he was trying to help. However, socialists themselves reacted with as much, if not more, genuine emotion as anyone who had known him; perhaps they felt he had given the very best part of himself, at considerable cost to his own health, in a cause that few Englishmen have ever pursued with such unshakeable tenacity and commitment. The editor of the *Clarion*, Robert Blatchford (1851–1943) spoke for many in writing, 'I cannot help thinking that it does not matter what goes into the *Clarion* this week, because William Morris is dead ... he was our best man, and he is dead.'

CREATED

London

MEDIUM

Pigskin

RELATED WORKS

Les Arts au Moyen Âge, published by Firmin Didot, 1873

William Morris

Arts & Crafts

Spring and *Autumn*, Cragside, *c.* 1873

Spring and *Autumn* were two of the four seasonal windows (for the inglenook fireplace in the dining room) among other elements designed by Morris, Marshall, Faulkner & Co. for the expansion of Cragside near Rothbury in mid-Northumberland. Originally a modest shooting lodge dramatically sited on a moorland crag, it was built for armaments manufacturer William Armstrong (1810–1900) in the years 1862–64, then extended from 1869 to designs by the Arts and Crafts architect Richard Norman Shaw (1831–1912). Belying its Tudor Revival style, Cragside was in fact one of the most technologically advanced houses of the period, with its own hydroelectric power station – then a ground-breaking idea – served by five new lakes created for that purpose. Morris, Rossetti, Burne-Jones, Webb and Brown all designed windows for Cragside, including the pair illustrated. Like Morris, Shaw trained in the office of G.E. Street; unlike him, he remained an architect, designing numerous private houses that made use of vernacular elements, a key feature of the Arts and Crafts aesthetic. Shaw was also responsible for the houses of Bedford Park in west London, effectively the first garden suburb, an idea that stemmed from the Arts and Crafts Movement and its resistance to the oppressive, commercial rationalism of industrial modernity.

CREATED

London

MEDIUM

Stained glass

RELATED WORKS

Tristan and Isolde windows at Harden Grange by William Morris et al., 1861

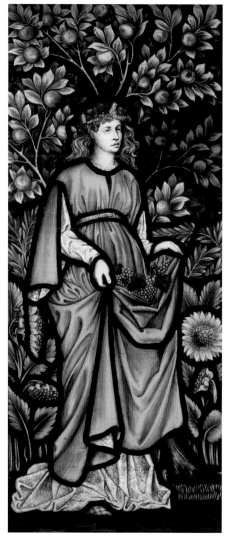

Swan, Rush and Iris dado design, 1877

Walter Crane adopted mirror symmetry for this wallpaper design around the same time as Morris began exploring it in his own work. A decade later, Crane was the first president of the Arts and Crafts Exhibition Society, founded in London in March 1887. The society was set up to promote the work of decorative rather than fine artists, but its members also had deeper motives than the mere need to sell their products. Crane was one of the foremost book illustrators and flat-pattern designers of the late nineteenth century, but he was also committed to the socialist cause and believed, like Morris, that a democratized decorative art should play a crucial role in establishing the happy and equal society he wanted to see. Also like Morris, he gave lectures to the Socialist League and designed the illustrations – often including a distinctive 'Angel of Freedom' – which adorn the covers of the various pamphlets and other publications of the Social Democratic Federation and then the League. Moreover, he designed a number of banners which the League and its successor, the Hammersmith Socialist Society, would carry with them on marches and demonstrations. The Arts and Crafts Exhibition Society held its first show at the New Gallery in London's Regent Street in October 1888, and Crane remained its President until 1891, whereupon Morris assumed the role, having at first been sceptical about an organization his example and his work had inspired.

CREATED

London

MEDIUM

Wallpaper

RELATED WORKS

Design for *Owl* wallpaper by Charles Francis Annesley Voysey, *c.* 1897

Walter Crane (1845–1915)

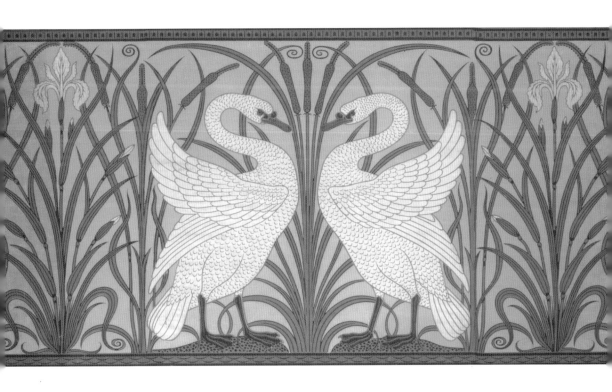

Dining chair, *c.* 1882

Courtesy of Granger/Bridgeman Images

The Arts and Crafts Movement thrived above all in the various groups that were formed with aims based on the social and aesthetic ideas of Ruskin and Morris. The first of these was the Century Guild, established in London in 1882 by the architect and designer Arthur Heygate Mackmurdo (1851–1942). Mackmurdo had travelled to Italy as a young man with the much older Ruskin, and later met Morris in London, whom he emulated by teaching himself various craft disciplines, such as carving, embroidery and cabinet-making – experiences that gave him the confidence to design audacious pieces like this classic chair. The aim of the Century Guild was to forge a 'Unity of Art', with 'all branches of Art no longer the sphere of the tradesman but of the artist', restoring 'building, decoration, glass-painting, pottery, wood carving, and metal to their right place beside painting and sculpture'. From 1884, the Guild also published its own quarterly magazine, *The Hobby Horse*, which featured contributions from luminaries such as Ruskin, Oscar Wilde (1854–1900) and Christina Rossetti (1830–94), but whose most lasting influence was the emphasis of its young chief editor, Herbert Horne (1864–1916), on graphic design. The Century Guild was in fact a short-lived venture, which had more or less collapsed by the time of the first Arts and Crafts Exhibition, but it offered a template for the other collectives that followed.

CREATED

London

MEDIUM

Mahogany and leather

RELATED WORKS

High-backed chair by Charles Rennie Mackintosh, *c.* 1897

Arthur Heygate Mackmurdo (1851–1942)

Swan chair, 1883–85

Courtesy of The Cheltenham Trust and Cheltenham Borough Council/Bridgeman Images

The architect and designer Charles Francis Annesley Voysey (1857–1941) designed more than 120 houses, with a style derived from English vernacular architecture, such as at Broad Leys on Lake Windermere in Cumbria. His houses were widely published not only in Britain but abroad, too, leading to the development of an international Arts and Crafts style in places such as the USA, and in mainland Europe influencing the emerging styles of Art Nouveau and Jugendstil. His wallpaper patterns, which made him a lot of money, exhibit the influence of Morris in the rough simplicity (as perceived at the time) of their repeating motifs, while the shadow of the older man can also be felt in essays such as 'Ideas and Things', published in 1909, which discusses the value of human as opposed to machine labour at some length. 'We may make doors and windows, chairs and tables with mechanical exactness,' Voysey writes, 'and be paid in coin in exchange, but neither we nor those who pay for it will gain any spiritual benefit from our labour unless we put our heart and minds into our work, anxiously seeking to impart some good thought and healthy feeling.' The design of this chair imparts a liquid sensuosity that clearly anticipates Art Nouveau.

CREATED

London

MEDIUM

Oak

RELATED WORKS

Bentwood chair by Michael Thonet, *c.* 1860s

Charles Francis Annesley Voysey (1857–1941)

Three-fold screen with acanthus leaves, tulips and roses, late nineteenth century

By the later 1880s, Morris had taken on the status of guru for the younger generation of English designers, whose admiration for him was utterly unqualified. This reverence was encapsulated in 1888 by the influential Arts and Crafts architect John Dando Sedding (1838–91), who, in Morris's presence at a meeting in Liverpool of the National Association for the Advancement of Art and its Application to Industry, apparently spoke for the whole assembly in saying: 'The one man who above all others has inspired hope and brought life and light into modern manufactures is William Morris. And this because, a very giant in design, cultured at the feet of antiquity, learned in the history of art, rich in faith, prodigal of his strength, he has united in his own person the two factors of Industrial Art which before were divided – design and craftsmanship. Fancy what a year of grace it were for England if our industries were placed under the guiding hand of "one vast Morris". Fancy a Morris installed in every factory – the Joseph of every grinding Pharaoh. The battle of the industries were half won!' Equally, by imparting his skills and values to those who knew him such as Dearle, who was probably involved in designing this three-fold screen, the influence of that giant in design spread across Britain and beyond, shaping the attitudes of an entire generation that followed.

CREATED

London

MEDIUM

Panels embroidered in silk, within a glazed mahogany frame

RELATED WORKS

Embroidered screen by Arthur Heygate Mackmurdo, 1884

William Morris & Co.

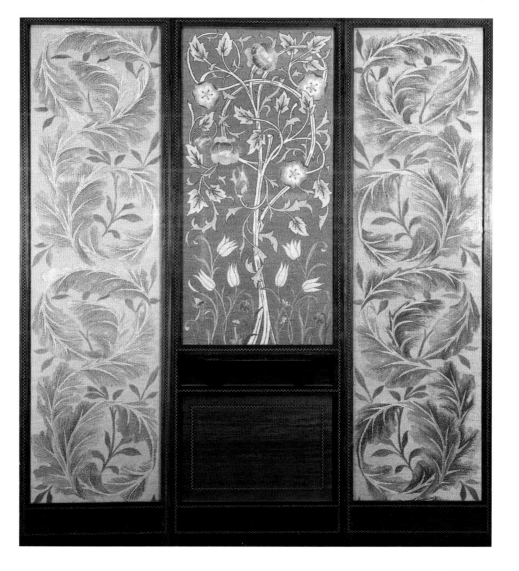

297

Interior of Wightwick Manor, Staffordshire, *c.* 1887–93

Wightwick Manor – a vernacular half-timbered Victorian manor house near Wolverhampton, though not strictly an Arts and Crafts house – was designed by the architect Edward Ould (1852–1909) for the paint and varnish manufacturer Theodore Mander (1853–1900), and built in two phases between 1887 and 1893. The interior drew on the talents of a large number of the leading designers of the Arts and Crafts Movement, including many of the leading names who worked for Morris & Co. Of wallpapers alone, the Manders chose 30 designs by Morris himself, plus 17 by Dearle, three by Morris's daughter May and four by other designers. There are also Morris & Co. fabric wall coverings and soft furnishings, furniture, metalwork and stained glass, tiles by William De Morgan and a Morris hand-knotted carpet 4.6 m (15 ft) square in the Oak Room pictured. Morris's design style was so distinctive that the company was sometimes given more or less a free hand when a client was sufficiently enamoured of the Morris aesthetic to trust it with a whole house interior. However, the Manders had enough confidence in their own aesthetic vision that they bought everything either through the catalogue or directly from the Oxford Street shop of Morris & Co.

CREATED

Wolverhampton

MEDIUM

Interior design

RELATED WORKS

Stanmore Hall, Stanmore, Middlesex by Morris & Co., 1888–96

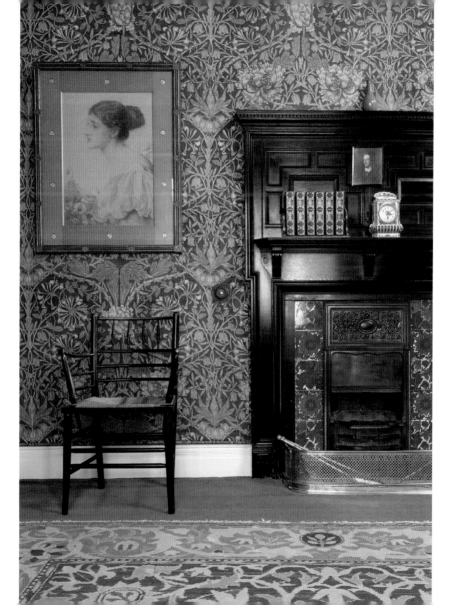

Bullerswood carpet, 1889

The huge *Bullerswood* carpet – 7.5 m (25 ft) long by 4 m (13 ft) wide – was Morris's last and probably greatest carpet design, although one that may have been a collaboration with Dearle, who had grown rapidly in confidence throughout the 1880s. It was one of two woven in 1889, to a commission from the wool trader John Sanderson for his house, Bullerswood, at Chislehurst in Kent. Of the two carpets, one was for the hall, with the other – this one – for the main drawing room, where it seems Morris exerted tight control over how the room was decorated and furnished, apparently with the owners' consent. Four years later, in 1893, the same owners allowed the carpet to be exhibited at the Fourth Arts and Crafts Exhibition in London. The first three had been held every year between 1888 and 1890, but the third was financially disastrous, so in 1891 Morris stepped up himself, as he often did, assuming the role of president of the Arts and Crafts Exhibition Society. The decision was subsequently taken that, rather than having annual shows, they would limit the frequency of exhibitions to those times when enough work of sufficient quality had been amassed, so as not to compromise the high standards for which the society stood.

CREATED

London

MEDIUM

Hand-knotted woollen pile on a cotton warp

RELATED WORKS

Holland Park carpet by William Morris, 1883

William Morris (1834–96) and **John Henry Dearle** (1859–1932)

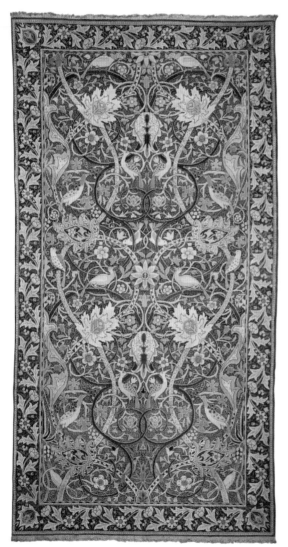

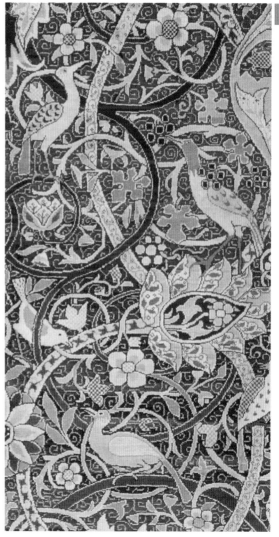

Occasional table, *c.* 1890

George Washington Jack (1855–1931) was born in New York to Scottish parents but immigrated to Glasgow at a young age when his mother returned home after Jack's father died. Here he trained as an architect before moving to London in 1880 and securing a position as assistant to Philip Webb. Jack's versatile talent soon became apparent to the ever-perceptive Webb, and before long he was designing for Morris & Co. In 1900, Webb retired and Jack took over his practice, designing furniture, mosaics, embroidery, stained glass and metalwork in the years that followed. By this period he was a longstanding member of the Art Workers' Guild and the Arts and Crafts Exhibition Society. He was also an excellent wood carver and taught the subject at the Central School of Arts and Crafts in London; from 1900, he also taught at the Royal College of Art. He made finely detailed, painted wood carvings of medieval figures – knights on horseback, ladies in castles – and in 1903 published an important book on the discipline, *Wood Carving: Design and Workmanship*. The unusual, elegant occasional or side table pictured here was also manufactured in mahogany, an example of which was shown at the Second Arts and Crafts Exhibition in 1889.

CREATED

London

MEDIUM

Walnut

RELATED WORKS

Round table by Philip Webb, *c.* 1860

George Washington Jack (1855–1931)

Homestead and the Forest cot quilt, 1890

Courtesy of Kelmscott Manor, Oxfordshire, UK/Bridgeman Images

Being the talented child of one of the great creative men of his age conferred both advantages and disadvantages. May Morris showed a great aptitude for embroidery from a very young age, with encouragement from her father and hands-on tuition from both her mother, Jane, and her aunt, Bessie Burden. She went on to study textile arts at the South Kensington School of Design, which later became the Royal College of Art. Having completed her course, aged just 23, she was appointed supervisor of the embroidery department of Morris & Co., a role her mother had filled before her. This quilt was embroidered for Kelmscott Manor, where May also executed what many regard as her *tour de force*, the embroidered hangings she made for Morris's own four-poster bed (*see* page 88), which were shown at the Fourth Arts and Crafts Society Exhibition in 1893. Although May never quite stepped out of her father's shadow, as her reputation grew as both designer and embroiderer she was invited to teach, from 1897, at the London County Council Central School of Art in London, before leading its embroidery department from 1899 to 1905. In 1907, still prevented from joining the Art Workers' Guild, which did not admit women, she established the Women's Guild of Arts with embroiderer Mary Elizabeth Turner (1854–1907).

CREATED

Kelmscott

MEDIUM

Embroidery on silk

RELATED WORKS

Owl hanging by John Henry Dearle, *c.* 1895

May Morris (1862–1938) **and Jane Morris** (1839–1914)

Wistaria, c. 1890

In his early career, Lewis Foreman Day (1845–1910) worked for a number of different manufacturers and established a strong reputation as a designer of stained glass, textiles, wallpapers, pottery, carpets and even painted leather panels, as in the case of this piece. In 1882, with Walter Crane he formed a group called The Fifteen – set up to debate ways of reviving the decorative arts – which two years later merged with another group, the St George's Art Society, to form the Art Workers' Guild. In his lifetime, Day was a leading figure in the Arts and Crafts Movement who, like Crane, was closely associated with Morris. He was also a noted educator of the next generation of designers, delivering lectures on art and design through the Royal Society of Arts, which became the basis of a number of influential books he published on the subject. His vision of the importance of art to society stemmed from a feeling similar to Morris – though more optimistic – that the urge to decorate our environment was an inescapable aspect of being human. In the chapter 'On Ornament' in his book *Some Principles of Every-day Art* (1890), he writes that 'every day and all day long we breathe the atmosphere of ornament. There is no escape from its influence.... And we can scarcely conceive a "coming race" without ornament.'

CREATED

London

MEDIUM

Painted leather

RELATED WORKS

Five-panel embroidered screen by Walter Crane, 1876

Lewis Foreman Day (1845–1910)

Two-handled vase, *c.* 1890

William De Morgan began decorating pottery for Morris, Marshall, Faulkner & Co. in 1863 and continued to design ceramics for the Firm for decades afterwards. Like others who came later, he was encouraged by Morris himself, and had soon set up his own workshop, a forerunner of similar ventures associated with the younger Arts and Crafts practitioners who came of age in the 1880s. His first workshop, in Fitzroy Square in London's West End, caught fire after De Morgan lost control of one of his early experiments. Moving to new premises in Chelsea in the early 1870s, he carried on undaunted, researching new glazes and pigments while fulfilling commissions for Morris & Co. Having worked initially as a stained-glass designer, De Morgan became fascinated by the iridescence that resulted whenever streaks of silver were overfired, which led to his revival of the ancient technique of lustre decoration, involving metal oxides being added to glazes applied to pottery items before final firing. By the 1880s, De Morgan was a major figure in the growing Arts and Crafts Movement. However, he also remained closely tied to Morris and was instrumental in finding the premises at Merton Abbey, where he, too, moved his business, building his own kilns alongside the workshops of Morris & Co. He subsequently moved to premises in Fulham in 1888, producing pieces like this classic vase.

CREATED

Fulham, London

MEDIUM

Earthenware with lusterware glaze

RELATED WORKS

Vase by Walter Crane, 1906

William De Morgan (1839–1917)

Daffodil Chintz furnishing textile, 1891

Courtesy of Private Collection/Bridgeman Images

By the time this textile was designed, Dearle, still barely 30, had assumed the role of chief designer at Morris & Co. Six years later, upon the death of Morris himself, he became the company's art director, a position he would hold until his retirement in 1932. He began as an assistant at the Morris & Co. shop on London's Oxford Street, but before long had switched to the glass-painting workshop in Queen Square, where Morris recognized his talent for drawing and took him under his wing. By the time of the move to Merton Abbey, Dearle was starting to train apprentices in executing the tapestry designs that Morris began to produce in the early 1880s. Until quite recently, Dearle's design contributions during the last decade of Morris's life were often wrongly attributed to the master himself, a measure of both their quality and the extent to which Dearle had absorbed the Morris aesthetic. Given that Dearle himself did nothing to correct those impressions at the time or later, this also indicates two things: that the Morris name was so renowned, it made commercial sense not to deflect potential sales by correct attribution; and that, if only for commercial reasons, Morris's ideal of the selfless, anonymous medieval craftsman had found its epitome in his faithful apprentice.

CREATED

Merton Abbey, London

MEDIUM

Printed cotton

RELATED WORKS

Wandle printed fabric by William Morris, 1884

John Henry Dearle (1859–1932)

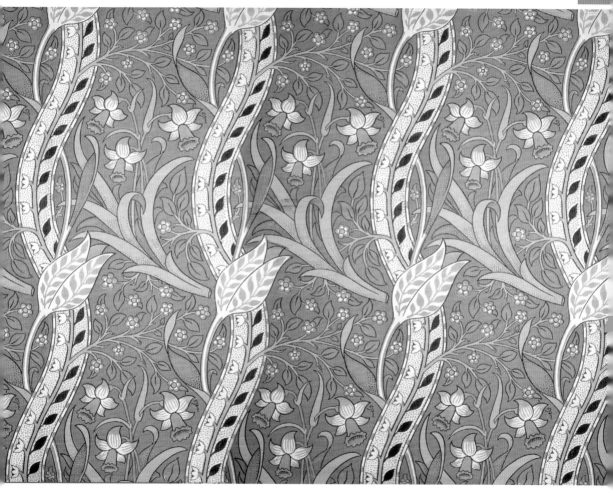

Portière made from Morris & Co. oak damask, 1892–93

Courtesy of Museum of Fine Arts, Boston, Massachusetts, USA/In memory of J.S. and Sayde Z. Gordon from Myron K. and Natalie G. Stone/Bridgeman Images

In June 1890, May Morris married Henry Halliday Sparling (1860–1924), Secretary of the Socialist League, whose politics, like her father's, she shared. The couple took out a lease on a house on the river at Hammersmith, just a few hundred yards from her parents at Kelmscott House. By this point, May had been running the embroidery department of Morris & Co., based at Queen Square, for five years. This was now moved to the drawing room of her new home, where the various young embroiderers who worked for her included Lily Yeats (1866–1949), sister of poet W.B. Yeats (1865–1939). May executed this fine embroidery during this same period of intense domestic industry, but stepped back from daily involvement with the company's affairs after the death of her father in 1896, whereupon the embroidery section moved to the Morris & Co. shop at 449 Oxford Street. May continued designing embroideries and also wallpapers for the company well into the twentieth century, and published a number of essays and articles on the subject in journals and books from the late 1880s onwards. Over the two decades following his death, now living at Kelmscott Manor, May also devoted herself to the task of editing and overseeing publication of the 24 volumes of her father's collected works.

CREATED

Hammersmith, London

MEDIUM

Silk damask embroidered with silk, with a silk fringe and cotton lining

RELATED WORKS

Pigeon wall hanging by John Henry Dearle, *c.* 1895

May Morris (1862–1938)

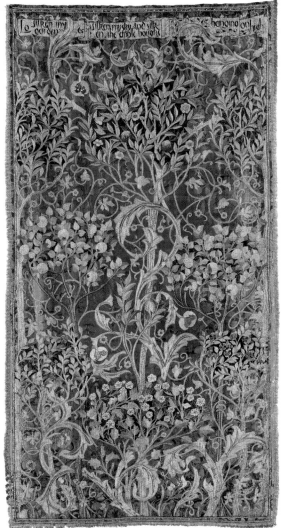

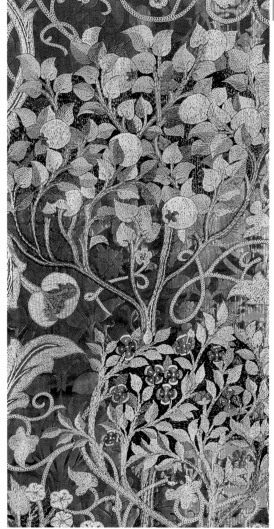

The Courtyard, Standen, East Grinstead, 1900

Courtesy of The Print Collector/Print Collector/Hulton Archive/Getty Images

By the early 1890s, Philip Webb was regarded by many as the father of Arts and Crafts architecture, whose most archetypal building was the country house where the use of vernacular styles – a central tenet of the Arts and Crafts philosophy, and of Webb's practice – was at its most convincing. His career was bookended by two of his greatest houses: Red House, designed for his dear friend William Morris, and Standen near East Grinstead in Sussex, his final and possibly finest building. The house was commissioned as a family home by James Beale, a London solicitor who made a fortune handling government contracts for the building of the Midland Railway. It effortlessly incorporates the sixteenth-century farmhouse, barn and other buildings that already occupied part of the site. Everywhere, details such as sandstone blocks with visible mason's chisel marks exhibit 'truth to materials', a core principle of the Arts and Crafts Movement, with their respect for craftsmanship and traditional methods of construction. Guided by Webb, the interior decoration was carried out using wallpapers, fabrics, carpets and other fittings from Morris & Co., along with brass fittings by William Arthur Smith Benson (1854–1924) and works of art by Burne-Jones and Ford Madox Brown.

CREATED

East Grinstead

MEDIUM

Architecture

RELATED WORKS

Blackwell by Mackay Hugh Baillie Scott, 1898–1900

Philip Webb (1831–1915) (architect)

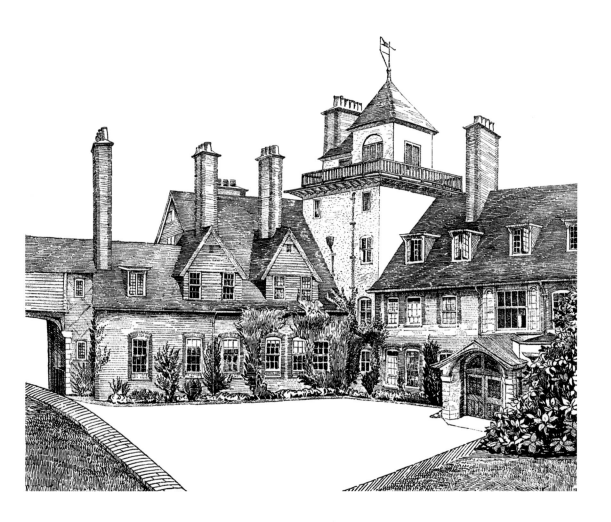

Diagonal Trail furnishing textile, 1893

Courtesy of Andreas von Einsiedel/The National Trust Photolibrary/Alamy Stock Photo

Morris's deepening commitment to socialism through the 1880s gave him new understanding of a problem which had vexed him throughout his career: the difficulty of making meaningful art in an unjust society, a question which became a central concern of the Arts and Crafts Movement. In his essay 'The Revival of Handicraft', published in the *Fortnightly Review* in November 1888, he admits to sharing a widely felt regret over the general disappearance of handicraft skills but insists that 'it is impossible to exclude socio-political questions from the consideration of aesthetics', disclaiming 'the mere aesthetic point of view which looks upon the ploughman and his bullocks and his plough, the reaper, his work, his wife, and his dinner, as so many elements which compose a pretty tapestry hanging, fit to adorn the study of a contemplative person of cultivation'. Pricking the bubble of this bourgeois view of life, he insists that until the subjects of that bucolic, sentimental scene become aesthetic agents themselves, the art that depicts them will remain trifling, 'that the reaper and his wife should have themselves a due share in all the fulness of life ... forcing me to bear part of the burden of its deficiencies, so that we may together be forced to attempt to remedy them, and have no very heavy burden to carry between us'.

CREATED

Merton Abbey, London

MEDIUM

Woven woollen fabric

RELATED WORKS

Floral design by Lindsay P. Butterfield, *c.* 1910

John Henry Dearle (1859–1932)

Cover of *The Revolt of Islam* by Percy Bysshe Shelley, 1893 or later

Thomas Cobden-Sanderson (1840–1922) was a middle-aged barrister bored with his career when he decided to switch to the vocation that linked him with the Arts and Crafts Movement. Already associated with Morris through his commitment to the socialist cause, after Cobden-Sanderson had wondered aloud one night at dinner with the Morrises which creative specialism he might take up, it was Jane who suggested bookbinding, noting that this 'would add an Art to our little community'. As it happened, one of his first commissions was to bind Morris's personal copy, in French translation, of Marx's *Das Kapital*, although at first, aside from this private work, it seems Morris was not all that encouraging of his friend's new vocation. However, Cobden-Sanderson persevered and in 1893 set up the Doves Bindery, with Emery Walker (1851–1933), in a building next to the Kelmscott Press and Kelmscott House, close to the famous Dove Inn on the Thames at Hammersmith. By creating beautiful versions of classic works, as in this case, Cobden-Sanderson's company revived the art of bookbinding and over the next few years, until Morris's death, bound special editions of books produced by the Kelmscott Press, with exquisitely incised pigskin covers designed by Morris himself. A few years later, Walker and Cobden-Sanderson created the Doves Press, which was part of the growing private press movement initiated by Morris's Kelmscott Press.

CREATED

Hammersmith, London

MEDIUM

Goatskin tooled in gold

RELATED WORKS

Das Kapital by Karl Marx (Morris's personal copy) bound by Thomas Cobden-Sanderson, 1884

Thomas Cobden-Sanderson (1840–1922)

Angeli Ministrantes tapestry, 1894

Courtesy of Private Collection/© The Maas Gallery, London, UK/Bridgeman Images

Morris and Burne-Jones began their careers with designs for stained-glass windows for churches; this design was one of a pair depicting angels originally devised for windows at Salisbury Cathedral in 1878. The same figures recommended themselves for tapestries some 17 years later and, in that form, with the addition of foliage and border decoration by Dearle, would prove popular as decorations for churches over the following few years, including for All Saints' Church, Brockhampton in Herefordshire, a church designed by William Richard Lethaby (1857–1931) and built in 1902. The Church of England remained an important source of income for some Arts and Crafts designers and for Morris & Co., with Burne-Jones continuing to fulfil major stained-glass commissions up until his death, two years after Morris. Stained glass continued to thrive as a medium into the twentieth century; tapestries, on the other hand, proved far more difficult to sell, given that the amount of work involved in making the largest pieces put them beyond the reach of most clients' pockets. In Morris's eyes 'the noblest of the weaving arts', this description of tapestry highlights the dual identity of the term 'Arts and Crafts' – the obvious difference between, say, a decorative patterned fabric or wallpaper and the narrative, almost painterly complexity of the very finest tapestries.

CREATED

Merton Abbey, London

MEDIUM

Woven wool, silk and mohair on a cotton warp

RELATED WORKS

The Seasons tapestry by William Morris and John Henry Dearle, 1890

Edward Burne-Jones (1833–98) **and John Henry Dearle** (1859–1932)

Compton curtain, c. 1896

For many years, this pattern was thought to be Morris's final wallpaper design, although it later emerged as one of many by Dearle that had been misidentified as his master's work. Produced as both a wallpaper and a textile, it was commissioned by Laurence W. Hodson (1864–1933), a noted patron of the arts and collector of Pre-Raphaelite paintings, for the interior redesign of his house, Compton Hall, near Wolverhampton, which Morris & Co. carried out in 1895–96. By this time Dearle had taken charge of large-scale undertakings such as the interior decoration of grand houses like Compton Hall or Stanmore Hall in Middlesex earlier in the decade. Although the misattribution of this design to Morris is a fine compliment, in fact by the time of Morris's death Dearle was developing a distinctive style of his own within the overall aesthetic associated with the Morris name. He also absorbed personal influences into his own designs, such as the Persian and Turkish textiles he studied at the South Kensington Museum, even if these patterns and traditions were essentially similar to some of those that had always captivated Morris himself.

CREATED

Merton Abbey, London

MEDIUM

Colour woodblock print on cotton

RELATED WORKS

Tiger Lily design for a printed textile by Lindsay P. Butterfield, 1896

John Henry Dearle (1859–1932)

Granville wallpaper, 1896

Courtesy of Private Collection/Bridgeman Images

In his essay 'The Revival of Handicraft', published in November 1888, Morris identifies the growth of machine-made goods with the increasing ignorance among the general population of 'all the methods and processes of manufacture', even with relatively simple forms of decoration such as this wallpaper. However, his critique, after years of immersion in Marxist thought, goes far deeper than that. 'Almost all goods,' he goes on, 'are made apart from the life of those who use them; we are not responsible for them, our will has had no part in their production, except so far as we form part of the market on which they can be forced for the profit of the capitalist whose money is employed in producing them. The market assumes that certain wares are wanted; it produces such wares, indeed, but their kind and quality are only adapted to the needs of the public in a very rough fashion, because the public needs are subordinated to the interest of the capitalist masters of the market, and they can force the public to put up with the less desirable article if they choose, as they generally do. The result is that in this direction our boasted individuality is a sham.' His own company products notwithstanding, in a consumerist age when the so-called individual is king (or queen), Morris's analysis is still bracingly relevant.

CREATED

Merton Abbey, London

MEDIUM

Wallpaper

RELATED WORKS

Peacock Garden wallpaper by Walter Crane, 1889

John Henry Dearle (1859–1932)

Oak Tree wallpaper, 1896

Courtesy of V&A Images/Alamy Stock Photo

The logic of Morris's thinking about the market system in which, as a businessman, he had to operate ran along the lines of the following: the choice we are offered by the 'free' market is not what we might actually choose based on our personalities and our deepest spiritual and material needs, but only what those who trade in the marketplace interpret those personalities and needs to be. Ergo, we should make these things for ourselves rather than buying things from a shop – even a shop such as Morris & Co. that sells quality carpets, fabrics and wallpapers such as this one. Only then will we understand how things are made and will thereby better appreciate the work of other makers, while at the same time, the experience of making will imbue us with a sense of fulfilment far richer than the pleasure of simply buying things from a shop. Alas, for Morris, the division of labour at the heart of the modern economy had served to deny the majority this experience of how to make things: 'what are the difficulties that beset its manufacture, what it ought to look like, feel like, smell like, or what it ought to cost apart from the profit of the middleman' – a set of factors amounting to far more than a mere technical challenge.

CREATED

Merton Abbey, London

MEDIUM

Wallpaper

RELATED WORKS

Jasmine wallpaper by William Morris, *c.* 1872

John Henry Dearle (1859–1932)

Detail of carved inlay on cabinet, 1898–99

Courtesy of The Cheltenham Trust and Cheltenham Borough Council/Bridgeman Images

In the late 1880s, a new group emerged with a more vigorous adherence to basic Arts and Crafts ideals. Charles Robert Ashbee (1863–1942) had trained as an architect, but his ambition – inspired by Ruskin and Morris – to establish an art school in the heart of the poorest part of London had led him to seek advice from Morris in 1887. The *éminence grise* was then at the height of his political activity and perhaps for this reason was less than enthusiastic about the young man's ideas. However, Ashbee, undeterred, raised the money he needed and in June 1888 the Guild and School of Handicraft opened in Whitechapel, turning out products from furniture to metalwork and offering evening classes to poor local men in carving, clay modelling, silversmithing and many other disciplines. The Guild's range of activities and roster of craftsmen expanded over the next decade, and their products were exhibited across Europe and America. In 1891, the organization moved to Mile End, where this cabinet was made, then in 1902, Ashbee moved its workshops and personnel from the heart of industrial London to the village of Chipping Campden in the Cotswolds, close to the movement's spiritual home of Kelmscott Manor, to live and work in an environment more conducive to the peaceful, rural existence that was central to the Arts and Crafts view of the craftsman's ideal life.

CREATED

London

MEDIUM

Mahogany, holly and brass

RELATED WORKS

Green-stained oak writing cabinet by Charles Francis Annesley Voysey, *c.* 1896

Charles Robert Ashbee (1863–1942)

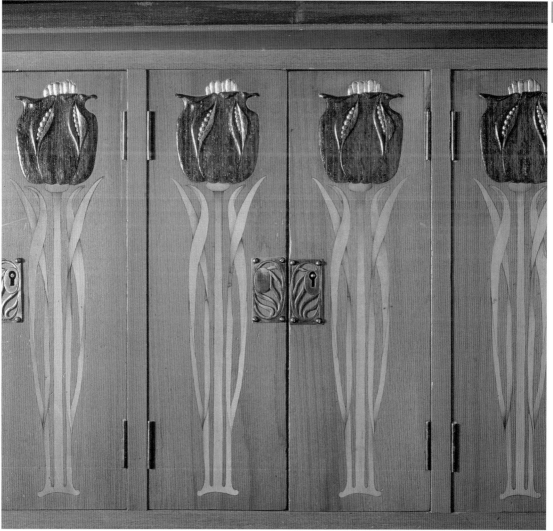

Coffee pot, before 1900

William Arthur Smith Benson was closely connected with Morris and his company for the whole of his professional life. Oxford-educated and another who came to designing through an architect's training, in 1880, with the direct encouragement of Morris, he opened a 'workshop for the production of turned metalwork on a commercial scale'. Morris was clearly very fond of him and impressed by his work, routinely addressing him with the pet name of 'Mr Brass Benson'. For the next several decades Benson continued to design for Morris & Co. – producing metalwork such as this coffee pot, furniture and even wallpaper, while also running his own company with a showroom on London's Bond Street. He was a member of the Art Workers' Guild and, in 1887, the first secretary of the Arts and Crafts Exhibition Society. In 1905, he was appointed as one of eight directors of Morris & Co. Unlike some of the other leading Arts and Crafts designers, he was not averse to using modern machine manufacture to help realize his design ideas, and in 1915 was a founder member of the Design Industries Association, whose expressed aim was to bring together 'the designer and the manufacturer (who) have so largely remained in separate compartments'.

CREATED

London

MEDIUM

Copper and brass

RELATED WORKS

Salt cellar with lid by Charles Robert Ashbee, 1899–1900

William Arthur Smith Benson (1854–1924)

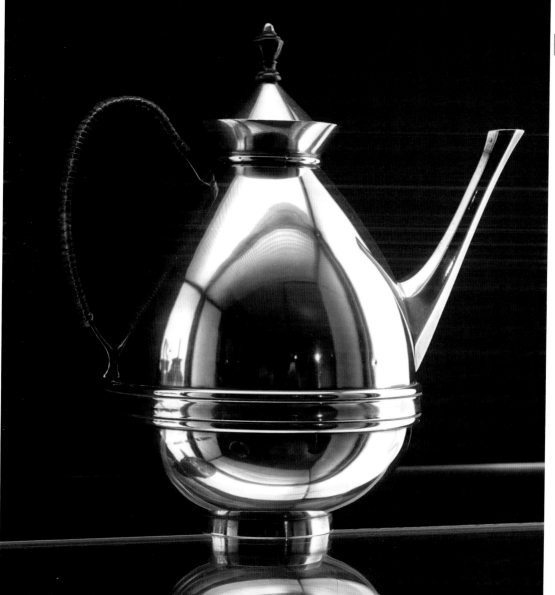

Oak dresser, *c.* 1900

Courtesy of Victoria and Albert Museum, London, UK/Bridgeman Images

William Richard Lethaby, an architect who trained with Norman Shaw, was a founder member in 1884 of the Art Workers' Guild, an organization whose purpose was to encourage parity of esteem for fine and applied arts, although these ideas of equality were not extended to practitioners themselves, as women were not admitted to the Guild until the 1960s. Lethaby was one of a group of young designers closely associated with Morris in the later 1880s, who were clearly influenced by his ideas in both design and politics. A successful architect whose buildings included churches in the Arts and Crafts style, Lethaby also designed books, stained glass and furniture such as this oak dresser, and was an important educator: as principal of the Central School of Arts and Crafts in 1900–12 and from 1908 as the first professor of design at the Royal College of Art. In his book *Art and Life*, he encapsulates the basic worldview of the Arts and Crafts Movement in saying, 'We must, above all, get rid of the grandeur idea of Art.... Art is but the garment of life. It is the well doing of what needs doing. Art is not the pride of the eye and the purse, it is a link with the child-spirit and the child-ages of the world.'

CREATED

London

MEDIUM

Oak

RELATED WORKS

Sideboard with plate-stand by Ernest Gimson, 1915

William Richard Lethaby (1857–1931)

Iris wallpaper, 1902

Morris's own workshops, like those of the Arts and Crafts makers who followed him, gave far more autonomy to the handicraftsperson than the average Victorian industrial worker could hope for. Nonetheless, they were not at liberty to deviate from the given design in a way we might have expected from such a staunch believer in the sovereign individual, based on the creative freedoms enjoyed by the medieval craftsman. These are extolled repeatedly across various essays and lectures of the 1880s, such as 'The Revival of Handicraft' of 1888. Citing the three great epochs of production described by Marx in *Das Kapital*, Morris explains: 'During the first or medieval period all production was individualistic in method; for though the workmen were combined into great associations for production and the organization of labour, they were so associated as citizens, not as mere workmen. There was little or no division of labour, and what machinery was used was simply of the nature of a multiplied tool, a help to the workman's hand-labour and not a supplanter of it. The workman worked for himself and not for any capitalistic employer, and he was accordingly master of his work and his time; this was the period of pure handicraft.' Though Dearle, the designer of this wallpaper, was a company man who would probably not have seen himself that way, he still rose highest within the business among all the apprentices who ever worked for Morris & Co.

CREATED

Merton Abbey, London

MEDIUM

Wallpaper

RELATED WORKS

Chrysanthemum wallpaper by William Morris, 1877

John Henry Dearle (1859–1932)

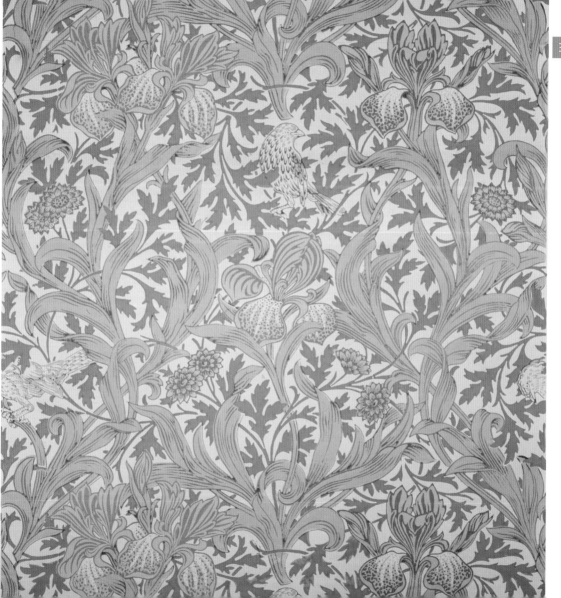

The Adoration tapestry, 1902

Courtesy of State Hermitage Museum, St. Petersburg, Russia /Bridgeman Images

In later life, Morris was consistently generous with the knowledge he had so sedulously acquired, giving lectures and writing essays in which he sets out hard-won insights into the challenges and rewards of different mediums, which proved a great inspiration for the younger Arts and Crafts designers. In 'Textiles', an essay from 1893, he writes: 'As in all wall-decoration, the first thing to be considered in the designing of Tapestry is the force, purity, and elegance of the *silhouette* of the objects represented, and nothing vague or indeterminate is admissible. But special excellences can be expected from it. Depth of tone, richness of colour, and exquisite gradation of tints are easily to be obtained in Tapestry; and it also demands that crispness and abundance of beautiful detail which was the especial characteristic of fully developed Medieval Art. The style of even the best period of the Renaissance is wholly unfit for Tapestry: accordingly we find that Tapestry retained its Gothic character longer than any other of the pictorial arts.' *The Adoration*, when first exhibited, was described by a correspondent for *The Queen* magazine as 'so perfect, indeed, in every detail, that there is nothing left to desire, and one feels inclined to linger over it until its perfections have been fully grasped'.

CREATED

Merton Abbey, London

MEDIUM

Woven wool, silk and mohair on a cotton warp

RELATED WORKS

The Attainment tapestry by William Morris, Edward Burne-Jones and John Henry Dearle, 1890–94

John Henry Dearle (1859–1932)

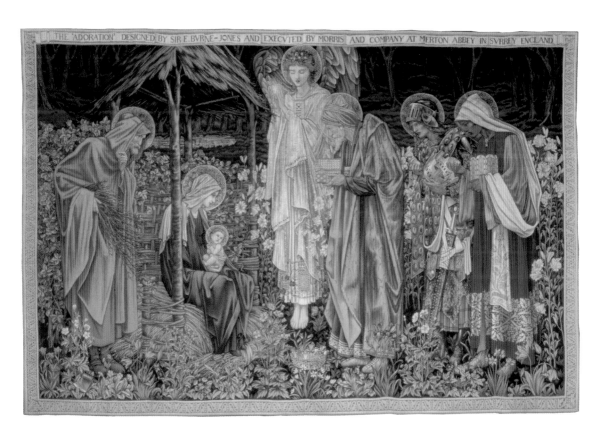

THE 'ADORATION' DESIGNED BY SIR E. BVRNE-JONES AND EXECVTED BY MORRIS AND COMPANY AT MERTON ABBEY IN SVRREY ENGLAND

Chair from the *Norman and Stacey* dining suite, *c.* 1904

Courtesy of Leeds Museums and Galleries (Lotherton Hall) UK/Bridgeman Images

Nowadays still largely (and inexplicably) forgotten, in his own lifetime Belgian-born Anglo-Welsh artist Frank Brangwyn (1867–1956) was a major figure in British art – a painter and muralist of exquisite sensitivity of touch, tone and colour. However, he began in 1882 as a Morris apprentice at Queen Square, enlarging designs and tracing drawings, imbibing not only technical knowledge but also an ethos he carried with him through life. In particular, he believed that an artist 'must be able to turn his hand to everything, for his mission is to decorate life ... he should be able to make pots and pans, doors and walls, monuments or cathedrals, carve, paint, and do everything asked of him'. Brangwyn had sufficient talent that such an ambition was well within his grasp, and his total output includes ceramics, textiles, stained glass and furniture such as this elegant chair. His versatility and lack of aesthetic agenda allowed him to move freely between movements and countries whose members otherwise did not mix. A born sensualist, he did not share the rather puritan view of Art Nouveau that was common among the English Arts and Crafts designers; in 1895, he was commissioned to paint a pair of murals for the entrance hall of the Maison de l'Art Nouveau, the influential Paris gallery of Siegfried Bing (1838–1905).

CREATED

London

MEDIUM

Mahogany with ebony inlay

RELATED WORKS

Swan chair by Charles Francis Annesley Voysey, 1883–85

Frank Brangwyn (1867–1956)

Single Stem wallpaper, c. 1905

Morris admitted that on a superficial level the movement toward the revival of handicraft was a pitiful effort when set beside the forces of commercialism it was trying to resist. However, he also saw this niche popularity of handicrafts as a cause for hope, writing in his 1888 essay 'The Revival of Handicraft' that 'the feeble protest ... against the vulgarization of all life' was a welcome sign, 'first because it is one token amongst others of the sickness of modern civilization; and next, because it may help to keep alive memories of the past which are necessary elements of the life of the future, and methods of work which no society could afford to lose'. In the end, for Morris, fundamental aspects of human nature would impel large numbers of individuals within societies to adopt a less 'vicarious life', a phrase he called 'the watchword of our civilization'. Indeed, our very concept of civilization was a big part of the problem, creating a hopeless underclass whose work was the most mindless drudgery, and an acquisitive middle class aspiring to ever-more effete forms of so-called civilized living; 'lopsided creatures' whose lives were 'complicated ... by the ceaseless creation of artificial wants which we refuse to supply for ourselves'. By the time this wallpaper was created, design fashion had moved on yet again, but Morris's assessment is a timeless critique of the shallowness and waste of modern life.

CREATED

Merton Abbey, London

MEDIUM

Wallpaper

RELATED WORKS

The Saladin wallpaper by Charles Francis Annesley Voysey, 1897

John Henry Dearle (1859–1932)

Tree Portière tapestry, c. 1909

Dearle designed his first tapestry for Morris & Co., called *Fox and Pheasant*, in 1887, and thereafter oversaw the production of every single tapestry woven at the company's Merton Abbey premises until his retirement in 1932; he was especially good at drawing foliage and animals, as is clear from this piece. Although Morris himself had been responsible for reviving the ancient art of tapestry in the early 1880s, it was Dearle's decades-long labour – both weaving and then designing – on the elaborate tapestries produced by Morris & Co. that has left us the main physical legacy of his master's vision for the medium. The designer Lewis Foreman Day, in describing what Dearle was to his mentor, spoke of Morris depending on 'the assistance of a pupil who entered so entirely into his spirit, that he could be relied upon to do much what he himself might have done'; in that regard Dearle was the natural choice to assume the role of chief designer in 1890. During the mid-1890s, after the Merton Abbey weavers had finished the great *Holy Grail* series, a dearth of orders for tapestry had forced a rethink of aesthetic priorities along more obviously affordable lines, although the trademark Morris motifs are still in evidence in this piece from the following decade.

CREATED

Merton Abbey, London

MEDIUM

Tapestry

RELATED WORKS

Angeli Laudantes tapestry by Edward Burne-Jones and John Henry Dearle, 1894

John Henry Dearle (1859–1932)

Sideboard back with a pair of candlesticks, 1915

Ernest Gimson (1864–1919) was another of the group of young architect-designers who gravitated to Morris through their membership of the Society for the Protection of Ancient Buildings and the Art Workers' Guild. In 1892, he was the first of his generation of designers to follow Morris's example in moving to the Cotswolds, where with the Barnsley brothers, Ernest (1863–1926) and Sidney (1865–1926), he set up an independent architecture and design practice, before branching off, initially with Ernest Barnsley, to focus on metalwork and pieces of furniture such as this sideboard, as well as architectural projects. Now regarded as one of the very finest Arts and Crafts designers, in a letter to Lethaby in 1916 Gimson reveals a still strong commitment to the ideals of the movement in terms that Morris himself might have used: 'I am with you,' he writes, 'in wanting intelligence and character in *all* man's work and I want it about as much as I want anything and I want the work to be such as can take it. I want it in organizers and designers but a thousand times more do I want it in the *people*, and it is for that reason that I so much dread the swamping of hand industry by machinery and of its ideals by competitive trade.'

CREATED

Sapperton

MEDIUM

Mixed, mainly walnut

RELATED WORKS

Sideboard by Lewis Foreman Day, *c.* 1880

Ernest Gimson (1864–1919)

Author Biographies

Julian Beecroft (author)

Julian Beecroft is a freelance writer specializing in art and cultural history. For Flame Tree, he has written books on Monet, Renoir, Dalí, Kahlo and Art Nouveau. He is also the author of *Lost Cities* and *Secret Cities*, also published by Flame Tree, as well as a guide to the culture and history of London published in 2017. He has contributed to *The Guardian*, *The Telegraph*, *1843* (*The Economist* magazine) and *The London Magazine*.

Helen Elletson (foreword)

Helen Elletson has been Curator of the William Morris Society's collection at Kelmscott House since 2000. She is also the Manager and Curator of the nearby Emery Walker's House, a riverside property with one of the best preserved Arts and Crafts interiors in Britain. Helen wrote *A History of Kelmscott House* in 2009 and *Highlights from the William Morris Society's Collection* in 2015, as well as publishing articles in magazines and books on the collections of both houses. Helen is also project lead of Arts and Crafts Hammersmith, which aims to develop innovative learning and outreach programmes.

Picture Credits: Prelims and Introductory Matter

Further Reading

Blakesley, Rosalind P., *The Arts and Crafts Movement*, London: Phaidon Press Ltd, 2006

Fiell, Charlotte and Peter, *Morris*, Cologne: Taschen GmbH, 2017

Greenlaw, Lavinia, *Questions of Travel: William Morris in Iceland*, London: Notting Hill Editions, 2017

Greensted, Mary, ed., *An Anthology of The Arts and Crafts Movement*, Aldershot: Lund Humphries, 2005

Holland, Owen, *William Morris's Utopianism: Propaganda, Politics and Prefiguration*, Basingstoke: Palgrave Macmillan, 2017

MacCarthy, Fiona, *Anarchy and Beauty: William Morris and his Legacy 1860–1960,* London: National Portrait Gallery, 2014

MacCarthy, Fiona, *William Morris: A Life of Our Time*, London: Faber and Faber, 1994

Morris, William, *News from Nowhere and Other Writings*, London: Penguin Classics, 1993

Naylor, Gillian, *William Morris by himself*, London: Macdonald Orbis, 1988

Ormiston, Rosalind & Wells, Nicholas Michael, *William Morris: Artist, Craftsman, Pioneer*, London: Flame Tree Publishing, 2010

Parry, Linda, *William Morris*, London: Philip Wilson Publishers, 1996

Parry, Linda, *William Morris Textiles*, London: Weidenfield and Nicholson, 1983

Parry, Linda (ed.), *William Morris: Art and Kelmscott*, Woodbridge: The Boydell Press, 1996

Robinson, Michael, *Arts & Crafts*, London: Flame Tree Publishing, 2018

Robinson, Michael, *The Pre-Raphaelites*, London: Flame Tree Publishing, 2018

Robinson, Michael, *William Morris: Masterpieces of Art*, London: Flame Tree Publishing, 2014

Ruskin, John, *The Nature of Gothic: A Chapter from The Stones of Venice* (with preface by William Morris), London: Euston Grove Press, 2008

Smith, Alison, *Edward Burne-Jones*, London: Tate Publishing, 2018

Thompson, Paul, *The Work of William Morris*, Oxford: Oxford University Press, 1991

Todd, Pamela, *William Morris and the Arts and Crafts Home*, London: Thames and Hudson Ltd, 2005

Wild, Tessa, *William Morris and his Palace of Art: Architecture, Interiors and Design at Red House*, London: Philip Wilson Publishers, 2018

The William Morris Internet Archive: Works: www.marxists.org/archive/morris/works/index.htm

Index by Work

General Index